Praise for *Body Horror:*

Best Book of 2017, Chicago Public Lib

2018 Lambda Literary Awards Finalis

T0273598

2017 Chicago Review of Books Nonfiction Award Shortlist

"Sharp, shocking, and darkly funny, the essays in this sapient collection … expose the twisted logic at the core of Western capitalism and our stunted understanding of both its violence and the illnesses it breeds. … Brainy and historically informed, this collection is less a rallying cry or a bitter diatribe than a series of irreverent and ruthlessly accurate jabs at a culture that is slowly devouring us."

—*Publisher's Weekly* (starred review)

"Books We Can't Wait to Read in 2017"—*Chicago Reader*

"Scary as fuck and liberating … Moore connects the dots that you did not even think were on the same page." —*Viva la Feminista*

"The metaphor that centers the collection … is captured in a comically macabre way by the book's cover art, which combines freak-show graphics with a punk-zine sensibility. And it is that extra edge, that bizarro brio, that makes this collection resonate long after the political harangue has faded. … By audaciously linking her disparate Body Horrors to a larger construct — more complex even than her own immune system, more menacing than mere patriarchy — Moore allows her essays, each plenty feisty its own right, to punch significantly above their individual weight. Whether one is ready in real life to attribute everything from Crohn's disease to Pacific Time to the machinations of the market, Moore's arguments land with force enough to make even the marginally politicized reader think."

—*Los Angeles Review of Books*

"[D]evastating in its unwillingness to flinch … *Body Horror* is an incredible, touching, intelligent collection that looks beyond what's comfortable to examine what is true."

—*Foreword* (five star review)

SWEET LITTLE CUNT

THE GRAPHIC WORK OF JULIE DOUCET

Other Books In The Critical Cartoons Series:

Ed vs. Yummy Fur: Or, What Happens When a Serial Comic Becomes a Graphic Novel by Brian Evenson

Carl Barks' Duck: Average American by Peter Schilling Jr.

Brighter Than You Think: Ten Stories by Alan Moore by Marc Sobel

Sweet Little Cunt: The Graphic Work of Julie Doucet
Critical Cartoons 004

Copyright © 2018 Anne Elizabeth Moore & Uncivilized Books.

All artwork is copyright © 2018 Julie Doucet.

Series Editor/Art Director: Tom Kaczynski
Copy Edits: Erik Hane
Production Assist: Ari Mulch

Uncivilized Books
2854 Columbus Ave
Minneapolis, MN 55407
USA

uncivilizedbooks.com

First Edition, Nov 2018
10 9 8 7 6 5 4 3 2 1

ISBN 978-1-941250-28-0

DISTRIBUTED TO THE TRADE BY:

Consortium Book Sales & Distribution, LLC.
34 Thirteenth Avenue NE,
Suite 101 Minneapolis,
MN 55413-1007
Orders: (800) 283-3572

Printed in Canada

CRITICAL CARTOONS

SWEET LITTLE CUNT

THE GRAPHIC WORK OF JULIE DOUCET

.........................

by Anne Elizabeth Moore

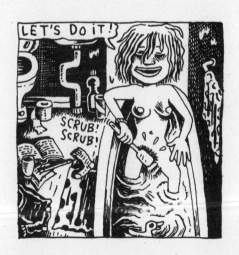

Uncivilized Books

CONTENTS

For Abe.

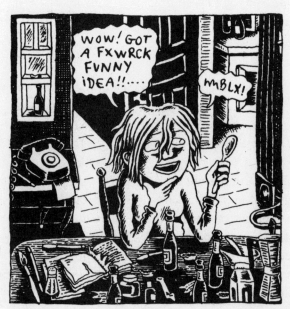

From "A Day in Julie Doucet's Life," *Dirty Plotte* #3 (1992).

INTRODUCTION

It is impossible to convey, to anyone who didn't stumble across the stuff on their own, the evanescent but ferocious intensity to be found in the photocopied page of any zine or comic from the late 1980s and early 1990s. Self-publishing in those days showed you, the reader, a culture being ripped apart, at the seams and straight through the middle, while on fire, the raw guts of oppression and abuse and injustice exposed and left behind to rot while you watched with a beer from a spot near the stage. French-Canadian artist and comics creator Julie Doucet invented a character, named Julie Doucet, who let you tag along as she did exactly that, can in hand, enjoying the show. Starting in 1987 on the pages of the fanzine *Dirty Plotte*, then continuing on through a comic-book series of the same name as well as several graphic novels, Julie-the-character gallivanted semi-innocently about the club, the city, the country (any country) concerned primarily with her own pleasure as the Berlin Wall crumbled somewhere behind her, a sign that the cultural undoing you felt in your bones had tangible political effects.

The daring adventures of Julie Doucet's smart, hot, disheveled, and sometimes rageful imaginary self just goofing

off or engaging in semi-erotic play with an array of mammalian co-conspirators have seared themselves into the minds of a generation of readers. These fanciful images from a world in flux pointed the way for creators seeking inspiration from nocturnal visions and creators with stories to share from their own experiences. Not to mention creators—women and nonbinary ones, in particular—who hadn't had impetus to imagine themselves in the creative role before coming across her work. Among other merits, Doucet's strips gifted the field of comics with the hope that creators who are not male might eventually see mainstream acceptance. I cannot stress enough how important this is. Yet I admit that when I am asked about important comics, or the importance of comics, the signature scenes from Doucet's oeuvre—Julie the man, Julie at a club, Julie hopping into a tub to scrub her cooter, Julie in flagrante with her elephant lover—are not the images that immediately pop into my head.

The panel that springs to mind instead is a quiet, domestic scene. Julie-the-character plays a minor role while her various home goods—discarded beer bottles, half-used condiments, an iron, forks, lamps, etc.—carry the action. The panel comes toward the end of one of her many dream comics, a plethora of narratives in which the renowned creator presumably lays bare the machinations of her subconscious mind. These are often transcribed in gruesome, delightful detail: Julie as a gunslinger dies alone in a saloon. Julie is upset that she can't find a decent brassiere at a basement warehouse sale. (Clearly a dream; Julie-the-artist didn't wear bras at the time.) Julie turns into a man overnight and—lucky her!—meets up with Mickey Dolenz of the rock-group/TV program The Monkees and makes a sex date with him. The very definition of dreamy!

Doucet's dream comics are something of an extension of her most beloved work, semiautobiographical tales of her imagined self—a bolder, louder version of the real-life artist—responding to semireal or pseudoreal scenarios that, occasionally, get unreal super fast. The dreams tend to be dictated by an interior logic that the reader becomes familiar with over the course of her Drawn & Quarterly series *Dirty Plotte*, black-and-white standard-sized pamphlet comic books ("floppies") published from 1991-1998 that contain the bulk of her internationally distributed comics output. While the dream comics often seem motivated by fear or anxiety, the comics that explore the artist's idealized persona are instigated most frequently by joy, desire, and curiosity. My favorite-ever comics panel—the one that pops into my mind unbidden when I am asked about the possibilities of the comics form, or my bizarre and oft-wavering devotion to it—reflects a mixture of these emotional states: a quivering, vibrant panel crammed with the promise of both terror and delight.

This particular dream story is from the first of the floppies, although the dream itself ranks among the lesser convolutions of Julie-the-artist's sleeping-mind logic. I must work to remember what happens in it, in fact, recalling at first only that the narrative trades in some sort of low-grade creepiness. Yet on the final page of the strip, Julie-the-character is awake, surrounded by small appliances in the comfort of her own home, no longer scared. Our protagonist remains confused by the dream, and is disheveled as always. Significantly, her sleepiness distracts her from the fact that her kitchen utensils, food containers, and electrical gadgets have all gathered just below her line of vision, on top of the table and along the floor, intent on annoying, harming, or murdering our heroine as she

goes about her normal, just-got-out-of-bed-from-a-nightmare business. The angry mob surrounding Julie-the-character is drawn with a line that is both anxious and playful, as if the hand that drew it were unable to contain its own energy. A fluted, used cereal bowl, spoon still intact, adopts a leadership role at the head of the mob; unwashed water glasses ooze germs and resentment. The table is stippled in an unpracticed hand, marking the strip as early in the artist's oeuvre, which adds to the ensuing chaos; the bathrobe that character Julie throws on upon awakening portends the artist's later, post-comics abstract print work.

"Unpracticed but effective" is what I would say of the background shading, if giving a three-hour lecture on this single panel, which I certainly could do. I would also add, with an excited arch to my right eyebrow, "This is an artist just days away from a crosshatching breakthrough!" Character development in such a lecture would inspire no critique, just awe. The relish with which an actual jar of relish threatens our protagonist is silly, inquisitive, thoughtful, endearing, and ultimately terrifying. All while Julie-the-character's smiling visage is warmly contented by the notes she jots in her dream journal, a device that allows her to speak directly to the reader from the page without breaking the diegetic spell, remaining oblivious to the dangers that seem set to befall her once the strip ends.

Entitled "dreamt February 17 1990," the final panel of this comic is intentionally destabilizing. We are, perhaps, to read the concerns that Julie-the-character's brain imagines at rest as insignificant compared to the dangers that await Julie-the-artist, awake in the kitchen. But are the real-life threats physical? Emotional? Metaphorical? Purely imagined? Exacerbated by

paranoia or clumsiness or slovenliness? Or maybe—and this is what gets me about that final panel every time it pops into my mind, which is almost every day, and which also presents the most likely possibility—a batch of murderous home goods is just a goddamn blast to draw, and Julie-the-artist has foisted it upon the world to terrorize us all a teeny, tiny bit, simply because she fucking felt like it.

Doucet's work, overall, is nothing but destabilizing. It throws readers for loops; it brought momentum and new creators to independent comics; it inspired one of today's most important publishers to develop solo-authored lines and thus acted as a flagship for the black-and-white boom even as it cleared a path for the graphic novel boom a decade later; it changed our very presumptions about who can and will master the form of comics. It is not hyperbole to suggest that Julie Doucet's comics changed history. Yet what's never been clear to anyone—the enduring mystery of the murderous home goods, if you will—is how much the upending of the form was ever truly the artist's intention.

I pressed Doucet once on the question. After gushing over the panel in an interview, I queried her on its visceral sense, lodged somewhere between imagination, dream, and reality, pointedly asking what she intended it to depict. Is it inward or outward perception? Silliness? Anxiety? Rage? Her response couldn't have been more destabilizing.

"Oh, I don't even have an iron," she told me.

Julie Doucet launched her comics career with the self-published *Dirty Plotte* in Montreal, Canada in 1987, after placing individual

strips in a student anthology and contributing to a friend's short-lived collaborative fanzine. For fourteen issues, she drew, wrote, and collaged the minicomic in her apartment on a monthly basis. The first issue was advertised in Factsheet Five, then a five-year-old print periodical from California devoted to reviews and ads for the independent press. *Factsheet Five* was one of a handful of publications to offer wide access to the smaller, weirder, independent projects that people like Doucet were crafting all around the globe prior to the appearance of the World Wide Web. Called fanzines or, in more recent years, zines, such publications are hand-forged by people whose work doesn't fit into aboveground, mainstream, or corporate-produced magazines and are disseminated throughout the cultural underground. The original term references the science fiction fan communities that developed the earliest independent print periodicals, an alternative mode of publishing particularly vital for female, queer, and nonbinary sci-fi writers who rarely saw their work included in more popular outlets. (Doucet's nod to the origins of the form appear in a three-story riff on scifi's masculocentrism called "Kirk and Spock in a New Spot," discussed in chapter five.)

Throughout the 1980s and 1990s, the independent press grew rapidly. The fall of the Berlin Wall eliminated a major barrier to the global spread of capitalism and its favored product, media, and Doucet's popularity was aided by the worldwide hunger for authentic international voices. Her strips appeared in American tabloids like *Screw* and French small press venues like S21'Art? and Model-Peltex as well as in Canadian mainstream and underground publications. Cartoonist Aline Kominsky-Crumb, then editing the comics anthology *Weirdo* she cofounded with her cartoonist husband Robert Crumb,

invited her to contribute a strip in 1989. Doucet would also appear in the Phoebe Gloeckner-edited *Wimmen's Comix* from Rip Off Press that year, as well as cartoonist Art Speigelman and editor Françoise Mouly's high-production-value, art-comics compendium *RAW* in 1989 and 1990. Chris Oliveros, then publishing a comics anthology in Montreal called *Drawn & Quarterly Magazine*, found a copy of her fanzine and wrote a letter to Doucet around the same time. The two met for coffee, and she mentioned she'd been looking for a publisher to put out a series of black-and-white pamphlet comics. Until then, Oliveros had not considered expanding his publishing scope to include solo-authored titles. He did it anyway, and Drawn & Quarterly (D&Q) then became an internationally acclaimed comics publishing house, now headed by Peggy Burns.

D&Q released *Dirty Plotte* #1 in January, 1991, and it was one of the more enduring titles to come out of the black-and-white boom, a period of rampant experimentation in independently published comics, when no title seemed likely to fail and thus no risks were too big for publishers. Doucet won a Harvey Award for Best New Series, appeared in Diane Noomin's *Twisted Sisters* anthology from Penguin, and was interviewed by *The Comics Journal* that same year. She moved to New York shortly thereafter, relocated within a year to Seattle, then to Berlin. *Leve tu Jambe, Mon Poisson est Mort!* (in English, *Lift Your Leg, My Fish is Dead!*, although the title remained untranslated for the English market) came out from D&Q in 1993, compiling work from the minicomics and elsewhere. A collection of dream and fantasy stories, *My Most Secret Desire,* came out in 1995, also from D&Q. Doucet returned to Montreal in 1998 to complete *Dirty Plotte* #12, which turned out to be the final in the pamphlet series. *My New York Diary* came out in 1999, *The Madame*

Paul Affair the following year, and *Long Time Relationship* in 2001, all from D&Q. *Dirty Plotte* came in at #96 on *The Comics Journal's* 1999 list of top comics of all time; *My New York Diary* won the Firecracker Award for Best Graphic Novel in 2000. The experimental art book *Elle Humour* came out from Picture Box in 2006, and *365 Days*, a comics diary kept from 2002-2003, came out from D&Q in 2007. Doucet was also publishing in France, Germany, Spain, Italy, Finland, and Japan throughout the 2000s. A book and film collaboration with Michel Gondry, *My New New York Diary*, emerged from Picture Box in 2010. This year, D&Q released a two-volume set of her work, *The Complete Dirty Plotte*, including several strips previously unpublished in English, selections from her diaries, both runs of *Dirty Plotte*, work that published contemporaneously to the series but appeared in other venues, and the entirety of *My New York Diary* and the *Madame Paul Affair*.

Around 2000, however, Doucet began backing away from calling herself a cartoonist, claiming that she was no longer interested in making comics. In 2010 she stopped drawing completely.

In the comics world I came up in—the precise one Julie Doucet would walk away from—a book like this might open with the first-person tale of a childhood spent tracking missing floppies to complete a full series run, either of a talking animal or a superhero line. (To some of us these become, at some point, fungible.) The book might then move into a descriptive set piece in which these comics rest, individually bagged, stored in cardboard magazine boxes, ordered according to some obscure system—reverse alpha by letterer, maybe, a reflection of the

author's fetishized knowledge / genuine expertise that a book like this is meant to display. The introduction to such a book would noticeably fail to include acknowledgement that the resting place of these comics could well be the author's mommie's basement. It might go equally unmentioned that the author also slept there, in a single bed, often unkempt. (This is intended to be less insulting than an acknowledgment that the archivist's life is neither financially lucrative nor terribly social.) Such a book may, additionally, include a far-too-detailed description of a superhero that the author identified with, accompanied by a laughing comparison of the character's on-paper physique to the writer's own physical self. The introduction would wholly overlook that the author is white, historically the target demographic for American and European comic books, and fail to acknowledge the economic comfort that the author, or comics creators, tend to rely on. Race, gender, and class diversity among folks who thought and wrote publicly about comics was, for a long time, rare. Conversations about the form were almost charmingly predictable.

That the conversation about comics remained so consistent for so long was a result of the presumption that the fairly small readership of the form was also homogeneous. The field of comics was imagined to be primarily straight, primarily white, primarily cis, and primarily male for the bulk of its history, largely based on the straight white cismen who felt most comfortable speaking up about the form. Attempts to point to a multiplicity of readerships, however, or acknowledge diverse and usually overlooked creators, ended up lost under the self-perpetuating logic of homogeneity. P. Craig Russell, George Herriman, Alison Bechdel, and Trina Robbins already exist, the thinking went, so the status quo was working just fine

for everyone. If concerns were raised about the sheer volume of titles by straight white cisdudes complaining about women on the page or depicting violence against them, or if anyone wondered aloud why a book about their teenage pregnancy or lesbian relationship was getting rejected, concerned parties were likely to hear about the wonders of romance comics, titles that pandered to a certain (and similarly imagined) subset of young women who only cared about love, or men, or heterosexual marriage, and whose main means of engagement with the world seemed to be waiting by the telephone. There is a place for women in comics, was the gist of the argument, and it was in the heyday of the genre, between the 1940s and the 1970s. The place for women in comics, in other words, was always "over there." The presumption of homogeneity thus perpetuated a more genuine homogeneity.

In the comics world I came up in, clearly, a book like this could only have been written by a man, a cismale—*cheezmahle*, as television producer Jill Soloway says it, the Italian pronunciation somehow making the alienating word that describes a person designated male at birth and comfortable with masculine pronouns much friendlier. That the vast majority of books like this one have been written, before now, by men makes it incredibly important to state, clearly and at the start, that in the comics world I came up in—the same one Julie Doucet eventually walked away from—the subject of a book-length work of comics criticism could never have been Julie Doucet.

"It would be possible to write the whole history of punk music without mentioning any male bands at all—and I think a lot

of them would find that very surprising," London-born artist, occasional band manager, and rock music journalist Caroline Coon told Helen Reddington for her book, *The Lost Women of Rock Music*. In her book on the Raincoats self-titled album for the 331/3 series, author Jenn Pelly goes on to do nearly that with a brilliant description of the late 1970s London independent music scene that arose, in Pelly's telling, naturally from four young women's shared sense of desire, curiosity, and play.

A similarly constructed history of independent comics might quickly prove impossible. Not because the facts aren't there, but because cismale readers, creators, booksellers, editors, and publishers would insert themselves into the story anyway. My interviews about Doucet's work or career, or updates on the project during the research process in comics circles or via social media were routinely interrupted by men eager to share their opinions—which invariably included an admission that Doucet's work had sexually excited the speaker. Why the doings of so many dongs was thought to be of interest to me was beyond my comprehension. I can scarcely imagine what it would have been like to have created the work under discussion. (Of course, Doucet tells us, in a strip from *Dirty Plotte* #3 called "Interlude," in which an otherwise pleasant scene on a busy urban street is interrupted by a man dropping trou and waggling his dick at us, telling us its name is "Pete" and threatening us if we harm it. We'll look at it more closely in chapter five.)

Worth underscoring is that Doucet's work elicits strong reactions, even today. These reactions may seem merely sexual, but quickly become proprietary, and are unmistakably dominated by a very vocal heterosexual masculine readership. These voices have dominated the conversation that Doucet's work could generate casting her oeuvre as historical

aberration, a mere lapse in homogeneity. The momentary failure of reassuring sameness that Doucet's work represented was excusable, in large part, because it was thought to pander to masculine desire. This is not corollary to the story of her work in comics, or what came after it; it is woven through both, inextricable from her career. Doucet's work imagines a world where feminine desire predominates. Masculine desire, in that work, is only acknowledged when it corresponds with the artist's own. Usually, however, it does not. That's when the boyfriend has to go, or Mickey Dolenz pops by, or the elephant gets called in to do what man cannot. The tension between the narratives explored in her work and what her most demanding readers wanted from it—and believed they got from it—defined Doucet's career in comics, and contributed to its brevity.

In content and form, Doucet's work asserts a quiet but unmistakable demand for her own autonomy and agency, but granting these proved a challenge for a sexually distracted readership. (Hilariously, the Urban Dictionary defines "Doucet" as "a tall, skinny, tan man who has the dick supreme. Pleasures girls like there's no tomorrow, and loves Coors Light." More traditional French scholars, however, will spot that the name is a diminutive of "sweet.")

There is a tendency to reward feminine narratives that manage to survive under such conditions with the title "feminist," as if it were an honorific. It's a label Doucet herself rejected then, and has only come around to more recently. It's a contested term, admittedly overused, embraced recently as the most efficient means to sell products like mainstream music, fancy underpants, and anti-rape lipstick. It will be helpful for our purposes to look at what the term means, and then determine if Doucet's work merits the description.

Let's agree that feminism is, in part, a theory of political, economic, and social equality across the spectrum of gender. The term also describes organized activity on behalf of women's rights and interests. Doucet's collection of work carved out a storytelling space in which she explored her own bodily desire and agency, and her insistence upon the sanctity of this space forced the comics industry to acknowledge a potential for creators that was not limited to certain gender identities. Despite the fact that her fanzine was billed on the cover as a "Comic Feministe de Mauvais Goût" (A "Feminist Comic of Bad Taste"), her frustrations lacked a coherent politic and notably never formulated a case for women's rights or interests in general. This was due primarily to the fact that her stories rarely featured more than a single female character, who usually went by the name of Julie Doucet.

Actually, sometimes Doucet's work depicted no women whatsoever. It has been described as distinctly unladylike, downright unfeminine, and even, at moments, antifeminist. Julie-the-character rarely perceived a gendered component to her various narrative struggles, and certainly the solutions invented to overcome them in the floppies didn't involve advocacy for a widespread cultural shift toward political, economic, or social equality across the gender spectrum. It is not until 365 Days that Julie-the-character falls in with a group of close-knit female friends, and the energetic shift is palpable, if short-lived: suddenly Doucet emerges as a collaborator, a supporter, a woman engaged in a culture that hasn't always proven welcoming of her kind. Doucet herself hints that she may not have embraced feminism because feminists didn't really embrace her, refusing to stock her fanzine in a local woman's bookstore on aesthetic and moral grounds. (I may be projecting

based on my own long history of ejection from feminist spaces for being unwashed and unkempt, or for making too many jokes, whether these were not sufficiently supportive of women's rights or because they indicate a general lack of seriousness.)

Whatever the impetus, Doucet, at least in the 1980s and 1990s, seemed to be something of a loner. The artist approached her career with a rock-and-roll swagger reminiscent of the one Camille Paglia ripped off from Mick Jagger, to use a mainstream reference, or the grittier one Kat Bjelland, from proto-riot grrrl band Babes in Toyland, was fronting on the Minneapolis stages of my own youth just as Doucet was launching her fanzine in Montreal. Like Paglia and Bjelland, Doucet established a career on masculine terrain, and to do it she adopted certain stereotypically masculine behaviors. It wasn't necessarily that she sought outright to dismantle the master's house so much as the house that she found herself in wasn't built to accommodate her, and the master had left his tools lying around. What's a resourceful girl to do?

As a feminist project, defined as one that calls for political, economic, and social equality across the spectrum of gender, or advocates for organized activities toward such ends, Doucet's work might fail on a technicality. I'm far from convinced that this discredits the work in any way, however, particularly when feminism has so clearly failed to accommodate the interests and talents of Julie Doucet. In other words, suggesting that Doucet's oeuvre might not be imbued with a feminist politic is not to say that it fails politically, or that it accomplishes no feminist goals. Indeed, Doucet changed the rules for women in comics—intentionally or not—by sometimes becoming a man in comics. (You remember those strips.) She acted as if there were no barriers to her success, gender-specific or otherwise. It's

an admirable strategy of destabilization, but a project rooted in individual exceptionalism does stand at odds with the project of feminism. Perhaps more important, such a project, at least in my experience, can also be intolerably exhausting.

Unaided by a feminist agenda, then, but pulsating with a vibrancy that infected both the field of comics and the generation of cartoonists to follow, Doucet's comics changed history. Even after she stopped making them.

I started my first full-time job in comics around the same time Doucet stopped identifying herself as a comics creator. It was the tail end of the 1990s, and I was distressed to discover that Doucet was not the only woman of my acquaintance to absent herself from the field. In fact, within five years of my first full-time comics gig, most women whose work I had cut my teeth reading and writing about were no longer making comics. New young women would emerge, filled with attitude and venom and seemingly ready for the long haul. Then a few years later, they too would disappear. I began collecting interviews with and anecdotes from female and nonbinary creators, increasingly concerned by the repetitive nature of the stories I was hearing.

In 2005, while reading for an annual comics anthology, I maintained elaborate lists of every single work published in English, in North America, that I could find. Overall, about 40% of the minis, pamphlets, newspaper and magazine strips, graphic novels, comics reportage, online strips, and anthologies I read came from creators with feminine names. Despite a reputation as an all boys' club, I was delighted to discover, only about 60% of the comics I was reading appeared to come from

dudes. I could detect no gendered difference in skill, but there was a gendered aspect to the publications the work appeared in: the vast majority of work by creators with traditionally feminine names was self-published, whereas the vast majority of work coming out from big-name, medium-name, or any-name-at-all publishers was by creators with masculine names.

Freedom of speech does not promise a platform, yet this difference points to a significant economic divide that directly impacts career longevity. To a creator, the financial distinction between scrounging to put out self-funded work for whatever audience one can muster on one's own and being supported in those efforts by a publisher and distributor and paid however minimally in a labor-intensive field is vast. If most women and nonbinary creators were only ever going to self-publish, it began to make sense why they might leave the field before they had established careers. Intrigued, I tested the theory a few years later with a survey of over 60 women comics creators. Most respondents earned less than 25% of their annual income from comics. More distressing, however, was that 60% of female creators were asked about, or overheard discussions of, sex or their own sexuality in what passes for a professional work environment in the field of comics. Moreover, about half of female creators polled had been misgendered, either in person or online, a strange and low-level means of refusing to acknowledge women's participation.

Yet data indicating low pay, a high incidence of sexual or gender-based harassment, or outright erasure can tell us only the bare bones of the story of gender bias in comics. Anecdotes poured in during the survey to fill out the rest of the picture. One creator of a popular newspaper strip was drawing in a café when a young man approached her, watched her draw for a while, then pointed to the strip she was working on and asked,

"Do you know the guy who draws that comic?" Another said she was accused of "sucking off one of the male editors" because she said she liked the strip he worked on, and another still was told by a boyfriend that her strip got more attention than his "because I was a girl and girls always got more attention from comics guys." Such stories arrived in the midst of a steady flow of complaints about how women and nonbinary folks were treated at conventions, in comic-book shops, or online: "Like an idiot," was the oft-voiced description, still heard, although less frequently, today.

Women being treated like idiots, while also being sexualized and miraculously still overlooked, is not a problem unique to comics, and how such generalized cultural tendencies impact creators' lives and careers in an already low-paying field is hard to discern. So, with a group of students in 2010, I conducted an overview of gender in comics anthologies, then considered an entry point to a successful print publishing career (made less significant with the rise of digital publishing). We counted character gender (by the 2000s, still only a quarter of all characters appeared to be female, up from a mere 5% in the 1990s) and dress (despite the gender disparity of characters, over twice as many female characters as male were presented without benefit of clothing in the 1980s, although more were offered vestments in each successive decade). Overall, women in comics anthologies were significantly more likely to appear naked in the pages of a comic than to be asked to draw one—over five times as likely, in fact. Yet our most significant finding was that having a woman anthology editor more than doubled the opportunities for women creators to see their work published.

Subsequent studies—including vast, organized character counts (in conjunction with the Ladydrawers Comics Collective

of Chicago, Illinois, published on *Truthout*, in *Bitch Magazine*, and in other venues) indicated further imbalances. A 2011 count of all characters in the 30 most recent books from 12 North American comics-exclusive publishers, for example, indicated that a pool of 40% female characters, 57% male characters, and 3% trans or nonbinary characters were drawn by a creator pool of 84% male creators and 16% female creators, with some publishers never offering women more than 8% of the gigs on offer. Further investigation revealed lower cover prices and fewer ads for books by female creators, an indication of the low economic expectations—and rewards—for women working in comics. (Publishers who claimed they were lowering barriers to access to work by women notably failed to compensate for the hit with a higher percentage of royalties.) In 2012, we conducted a survey of every creator we could find—men, women, nonbinary people, even people who wouldn't have called themselves comics creators, but combined text and image in a sequential art narrative.[1] Of the folks we polled, only 54% identified as male, while 39% identified as female, and 7% identified as genderqueer, trans, nonbinary, or other.[2]

....................

1 We had begun to notice, at some point, that women and nonbinary people who were pretty clearly engaged in the process of combining text and image in sequential, narrative forms, weren't calling what they made comics, or themselves comics creators. Those words, they would tell us, felt awkward, inappropriate. Young cismale creators didn't seem to feel that way, however, and neither did cisfemale creators who chose to work under masculine num001 It I ı ıma an if the term "comics" had itself become gendered.

2 The language gets a bit tricky, as the vocabulary we use to talk about gender has changed rapidly in recent years. We asked creators to self-identify gender, and "cismale" was not a term in popular use at the time. I have duplicated the original language of the survey in this description, which means we have no means of distinguishing transmen from cismen, or transwomen from ciswomen, unless folks self-identified as such.

This challenges the presumption that comics remain a male-dominated form, and approximated my own findings of nearly a decade earlier. Yet the new data were even more interesting: equal rates of women and men—slightly over half of each—said they regularly submitted work to publishers, while only about a third of nonbinary creators had done so. A full three-quarters of male creators polled said they'd had work published by someone other than themselves, while female creators were published at around the same rates as they were submitting work. (So were non-binary folk.) In other words, women and nonbinary people submit work to publishers and, more or less, see that work published. Whereas men in comics are getting more work published than they are submitting it, indicating that their work is being sought out for publication. This, too, can impact career longevity: not having to submit work saves vast amounts of time and energy.

And money. For venues matter, too. Men are seeing their work in magazines, floppies, newspapers, and, of course, graphic novels, while women and nonbinary creators are more likely to have work in smaller periodicals, online, or in zines published by friends—unless they're self-publishing. The financial impact is profound: only around 65% of both men and women said they earned any money at all from comics annually. About 30% broke even, and about 5% of men lost money. (This percentage is slightly higher for women, fewer of whom broke even.) Meanwhile, only 17% of nonbinary creators made any money at all. The data gets downright crazy when we look at how much money we're talking about. Ninety-two percent of the creators who earned over the poverty line from work in comics in 2012 were men, and 8% were women. On average, men reported they make $5,131 per year and women reported making $1,538 per

year. No single nonbinary creator reported earning more than $600 per year. To break that down even further, for every dollar a man earns in comics, a woman takes home 27 cents, while a nonbinary person makes only 3.5 cents.

Doucet has said that such factors—lack of access to publishers, being misgendered, sexual harassment—did not impact her career. Yet when I asked her why she had stopped making comics for a *Punk Planet* interview published in 2006 (reprinted in this volume), she told me she had grown tired of the "all-boys crowd." She also cited exhaustion and finances. "I was making just enough money to be able to live, but not enough to be able to take a break," she responded. I didn't ask about actual earnings or about particular boys she'd grown tired of, but even without citing names and figures, it's not hard to look at the industry as a whole and grasp pretty quickly why anyone who didn't feel part of an all-boys crowd might not hang around long, no matter how talented they were.

Quantitative data offers new perspectives on a medium that tends to be discussed subjectively, and can be particularly helpful for fields that historically privilege white patriarchal heteronormative voices. From here on out, though, we'll spend time in a world significantly less beholden to the laws of man or nature. We'll explore Doucet's world using more intuitive means.

In the chapters that follow, we will employ an informal process, driven by curiosity, joy, and my own need for constant exploration. Because I'm not convinced it matters how strictly we hold the line between comics and not-comics, I will include some discussion of Doucet's less narrative, post-comics work,

and I will situate her oeuvre in the larger culture, not limiting my analysis to the field of comics or the books themselves. This represents a break with recent comics criticism, which forwards a comics-specific language and avoids terms pulled from cinema, music, or literature. My sense, however, based on analysis of the intersection of gender, race, and comics, is that specialization has done quite a bit to limit the variety of folks who feel they can participate in the industry, a tendency I do not want to perpetuate. Additionally, it is relevant that Doucet's post-comics releases are marketed as "graphic novels," a term with a contentious history. A graphic novel is a longform fictional narrative told partially, or primarily, through pictures. Thus, Doucet can be said to have left comics but still be producing graphic novels—experimental (meaning: not novels) though some of them may be.

The chapters in this book are organized into loose genre categories, including several I have already suggested: The Actual Self, or the autobiographical work Doucet is most frequently associated with; the Imagined Self, or the semifictional adventures of Julie-the-character in an idealized world; the Dreamed Self, or the transcriptions of nocturnal narratives that arise primarily from anxiety and fear; and the Not-Self-At-All, Doucet's fictional works. I add to this the Unknown Self, the final chapter. Doucet herself suggests, while discussing her epilepsy as well as her career, that she, and her work, occasionally operate in ways outside of her control or awareness. Of course, she is also still alive, still working, and we simply don't know how her work will change in the future. For the most part, I discuss Doucet's approximately 150 separate English-language works on their own merits (approximately 15 of which are not hand-drawn, sequential, paneled narratives)

or in conversation with other cultural products most relevant to Doucet's subject matter and tone. In the final chapter, I put Doucet's comics in conversation with what many might consider the form of comics itself.

This organizational model is a nod to the impossibility of dividing Doucet's work into "early," "mid," or "late" career strips. She was simply too talented from the start to have more than a handful of strips that we could call "early," and her "late" work comes after she proclaimed herself done with the field. This model also reflects how D&Q, her primary English-language publisher, has released her work. Moreover, the categories are discernible in the work itself. Yet by dividing Doucet's work into distinct subject categories—or rather, into presumed subject categories, since the actual distinction between a dream, a hope, a memory, and an experienced event versus an invented one is a matter of dispute throughout the histories of both image and language—we also situate the work in the reader's experience of it. By this I mean that these subject categories are all distinguishable by the imagined distance between the reader and creator. Readers, it seems, always wanted something specific from Doucet. Many want it, still. A certain kind of self-revelatory storyline, I think, and many calibrated their enjoyment of Doucet's work based on how much they received of what they demanded. Her most vocal readers wanted, in other words, Julie herself, the artist, with all the weirdness and messiness and antisocial-ness intact. They wanted her presented honestly and humorously, and they wanted her stories to seem true. Many also wanted them to *be* true. This desire was so strong that it went well beyond the artist herself. More than one contemporary woman creator has shared tales of pressure, from publishers

and on dates, to conform better to the drawing style or sexual bravado on display in Doucet's work.

The orgnization of this book is also informed by Doucet, who is interested in exploring her ontological selves. It is central to understanding Doucet's work to recognize that she cultivates a desire for her personas that is both literary and erotic. Readers wanted to read about Julie-the-character as much as they just *wanted* Julie-the-character. To some degree, we must acknowledge that such cultivation takes skill.

That Doucet's work elicits desire—erotic, maybe, but *palpable* even more than that—can't be overlooked. Yet her project was not limited to anything so banal as sexual liberation. Her work points to a possible future where comics creators can explore joy, free of gendered—and other—limitations. However, the fulfillment of this promise will not come through the same conversations that have always been held in the field of comics. In what follows, I aim to undertake something like a feminist comics criticism, or more accurately, an intersectional feminist socialist comics criticism, one that imagines liberatory potential for creators and readers from a range of backgrounds and bearing a range of identities. It may well fail, but I can find no better occasion to measure the existing world against an imagined, welcoming future than in a book on Julie Doucet.

OK. I know I am keeping you from the vag with all this chatter about cash and diversity, so here's the tl;dr: we can find in the work of Julie Doucet a new way to think and talk about comics. Let me show you.

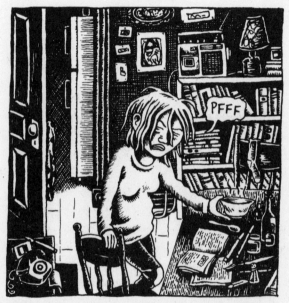

From "A Day in Julie Doucet's Life," *Dirty Plotte* #3 (1992).

THE ACTUAL SELF

The room I book during my stay in Montreal is, by happenstance, on Rue de la Visitation, a few blocks north of the apartment where Julie Doucet completed her most iconic strips. It is that rental that her friend Drey Rival takes over when she moves to New York in the autobiographical *My New York Diary*; later, Drey reports someone has broken into and trashed the apartment. When Julie next visits—in the final D&Q floppy—the place is irreparable. She retrieves her cat and says goodbye to the building. The final panels depicting the wreckage of the flat on Visitation Street show it strewn with records, books, broken stuff, and plain old garbage; Doucet's normally chaotic life has gone fully feral by *Dirty Plotte* #12.

The apartment forms a story arc of its own: the cramped kitchen, sparse bedroom, book-filled workspace, and toilet (in use) first appear in *Dirty Plotte* #3, "A Day in Julie Doucet's Life." It is the "home sweet home" in what is labeled "Julie's Holy Triangle." The other two daily stops on Julie's out-of-doors rounds include the post office, where she retrieves correspondence, and a convenience store. It's where Julie buys beer.

"A Day in Julie Doucet's Life" reads like an honest, if rambling, account of what the artist's life was like in late 1990 and early 1991. Julie-the-character wakes up in a pile of comics and strewn clothes, pees herself conscious in the bathroom, makes and drinks coffee, wracks her brain for a funny idea, drinks more coffee, briefly visits the outside world, fails to answer the telephone, drinks a beer, and maybe, just maybe, starts to jot some notes toward a comic at some point—although only for a second. It feels accurate, at least to me. This was what *my* life looked like in 1990-91, down to the ripped-up bad ideas strewn around the apartment, huddles of beer bottles both empty and full in various corners of the room, and knock-off Bialetti Moka espresso pot that, more or less, held full responsibility for my productivity on any given day.

Remarkably, it's a seven-page strip. The dialogue in most panels is the garbled incoherence of a person who has no desire to communicate with other humans. ("Let's fczk bdamn fuk coffee," she says at one point.) Until, that is, Julie-the-character finds a funny idea in the reflection of a spoon, whereupon she laughs herself to tears for a full page. She is still communicating nothing coherent, but has now set her mind to the eventual task. Basically, in other words, nothing happens in seven pages. The television program Seinfeld was, at the time, said to have captured the American imagination by being "a show about nothing," a descriptor that emerged from the sitcom itself—specifically, a pitch one character makes to create a metafictional television program based on the Seinfeld characters. But Seinfeld depicts people interacting with each other, communicating bitterly about their boring lives while seemingly endless piles of disposable income appear out of nowhere to keep them stably discontent. That it is a show about

nothing is bunk; Seinfeld is a show about idle, middle-class New Yorkers who cared so little about the political ramifications of their moneyed self-indulgence that they drove this country directly into the conservative, fearful, white supremacist state it's in today. Literally nothing happens in "A Day in Julie Doucet's Life," nor, arguably, in the entire *Dirty Plotte* series. It begins as a grand adventure, with Julie-the-character leaving Montreal to discover her fortune, and ends with Julie-the-artist back in Montreal, disavowing comics entirely. That there is no real "fortune" to be gained in comics is relevant, or put another way, that large swaths of a Seinfeld-watching audience would likely find Doucet's self-forged career trajectory a waste of time is significant. *Dirty Plotte*, in other words, is about the efforts, heartbreak, talent, joy, and enthusiasm that may seem like nothing to outsiders, or may amount to nothing, at the end of the day. Each strip depicts more effort and fewer outcomes than any episode of Seinfeld, but could never be accused of being "about nothing." Doucet's version of "nothing," particularly the one that shows up in "A Day in Julie Doucet's Life," speaks volumes about the creative life, who is offered the opportunity to pursue it, at what cost, and why anyone would bother.

In "A Day in Julie Doucet's Life," the artist's letterforms are still awkward, although they no longer read as simply her handwriting. (By the next issue, *Dirty Plotte* #4, the lettering is consistent, legible, and wholly unique.) Her line-work is all there by the third issue, however, along with the expressiveness, the instantaneous world-building, and the gutting, raw talent that marks her work. "Oh La La What A Strange Dream!"— where Julie-the-character launches into space and masturbates with a cookie—appears in the same issue. So do "Le Strip Tease du Lecteur," in which Julie dismembers a male reader, the third

installment of the fiction story, "Monkey and the Living Dead," and "Interlude," in which we meet Pete, the penis of a random stranger on the street.

By *Dirty Plotte* #3, Doucet has more or less mastered the form of comics. Stories are consistently solid despite the plethora of forms they take. Inks are confident but responsive and appear to capture, as opposed to reflect, life. Doucet crafts an entire universe in each panel that sucks readers in, like the vacuum she apparently never owned, to the visuals, yes, but also the smells and sounds and energy of that early 1990s apartment, situated in the Montreal neighborhood just then becoming known as Gay Village. The apartment is ground zero for a certain teeny-tiny subset of North American comics creators—women, mostly, who'd credit the strips made on Visitation Street as the reason they got into the field in the first place.

There's a Starbucks on the corner now, which will surprise no one today, but would have gutted Doucet's readers, if not the artist herself, a couple decades ago. Who knows how the strip would have read were Julie-the-character planted at the coffee franchise for seven pages crabbing at passersby and gazing into the reflection in a plastic spoon. The neighborhood's come up a bit in the meantime too: north of Rue Sainte-Catherine, the apartments on Visitation Street could still believably house students or artists. South of the now bustling shopping way, however, everything looks rehabbed, including the residents taking dogs out for afternoon strolls, always in pairs: a larger, bulky dog for guarding the home and a tiny companion dog for the big dog.

Since leaving that apartment for New York, Doucet lived for a bit in Seattle, then Berlin, before returning to Montreal. Today, she lives on a quiet street about five kilometers northwest of her

old place, in a tidy brick row house, a perky yellow bike locked to the front gate.

Doucet lives like a fancy bachelor, or a European intellectual. She's been in this apartment for ten years, but hasn't covered every inch of space with stuff, as my dirtier pals tend to—plastering walls with remnants of artistic lives that never quite make it onto CVs but demand commemoration. There's no clutter, either, as from a dog or kids, or the kind that used to be common in her panels. There are only austerely displayed testaments, selected and carefully positioned about her home, always accessible for consultation: a shelf of beloved comics, encased in glass, delightfully wretched papier-mâché dolls made by Montreal collaborators, an impressive display of classic literature, an array of records stacked against the wall. (I don't flip through the albums, although only because John Porcellino has warned me: "They're bands you've never heard of! All French!") Two rooms are reserved for her studio, although one also houses the washing machine. ("That's where the plug is," Julie tells me, and shrugs.) A small alcove off the living room is her bedroom, not remarkably different from the one depicted in "A Day in Julie Doucet's Life." What is different is the garden behind the apartment, about as big as the bedroom. Julie's growing grapes! Two years ago her boyfriend made a batch of wine with them but it wasn't sweet enough. They're going to let that batch sit a bit longer and then taste it again. Julie-the-artist today is more patient than the protagonist of her autobiographical comics.

We sit at a small square table in the kitchen. It's late fall, raining and cold, so we each have on two sweaters. The cat, Jojo, toys with me for a bit, then consents to sit on my lap. She's ten. Apparently when Julie adopted her, she was a bit too friendly,

always trying to follow local children into their school down the block. "About ten times I had to go [fetch] her," Julie opines, almost rolling her eyes. Thankfully everyone's mellowed out a little since then.

North Americans don't have many pictures of the living spaces of single, middle-aged women. In fact we tend not to picture middle-aged women at all, and certainly have no popular images of successful, brilliant, childless, unmarried ones to consult. We can easily call to mind the lady who died alone in her apartment overcrowded with cats, the doddering grandmotherly type who hovers over every visitor including the mail delivery person, or the 50-year-old with a full face of makeup who dresses like a 19-year-old in a bar hoping she doesn't get carded. These are the images we are given to grow into as women who maintain economic and bodily autonomy, and they fucking *suck*. No one I know is that sad or delusional— and most that I know are more confident and way hotter than they were at 19. The women I know who live alone and build worlds *do exactly that*, every day, and fall into bed every night exhausted from helping to craft a future where other women and nonbinary folks can do the same. They might drink. There's probably a cat or two. The coffee still happens. But the environment such women create for themselves is infused with an energy you may not even know exists unless you know such women yourself.

Like the other single, middle-aged lady geniuses of my acquaintance, Julie Doucet has crafted an exquisite atmosphere stocked with every single thing she might need to pursue whatever direction her creative practice might take at any given moment. She has distilled her life to the elements that fulfill her and eradicated those components that do not. One senses

immediately when one is invited into such spaces that you have been chosen, somehow, selected among many contenders with a great honor.

Thankfully, the solemnity of such women is, in practice, always debased and profane. After we talk for a few hours, Julie pulls out her diaries to reveal gloriously decorated entries, collaged and color-coded, occasionally employing no text at all, just images. Here's Julie, for example, sitting in a chair. Here's Julie walking along the street. Here's Julie eating a hamburger. Here's Julie masturbating. And again.

These diaries, she tells me, were never filled with appointments or tasks in advance. She only color-coded them once a project had been completed: yellow for a strip for one publication, blue for another. The 1990s are overwhelmingly colorful. The eyes almost sting. She's underlined the days she was bleeding in black, and one cycle has her apparently not completing anything. "Did you stop working when you were bleeding?" I ask, vaguely aware that the question never once came up during my pursuit of a Very Important Master's Degree in Art History from an Internationally Renowned Art Institution.

"Oh no, I liked it," she says, easily. We talk about menstruation for a while. The awesome sensation of blood gushing through your sex parts. The power of the body to alert you to what will happen in the future. The comfort of communicative pain. The mysterious specter of menopause and how little we know about it. Hot flashes. The bummer of cramps without blood. We discuss the subject in some depth. In fact, Julie and I spend more time discussing the functioning of our various reproductive bits, and in greater detail, than I have with any of my closest friends for some years. Or, for that matter, with medical professionals, who tend to ask if I'm still having periods, and leave it at that.

On most matters, Doucet is soft-spoken, which means you must lean in and be patient while she decides whether or not she will respond to you, or what you meant by the question you asked. Her hair is mid-length and light brown and she's wearing dark-rimmed glasses, the kind that state forthrightly that they are glasses and that she is wearing them. One of her sweaters is striped, the other a cardigan. (In the 1990s, we would have called it a Party Cardy.) Jojo is mostly black, which goes with everything. We talk, on and off the record, and look through work being prepared for the upcoming D&Q collection.

I apologize for conducting the interview in English, indeed for not being able to deal with much of French language or culture at all. I've studied several romance languages and usually adapt to them quickly, but the logic of French has always eluded me. I say this to Julie and she eyes me evenly. I am aware that am admitting to her that there is something central I do not understand about her, her work, and her culture. I do it because I am not the only one; most US comics readers find her so mysterious, in part, because they don't get the French in some fundamental way, or think of her as Canadian, otherwise known as practically American but not. (Americans tend to think that about everyone, including Americans they don't like. It is a hallmark of empire.)

As I sit there, I catch myself wondering, "Why does talking to Julie Doucet feel so *normal?*" Then I'll remember that, of all my favorite authors, living or dead, I've probably reread Doucet's work most often. It feels normal because I used it to build the world I now live in.

Doucet's place in North American comics is assured, certainly, and the women that made sure this could happen have largely forgotten their efforts. "Did I?" Phoebe Gloeckner asks when I remind her that she tapped Doucet to contribute to *Wimmen's Comix* #15, making her one of Doucet's first North American editors. "Did she do it?" I nod. "Good," Gloeckner responds, shaking her shiny black hair and laughing. "She's a trooper."

With a cover by Gloeckner depicting a young girl playing with fashion dolls, the issue features Angela Bocage, Lee Marrs, M. K. Brown, Aline Kominsky-Crumb, and Sophie Crumb, among others, and was published by Rip Off Press, after Last Gasp and then Renegade Press had both abandoned the title. Three contributions appear from Doucet: "You Know, I'm a Very Shy Girl," "The First Time I Shaved My Legs," and "Tampax Again."

"I remember seeing her work and being blown away. I thought, she should be in *Wimmen's Comix*, but who wants to be in *Wimmen's Comix*?" Gloeckner says of the contentious anthology. "I don't want to be in *Wimmen's Comix*."

Gloeckner's participation in the anthology always felt forced. "I started doing comics when I was 14," she explains:

> Nobody my age did comics. I was like, I'm gonna draw comics. I could not get published by the comics [press]. My friends did not think comics were cool, so they had no interest. So I was totally working in a vacuum. I was like, where do I fit in? There was no place. It was just *Wimmen's Comix*. It was almost like a chore: 'We're gonna do another issue of *Wimmen's Comix*,' then there would be an argument about what the theme was going to be. There was so much infighting. It was ridiculous.

I didn't even know what they were arguing about half the time, because I was a lot younger. I did it because it kept this rhythm. Every month I would do a story. I really wanted to do a novel or something, but it didn't seem like there was any way I could ever get published on my own. No one ever read *Wimmen's Comix*. There were good comics in there! There were bad comics in there. That's what I always loved about undergrounds in general, the good and the bad, they made either one more exciting, to be in proximity.

But Julie Doucet was great. Her artwork was so bold and obsessive and good in every way. I remember the letter I got from her because I remember the envelope. I met her, and I was pregnant. I remember that I was embarrassed that I was pregnant because I didn't know many women who'd had babies. I was at the San Diego Comic-Con. Again I felt like I didn't fit in. We had this little conversation about [pregnancy], just standing at some booth.

What Gloeckner's comments reveal about the weird space created by gender-exclusive anthologies—clearly necessary, but ever-derided from the outside and difficult to navigate from the inside—is remarkable considering Gloeckner's own foundational work in the form, including *The Diary of a Teenage Girl* and *A Child's Life and Other Stories*. I include them in full to highlight that, despite the ghettoization and frustrations they raised, women-only anthologies were one of few options for female creators seeking to publish comics in the late 1980s in North America.

Doucet, however, situates herself in the French tradition, both of comics and of culture, and this, to some degree, explains her sexual frankness as well as the ease with which she walked away from the US scene a decade or so later. French culture tends to be more sexually open compared to the puritanism of most American media; it's also rooted in a more reasoned understanding of Marxism. But French comics, at the time, had even fewer publishing options than the US did: L'Association, an independent publishing house founded in Paris by a consortium of artists in the throes of a DIY/post-punk frenzy, wouldn't come together until 1990. (Doucet was approached by the house the following year; her collection *Ciboire de Criss* was published by L'Association in 1996.)

Indeed, Doucet was raised on French comics, describing a childhood home littered with *Rubrique-à-Brac*, *Tintin*, *Asterix*, Nakita Mandryka's *Le Concombre masque*, and works by F'murrr (Richard Peyzaret), Willem (Bernard Willem Holtrop), and Jules Vuillemin in her 1991 interview with *The Comics Journal*. In her kitchen, she fills in a few more gaps, discussing Loire, France-based feminist cartoonist Chantal Montellier, and a classmate in a comics theory class she took in junior college that led her to Nicole Claveloux and a whole world of women cartoonists. (She didn't discover the American underground for a while and read titles like *Zap Comix* and the *Fabulous Furry Freak Brothers* first in translation. She expresses no knowledge of or interest in superheroes whatsoever.)

Doucet, in other words, was always just visiting the Anglophile world of comics. Her work can perhaps be viewed as work in translation, even when written originally in English.

At the heart of Doucet's work is a faith in both her talent and the interestingness of her own experiences. These were often explored together in straightforward autobiography. Editorial strips, diary comics, and a few short memoir pieces operate similarly: each is an attempt to convey lived experience through the straightforward presentation of events. The number of individual strips that we might consider tales of her Actual Self make up about a fifth of her output—although these strips and stories tended to be longer and more in-depth than the others. *My New York Diary*, *The Madame Paul Affair*, and *365 Days*— among her most important comics—are pretty much straight autobiography. They are the strips in which her storytelling, drawing abilities, and lettering skills are all at their peak. Doucet, when conveying her own lived experience, churns out her most consistently polished work.

The best of these tales stop just short of memoir. What is so lovely about the majority of the autobio works is that events depicted in them seem to come at the reader with the same suddenness and confusion with which they were inflicted upon the creator, unfiltered by anger or sorrow or understanding. Doucet's autobiographical work offers an extremely rare opportunity to view the life of a talented young woman from the inside, free of the life lessons that often seem included to justify womens' stories. (Even *My New York Diary* feels fresh and exciting, although the strips were several years in the making. Doucet's talent is to make her experiences feel urgent but never rushed.)

Doucet makes no claim to expertise, only to experience, and in the autobio work we are granted all-access passes to her life minus any boring overthinking or introspection. "A Day in the Life of Julie Doucet," for example, is a frustrating experience, as much to read as it was likely to live. It is also remarkably

unproductive. And probably, most annoying of all, totally accurate. At seven pages? Doucet tells tales of men who have labium grafted on to their bodies and then learn ventriloquism to speak from them in about half that.

But these seven pages of silly nonsense are telling. As we can see more and more of the daily effects of late-stage capitalism on arts and culture in North America, it becomes easier to read this strip. Doucet is alone, amusing herself, tending to her needs: no cell phone, no email, no pals, no man. Spending the day in pursuit of a laugh. It's still rare to see a woman gleefully taking care of herself, even 25-plus years after the strip first appeared. It's even more unusual to watch a woman in the solo act of creation (although we can watch many in the act of procreation). There's a stillness to the strip, a marked lack of anxiety. Readers today may have a hard time perceiving it, as there are so few contemporary examples of it: we're not looking at a woman stressing out over money or worried about getting ahead or saying shitty things about other women in an attempt to further her own career. We are looking at a woman who lives on, and needs, almost nothing, and who is, at least for now, satisfied with that. How few images we have of women comfortable with their own weirdness, thriving in it, modeling it for others.

The strip is also about cartooning, or cartooning in the 1990s. There were no comics degrees, and the notion of comics as a profession was still laughable. The business cards I had printed up at the end of that decade at my First Comics Job Ever were openly mocked, not only by doctor relatives at family gatherings, but by my accountant, folks in the larger literary world, and by people who held comparatively stupider jobs, like "coolhunter." The fact is that being a comics professional in the 1990s meant

spending time alone with a spoon in a room that you did not leave all day, and pouring your motherfucking heart into the retelling of the experience.

We'll look at the autobio strips that emerged from such a practice by dividing them into short, medium-length, and longer strips because each of these tend to offer different qualities. Doucet's short autobio works are often about the process of cartooning or artmaking, annoying interpersonal squabbles, or her own personality quirks. The medium-form pieces fill out autobiographical details, and operate best when read alongside longer works. In the longer autobio narratives, we watch relationships unfold and history repeat itself and, best of all, we fall into the rhythm of a brilliant, successful artist we also happen to like.

SHORT FORM AUTOBIO

Julie Doucet introduces her work in the short editorial strip "Plotte?" from 1990, an attempt to explain the seemingly unfriendly phrase she came up with after scanning the dictionary for a name for her fanzine. It opens *Dirty Plotte* #1, in fact, is the very first strip on the very first page, although it originally appeared in the self-published *Dirty Plotte* minicomics. The single-page, black-and-white strip begins with two sexy, near-naked characters—one busting out of her lingerie and another whose ratty ole panties are nearly rotting off her—and a map of Quebec. Julie-the-character shows up in the second panel in a pair of jeans and a button-down shirt, her sparse studio given over to an easel, on which sits a diagrammatic drawing of the external female genital organs, labeled, unhelpfully, in

Mandarin. Doucet has scrawled the word "PLOTTE" over all this, including an arrow pointing vaguely to the center of the diagram. She presents the drawing with the dialogue, "So this is a plotte." (It's a slightly kinder word for *cunt*, something along the lines of the harshly uttered epithet, *v-hole*.) Three more panels fill out various uses of the word—a synonym for both "attractive, sexual woman," and "skanky slut"—before our scuzzier, underwear-clad hostess—drooling, smoking, a razor blade around her neck, and tricked out in uneven, slept-in eye makeup—reminds us that "plotte is a very dirty word…"

The linework is sketchy, although notably accomplished for a first piece in a first issue of any comic. There's something reminiscent of early Ellen Forney here, featuring the BDSM-like trappings of late 1980s punk and a put-upon brazenness tricked out in professorial drag. That the diagram is in Mandarin matters: readers, mostly men, clearly won't get how that thing's supposed to work anyway, so why waste effort on translating the schematics? Doucet establishes in the strip a firm barrier; to comprehend her work, US comics readers must assimilate a Quebecois word. Doucet demands we recognize her homeland. Although she will spend the next twelve floppies trying to escape it, she will eventually return home to Montreal.

She even appears on the map, a small frog labeled "me" with an arrow. Which is to say, she distinguishes herself from both the fancy-if-cold lingerie-clad seductress, as well as the unbathed punk with droopy stockings, in the guise of a slur used to denigrate French people. Doucet is not trying to turn anyone on. She's acknowledging how easy it would be to do— she's got two characters to cover all the bases—but she's not drawing this comic to seduce men.

What she is doing is conveying the raw experience of being a woman—a person, in a gendered body—whose stories don't get told very often. And she's doing it in a medium traditionally inhospitable to such tales. In "At Night When I Go to Bed" from 1988 (reprinted from the minis in *Dirty Plotte* #2), Julie confesses that she picks her nose. It's a full three years before Chester Brown's ballyhooed autobiographical admission, in the April 1991 *Yummy Fur*, that he did the same. Such content was usually relegated to *MAD*, where Harvey Kurtzman and Will Elder have Melvin Mole digging in his own nostril in January 1953, and subsequent nose-picking scenes become regular features, always a single digit buried up in a face, usually Alfred E. Neuman's—the very picture of juvenile disobedience. Doucet, however, goes a step further than *MAD*; she awakens one night to discover her cats have been eating her boogers from the spot where she keeps them, on the floor near her bed. Some interesting cross-hatching fills out the single dark, nighttime panel, and some deep-black blacks provide a sense of distance, but the characters otherwise retain the flat features of Doucet's earliest strips. Shadows tend to be over-clunky, and objects, while in disarray, do not convey the vibrancy they will soon come to. What's on display here is Doucet's instinct: to find an unseemly story we do not want to publicly admit we relate to, and to pull us into it anyway.

A handful of early strips are remarkable only for their prototypical approach to autobiography and Doucet's attempts to develop her Imagined Self, a character that is largely autobiographical, but idealized. An early half-page strip called "Month of December" (drawn in 1988, reprinted in *Dirty Plotte* #2 from the zines), is liney and very early, with only hints of Doucet's later lettering style. A character we presume is Julie

(because few other female characters are on offer) walks along a bridge as winter sets in. It is mostly a nature study—the falling snow here is the appeal, a tiny hint of her later drug-fueled visions of stylized Kotex flowers from "The Best Time I've Ever Had on Acid" in *Dirty Plotte* #4—and a drawing exercise. An untitled piece from the following year, first published in the minis and reprinted in *Léve Ta Jambe*, is slightly less exploratory, marked by dialogue that begins "So … your place or mine?". Julie—again we presume—and a boyfriend walk around in the snow, in love. The piece is rooted in the same romanticism that will later lead Julie-the-character into all sorts of trouble with men, but the emotion is established through a rare depiction of nature, a subject Doucet tends to avoid.

In "Christmas is coming," a four-panel strip from the minis and *Dirty Plotte* #2, a sketchy Julie (now clearly identifiable from the mess she leaves by her bedside) stresses out about the holidays in November. It offers a glimpse of the depth of her anxiety and her allegiance to religious traditions and family life—threads that run through her work but never become its focus. "You Know, I'm a Very Shy Girl," drawn in 1989, and reprinted from the minis in *Dirty Plotte* #1 and *Wimmen's Comix*, has a relaxed line, although it displays an inconsistency in character appearance from one panel to the next. It's a single-page strip, wherein Julie explains that she prefers her gum come with comics—Bazooka is the most popular brand—so she has something to say to strangers. However, when she meets one, he doesn't appreciate her approach. The autobiographical character that comes through in these strips is conservative—shy, respectful of (if annoyed by) religion, engaged in heteronormative romanticism—something readers come to ignore or forget about, perhaps distracted by the brazenness of Doucet's Imagined Self.

It is to her credit as a writer and a draftsperson that the work reads smoothly, regardless of the complexity of its language. The occasional clunkiness of Doucet's Quebecois Francophone English is the linguistic version of Doucet's floor: comforting, jouyous, and lively, if not, by any stretch of the imagination, clean.

Yet some strips seem lost in a translation that may not be linguistic, or act as experiments and drawing exercises more than they do stories. "Peter M.'s Very Good Joke" (also appearing as "Peter M.'s Funny Jokes!" in subsequent collections) is a half-page black-and-white strip from *Dirty Plotte* #4. In it, Peter M. pulls a silly visual gag that probably works best on toddlers, but still reads as a charming interaction between two friends at a house party.

Doucet's earliest autobiographical work can be summarized in a single-panel image from 1988 called "I'm Proud of My Life, but Don't Ask Me Why." Reprinted from the minis in various forums, Julie-the-character is depicted as junkier and less pretty than she would later become in the floppies, and geekier, with more protuberant labia. She takes the guise of the Hindu goddess Parvati, who oversees love and art, and has inks and pencils and erasers and snakes coming out of her head, all Medusa-like, as well as coffee and, for some reason, a bottle of ketchup. (It's the most telling detail; all Doucet's best strips contain at least one bottle of ketchup.) The cultural appropriation doesn't hold up terribly well—the Hindu goddess doesn't reference anything that a Greek or Roman monster or deity couldn't, and hints at an unacknowledged colonialism—but it's the kind of image one is urged to make in art school to prove you stayed awake during art history slide lectures. What is appealing is Doucet's attempt to clearly lay out her symbology, fusing the tiny, meaningful objects she uses to create her character, herself, with her physical

representation, jamming images into a panel, collage-like, and creating from the chaos a cohesive, thoughtful whole.

By "The Best Time I've Ever Had on Acid" from 1990 (reprinted from the minis in *Dirty Plotte* #4 as well as *Léve Ta Jambe*), Doucet's symbology is fully established. In the two-page strip, Julie and a friend drop acid and Julie hallucinates menstrual product Kotex-brand flowers everywhere. The drug-fueled narrative fits easily into the space between a dream and a memoir—another example of how fantasy and reality and fiction combine in Doucet's work, grounded in her feminine experience of the world.

Hilariously, the two-page strip ends with a closeup of the Kotex flowers, a pull-out from a product description drawn from an ad that features the brand's distinctive adhesive strips. It was not uncommon to mimic the language of advertising and mass media in late 1980s and early 1990s fanzines; emulation without exaggeration or subversion, however, was less common.

The strip's snark-free re-presentation of a straightforward ad for a real-life product anticipates the way Welsey Willis would end his songs a few years later in Chicago. "Rock over London, Rock on Chicago! Wheaties, breakfast of champions," is how Willis closes "Rock and Roll McDonald's," a song from his *Greatest Hits* compilation. Willis, a visual artist and musician who grew to popularity in the mid-1990s, struck an imposing presence around Chicago at the time, with his 300-pound frame, lack of social inhibitions due to mental illness, and a fondness for head-butting and screaming "Raarh!" It was never clear if Willis's enthusiasm for the products he marketed was genuine, an ambiguity we can also find in *Dirty Plotte*.

Doucet does seem to prefer Tampax over Kotex, at least, and rants it pride of place in "Tampax Again" from 1988, first

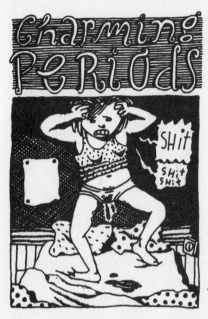

From "Charming periods,"
Dirty Plotte #2 (1992).

published in *Wimmin's Comix* and collected in *Léve Ta Jambe*. In it, a boy on the beach describes the joy of the menstrual product in phrases gleaned entirely from ads. It's early Doucet, clearly: characters are outlined with a shaky line and have deep-set eyes reminiscent of Nicole Claveloux. The boy is drawn suspiciously like later Julie-the-character, but there's no need for Freudian analysis: Julie will go on to explore her own penis envy (it's slight, and fades immediately upon examination) in later works. Notable is that she uses advertising phrases for an existing commercial menstrual product to describe a boyhood ideal of freedom and the pursuit of happiness—a tiny reversal that comedically turns on preconceptions of gendered ideals. ("Heavy Flow," also from *Wimmin's Comix* and *Léve Ta Jambe*, "Levitation" or "One Morning" from *Dirty Plotte* #1, and "Charming Periods" from *Dirty Plotte* #2 all mention Tampax by name, and the brand appears in a handful of unpublished strips from the period, as well as a handful of diary entries.)

"Ballet With My Phone" from 1991's *Dirty Plotte* #4 is a precursor to a handful of dance and movement-based strips. In the two-page piece, Julie's phone rings while she draws. She

dances toward the telephone's clang but fails to catch the caller. The strip ends with the phone running away from a bottle-wielding Julie, explaining to readers that she prefers letters. It's the phone, actually, that does most of the dancing, tiny legs from under its base jumping and twirling through the scuzz of the apartment. Julie-the-character learns the steps soon enough, becoming more graceful over the course of the strip, which eloquently serves a straightforward editorial function.

Grace is not Doucet's métier, however, as the vengeful final image of Julie threatening the fleeing phone will attest: she's more frequently steeped in a simmering rage that hums with destruction. In "Good Evening, Ladies and Gentlemen…" from *Dirty Plotte* #7 in 1993, Julie bangs her head against the wall in a graphic display of trying to come up with new, hilarious ideas every week. It's another playful approach to editorial duties: she announces that she'll feature collaborators in her next issue. (It was not a popular move, and she tells me later that it was intended partially to share the workload of a grueling publishing schedule, and partially to share her growing platform with friends.)

It's important to keep representations of feminine self-abuse in perspective. Autobiographical comics from women creators in the US at the time tended to feature self-destructive behavior as a significant plot point, even a marketing gimmick. In the post-Weinstein era, we can see that major media adopted violence against women as a theme because it allowed for greater control over the female workforce. (See Quentin Tarantino's recent apologies for his treatment of Uma Thurman in *Pulp Fiction*, for example, or the numerous allegations that Harvey Weinstein himself used onscreen nudity and rape scenes for personal sexual satisfaction and to punish women who rejected him.)

Personal zines and comics of the early- to mid-1990s riot grrrl era, fueled by the ethos of second-wave feminist consciousness-raising, often became mired in the logic that played out under such media representations. Ariel Bordeaux's inventive and charming *Deep Girl* was accused of reveling in self-abuse, for example, even meriting a 1994 letter from a hapless male reader who provided the artist with unhelpful hints for raising her self-esteem.

"*Deep Girl* #1 didn't quite live up to all the praise," the letter begins, calling Bordeaux's work "god-damned boring auto-bio comics," before launching into his suggestions for improvement. Makeup, jewelry, hairstyle, brassieres, and various personal cleaning products are all mentioned. Where the letter goes off the rails, however, is when the writer suggests cosmetic surgery before ending with a false cheer for the joys of feminist self-acceptance.

Reprinting it—in the minicomic, and then again in the *Paper Rocket* minicomics compilation *The Complete Deep Girl*—is Bordeaux's way of responding to reader concern over the way she depicts herself: hilariously big-lipped and wide-bellied, her nay-saying voice always included in panels chock-full of self-doubt and hesitation. In the 1990s, I admit I couldn't take in such work—I had the same voice in my own head and saw no benefit to being reminded that the constant negative feedback loop was universal. What's fascinating to me upon re-reading is that Bordeaux uses the trope of nagging self-criticism to explore her relationships with other women, featuring several full-length stories that contain no male characters at all. Relationships with women are difficult, Bordeaux's work contends, and while they contain endless possibilities for self-flagellation, they remain vital.

Doucet's work avoids attrition, at least most of the time. ("May Be I Don't Really Exist" from 1989, discussed in the following section, is a rare foray into the realm.) But Doucet's work can also be isolating. Occasionally the isolation is literal. In the first New York City strip, "New York City, May 1991" from *Dirty Plotte* #4, we have early Doucet—a less assured line and a character that seems young and naïve (later she will come to seem less naïve than bored by shenanigans). Julie up and moves to the Big Apple to be with Mike, her former pen pal and current boyfriend. A city in which you can't breathe without inhaling the stench of another person becomes a deeply disaffecting place where Julie only feels more alone.

Doucet rarely embraces the task of portraying her inner life on the page, although "Here's the Fucking Title" from *Dirty Plotte* #6, drawn in 1991 but published in 1993, comes pretty close. Here we have collage, lots of jam-packed panels with experimental borders that exhibit Doucet's interest in the animus of inanimate objects, and silly references to the tools used in comics. The plot, which hardly matters, covers Julie-the-character's wacky, playful, and psychedelic misadventures in the city. The strip comes closest to looking like the diary entries she was making at the time—a style later explored more thoroughly in art books and prints after she moved away from the comics form. It is a crowded single page, full-on horror vacui in which all the empty spaces have been crammed with more horrors: stinging insects, sticky goo, mangy dogs. Of course, there is a bottle of ketchup. Safety pins, another Doucet staple, also ring the opening image.

It's a turning point in Doucet's work, somehow. The normally comforting detritus of the city landscape provokes anxiety by the mid-point of her comic-book series, but Julie-the-character

hasn't yet learned to leave it behind, as she will when she moves out of her place on Visitation Street in the final issue of *Dirty Plotte*. Significantly, issue six is where we first meet Julie-the-man, but it is not until the cover of issue seven that we meet "NEVER SEEN BEFORE Julie as a REAL woman!" Collaged about this figure are lipsticks, diet books, sex guides, clams, and a labelled "bunch of girlfriends," all encased in a looping, decorative line as distinctively Doucet as her lettering style. This version of Julie has features labeled with text: "brain," "tits," and an erect-nosed "admirer" who stands between her legs and gapes up at her muff, ejaculating his praise, of course in French. ("C'est … c'est MAGNIFIQUE!") Unlabeled is her own elongated, hairy sniffer. This "REAL" woman exists in the world inhabited by the fictional characters Robert the Elevator Operator and a nameless, boxers-wearing crimestopper.

Yet the Julie we meet inside *Dirty Plotte* #7 is less secure and more restrained than previous versions. (Less cocky, as it were.) This is the floppy in which Julie loses her virginity to a man who tells her he is an artist; she thereafter pursues relationships with men that undercut her own creative drive. By *Dirty Plotte* #8, the newly anointed "REAL woman" is giving full pages of her solo-authored title over to male creators—which, thankfully, ends again with issue nine.

At some point, Doucet steps back, refusing to put quite so much of herself on the page, letting her quirks and talent and visual style take center stage, as in the three "Mein Allerschönstes ABC" strips. These are part autobio, part dream—from *Dirty Plotte* #11—and are hardly longer than a page each, drawn after her two-and-a-half frustrating years in Berlin. Only once back in Montreal did she study German, and her playful zine *Der Stein* documents her process *auf Deutsch*.

"Mein Allerschönstes ABC" ("My Most Beautiful ABC") first appeared in Reprodukt's *Schnitte* in 1997. In one strip, Julie meets her friend Bertha in a bar (she looks a lot like Sophie in the *Madame Paul Affair*, although with more chin hair) and they fight about boobs until they spot Blixa Bargeld, frontman of German Industrial band Einstürzende Neubauten, wearing a remarkable blue hat. In another, Julie goes on a camping trip to China and becomes annoyed by her seatmate, so she jumps out of the plane with the pilot, with whom she falls in love. The strips themselves are emotionally expressive, although not personally revelatory, and the performative energy saved in the shift seems to come through in sharper lines, biting detail, and a welcome whimsy.

MEDIUM-FORM AUTOBIO

"Julie in Junior College" was published in *Dirty Plotte* #9 in 1995 and depicts events from autumn 1983. It's an art-school memoir and includes her first rocky relationship with a man who turns out to be manipulative, controlling, and intent on self-harm, a theme explored in all the stories in the collection *My New York Diaries*. (We also meet a real-life Pierre, who acts as the inspiration for Martin, the fictional entrepreneur who soaks his dishes in his tub and becomes a millionaire making beer out of his bathwater in *Dirty Plotte* #1.)

In an article on the French-language version of the collection *My New York Diaries* called "Changements d'adresses" published in the Spring 2012 edition of *European Comics Art*, the academic Catriona MacLeod notes that Julie-the-character's primary personality trait appears to be traumatization "by a

series of unhealthy interactions with the opposite sex." Male characters are described as "mentally unstable or sociopathic, and as constantly destructive and repressive influences disrupting Julie's focus on her developing artistic career."

Indeed, her sexual interaction with Pierre, a classmate, does not seem to be driven by Julie-the-character's own libido: when she's caught staring at his schlong out of curiosity, he takes it for seduction. "Oh well," is how she ends the strip, as the lights go off and he mounts her. Julie seems reticent. This could be read as shyness, the behavior of an inexperienced but willing ingénue. The cultural tendency to weigh more heavily the masculine version of events supports such a reading. But what if Julie-the-character were just curious? What if this were a story about an inquisitive young woman who fully believed she might find out about the world on her own terms, being taken sexual advantage of by any man who comes along, a gender-reversed Candide? What if this were a story about a young woman who wanted something she was denied, knowledge acquired on her own terms—a stunted Faust—instead of a story about awkward sex?

It's not until we meet Louis in the same strip that we clearly perceive the trauma MacLeod identifies. At first, he annoys. Louis, a psychology student, is in desperate need of analysis. But he likes Julie, a lot, and overwhelms her with adoration. She relents, but quickly realizes her mistake. In cleverly drawn panels depicting characters with intricately furrowed brows set against deeply cross-hatched backgrounds, Louis wheedles his way into her apartment with a final proposal: he will commit suicide in her presence. Julie, who has finals the next day, is furious. For three pages she tells him to stop and leave—denying her consent as staunchly and as loudly as possible—before he cuts his wrists, which requires that she abandon her work and tend to him. She's

back at her desk 15 minutes after he falls asleep, attacking her assignment with a fury and a "Fuck!". She passes, perhaps barely, harboring lingering concern about Louis, who shows up in the school hallway moments later, nothing amiss. The emotional labor of caring for him, stolen, goes unacknowledged. That she was kept from her own work in order to manage a man's emotional state becomes just another incident in a young woman's life.

One could argue that Doucet was deliberately depicting male characters in the way that male cartoonists have depicted female characters since the origins of the medium—absent of reason, unmotivated by intelligence—but I read no vengeance in this tale. I'd suggest instead that the depiction of male characters, ranging from self-absorbed to infantile, is a far more radical act than revenge: Doucet is simply telling the truth about how young men behave, shocking though it may be to a culture, and in a medium, used to the young men's version of that narrative.

Truth, maybe, but nowhere does Doucet reveal or charge anything unseemly. Other strips, though, seem to cross into uncomfortable personal territory: An untitled strip (called "The Bath" or "May Be I Don't Really Exist") from 1989 and "The First Time" from 1993.

In the former, a single-page strip reprinted in *Léve Ta Jambe*, Julie suffers a brief crisis of self-confidence in the tub, wondering for a moment if she is just another "piece of furniture." As she begins to talk herself out of it, castigating herself for being "crazy," voices from unseen speakers, and the sink, tub faucet, and toilet weigh in with a range of opinions on her sanity. She escapes the bath, and presumably the self-defeating mindset, by running naked from the room, Doucet's version of two feet hoisted into the air upon the faint of an off-screen character. Still crudely drawn, the inanimate

objects become sentient, sharpening the pending ontological focus of Doucet's interests.

One could draw a comparison to a certain Gabrielle Bell strip from the 2004 *Kramer's Ergot* anthology, except that Julie here seems to best her existential crisis by both running away from it in the narrative and depicting it humorously. The protagonist of Bell's strip, on the other hand, remains fully subject to it. "Cecil and Jordan in New York" is a depressive, full-color story about the isolation of moving to a new city in the dead of winter. Cecil, a filmmaker, and Jordan, his self-described "girlfriend" (who actually manages the finances, assists with screenings, and locates their housing), move to the big city together. But Jordan feels useless, she says, "and that is why I sometimes transform myself into a chair." As a chair, she is found by another man, and taken to his home, where he sits on her. When he is at work, she spends time in his apartment, as a woman; when he returns, he sits on her again. She's not missed by Cecil, who forgets about her entirely. "I've never felt so useful," she says. The story of feminine desire for self-effacement is made even more awkward by the fact that it is the only woman-penned strip in the massive collection. Both Doucet's strip and Bell's feel brutal but honest, jarring reads offset by the creator's mastery of form.

First appearing in *Dirty Plotte* #7 and later snuck into the otherwise fully confident collection *My New York Diary*, "The First Time" is a complex coming-of-age story. The lettering is awkward and the characters aren't quite as sharply drawn as in the main narrative in the collection. The blacks, however, are true and drapery is accomplished. The ten-page black-and-white strip tells the story of a loss of virginity, readers presume, and this does happen in the strip. But as McLeod points out, the figure imaged in the title sequence is not the first man Julie-the-

character has sex with but Chuck, an initially friendly character who grows more sexually menacing as the story proceeds, leading readers to question which "first time" the title points to.

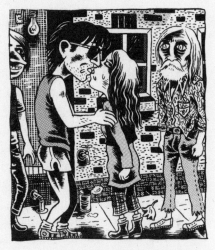

From "The First Time," *Dirty Plotte* #7 (1993).

In the strip, Julie-the-character is out with a friend, and the two meet up with Chuck and some of his pals. Julie seems unaware of how skeevy and awful this crowd is, as they sexually intimidate and objectify her. Chuck, for example, convinces Julie to kiss him, and becomes incensed when she doesn't use her tongue. An older man, George, rescues her by offering to show her his paintings. In his apartment, he kisses her too, claiming this was not his original intention. Julie relents and has sex with him—yes, for the first time—with another, "Oh well."

It's never clear if Julie feels in control of her decisions or her environment, and there's little of the self-confident person on the page that we otherwise believe the character to be. Perhaps most distressingly, there are few moments of delight, or even calm, in these panels. Even in those that take place outside— Doucet's work is rarely set out of doors—the twigs and birds are less vibrant than the average empty beer bottle or discarded shoe kicking around her more frequently depicted unkempt apartment. The leaves, in fact, all look like grabby hands. The

character tells us she's relieved to be free of her virginity, to not be "a baby anymore." Yet the final panel depicts her ghosted, a white cutout figure against an all-black background; a mere negative of what she used to be, which was a body.

MacLeod argues that this device is more than a cartooning trope. The "ghostly image of the protagonist," she suggests, represents "a symbolic death for the character, the deletion of her image from within the white outline suggesting an effacement of her identity."

I'm not convinced that Doucet's early sexual experiences erased something of herself from the world—although they did, clearly, interfere with her ability to get work done. (Doucet told me in 2006 that one reason she stopped making comics was because her dating life was so difficult to navigate as a successful woman.) But ghosts don't abandon influence over the living world. They collect it; it grows. In the absence of a physical presence, in fact, wielding ephemeral influence is the only thing they can do. A haunting influence over the world is all ghosts have left, and if you can't find evidence in this particular narrative, you can certainly see it in Doucet's career.

LONG FORM AUTOBIO

In terms of narrative depth, character development, and stylistic exploration, Doucet's longform autobio works—*My New York Diary*, *The Madame Paul Affair*, and *365 Days*—offer her most significant formal contributions to comics. The last title is hardly ever noted among her comics work, however, because it is essentially a diary comic and not a constructed narrative; the second gets overlooked because it was serially published in

a newspaper before its collected release. Of course, there are many ways to discredit women's contributions to artistic forms, and claiming they don't meet basic qualifications for inclusion is only the first.

Theorist and science fiction writer Joanna Russ calls this particular example of feminine erasure "Denial by False Categorizing" In her 1983 guidebook *How to Suppress Women's Writing*. It's:

> a complicated now-you-see-it-now-you-don't sleight of hand in which works or authors are belittled by assigning them to the 'wrong' category, [or by] denying them entry to the 'right' category... The assignment of genre can also function as false categorizing, especially when work appears to fall between established genres and can thereby be assigned to either (and then called an imperfect example of it) or chided for belonging to neither.

The autobiographical intentions of these three long-form works, however, cannot be denied. *My New York Diary* is the story of Julie Doucet's short-lived residence in New York City; *The Madame Paul Affair* outlines an adventure Doucet had with the bizarre landlady of a Montreal apartment; *365 Days* is the account of successful mid-career Doucet's mundane activities, brilliantly illustrated. Only one—*My New York Diary*—appeared first in the *Dirty Plotte* floppies; *The Madame Paul Affair* was serialized in a Montreal alternative newspaper.

The first installment of *My New York Diary* appeared in *Purity Plotte* (*Dirty Plotte* #10) in 1996, and the storyline dominated

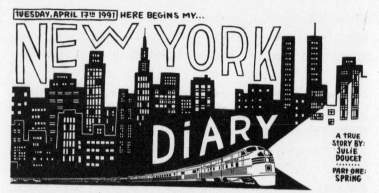

From "My New York Diary, Part One: Spring," *Dirty Plotte* #10 (1996).

the pamphlets for the remainder of the series. Depicting events between late summer 1991, when Julie left Canada, and spring 1992, when she returned, the story was her deepest and most thoughtfully constructed narrative yet, allowing her to pull in her bizarre sense of humor, her sexuality, her interests in the workings of her body in and outside of disease, her drug-fueled explorations, and her dogged work ethic. It is the story of Julie's move to New York City's Washington Heights, where her new boyfriend Mike grows possessive and abusive. Throughout the narrative her career blossoms but her epilepsy—fueled by stress, drugs, and alcohol—worsens. She eventually leaves New York, career intact but heart bruised. The story is rendered with a mature lettering and drawing style that ably conveys rapidly mounting anxiety.

The much-anticipated move to New York—Julie the character is eager to leave Montreal throughout the run of the floppies, a desire that also fuels *365 Days*—appears to offer little initial change to her life; the cozy clutter of her apartment on Visitation Street (left, with her cat Charlotte, in the care of her friend Drey Rival) is reminiscent of the grunge lining the train station

where Mike fetches her upon arrival. His apartment, too, is littered with the detritus we have come to read as Julie's natural milieu. (The character has become, by this point, a Pig Pen for the alt-weekly set.) But we soon see that Mike's place contains a slightly higher percentage of broken items than usual: the paint is peeling and the knocked-over empties on the floor seem less friendly. Also there are cockroaches.

At first, Julie doesn't mind; she spends her time mewling around in love with Mike. The two shop together—for beer— and goof off, but her second night in the new city is already isolating: Julie and Mike do whippets in front of the TV and refuse to answer the phone. When the couple heads to a CBGB's concert, however, we get five panels jam-packed with interesting characters straight out of Doucet's later work, *Long-Time Relationship*. The Voluptuous Horror of Karen Black (VHOKB) is playing, and Doucet's grounding in punk is on full display. The lush complication of people in music venues—Doucet's dreamed Nick Cave concert scenes from "Do You Trust Me" in 1996 offer another example—synthesizes the thrill of live music; the noisy, indescribable performance art-punk of VHOKB (with Kembra Pfahler, lead) is metastasized into a topless woman in pasties and a few recognizable lyrics (the band is covering "I Wanna be Your Dog"). Somehow, remarkably, the venue is cleaner than the train station or any of Julie's residences; that is, the clutter that surrounds our protagonist—is it external, or internal?— has largely cleared away in the crush of people and their wild enthusiasm for the captivating performance. Yet even the concert turns isolating. Mike's friends, also in attendance, have no real interest in Julie, and conversation peters out quickly.

Julie is warmed a few days later by the delivery of John Porcellino's *King-Cat* #26. Early in Porcellino's long-running

self-published comics series, it's an issue very much in keeping with Doucet's own work, containing several dream stories that follow her own approach to the form. It's from back when the series was a tried-and-true fanzine, with "Top Six" and "Bottom Six" lists (Throwing Muses' *The Real Ramona* is on the former, and insomnia and hatred are on the latter); a hand-drawn, photocopied document shared among a group of like-minded, if far-flung, peers.

Julie's comfort doesn't last. A week later, she and Mike are snorting cocaine and tensions mount. When Julie interrupts sex to answer the phone, Mike and his boner are incensed. A skeleton hanging on the bedframe ominously enters the panel as Mike's anger elevates, first when the phone rings and then, later, when he turns his back on her to go to sleep. Mike punishes Julie—clearly nervous in the new city—by forcing her to run her daily errands alone. She sweats through the neighborhood, hypercritically berating herself for her fear. When she arrives home, safe, Mike consents to another excursion in her company, his manipulative tactics exhibiting a pattern of isolation followed by reward.

Within a month, the relationship has gone sour. Julie has gotten pregnant, but this isn't the problem. She goes to a hospital for a checkup, which also isn't the problem, and neither is the fact that a sonogram has caused some bleeding that the doctors didn't explain. The pressing problem is more immediate than questions of relationship stability or maternity or impact on Julie's career: the problem is that Julie is about to bleed through her pants and Mike doesn't seem to care, or even believe her. She miscarries into the toilet; he insists it's only a blood clot. She knows he's wrong and screams at him through clenched teeth, enraged at the ease with which he erases her hard-earned bodily knowledge

and agency. He demands she take another pregnancy test. She does, to keep peace, and is proven correct, but perceptive readers will wonder why she bothered to take the test at all.

A *Raw* party shortly thereafter lends the same crowded sense of calm that the VHOKB show did, and a similar decrease in clutter. Charles Burns is there, acting strangely, and Art Spiegelman, acting kindly, and a cool Leslie Sternbergh you immediately want to befriend. The strip is a rare, underplayed acknowledgement of her entry into the upper echelons of American art comics. But Mike's not happy—he's acting jealous and petty—and it brings Julie down. Drugs help her tackle the workload her new associates bring, but come with nasty side effects. During a bad seizure, she believes herself to be back in her Montreal apartment on Visitation Street, and it is the first time readers are made aware that she is truly more comfortable in Quebec.

We're also introduced then to Julie's illness or, rather, her history of waking up in unusual places with new bruises. One relevant character from her past is Phil, a self-described "thief" who steals her away from a hospital after one particularly bad seizure, as we see in flashback. Very quickly, Phil sees Julie home and seduces her. These, at least, are the events relayed in the narrative, but the truth may be less romantic. Julie has a small spinning whirl over her head during the scene, the cartoon indicator of great confusion. She has, after all, just had a seizure and been given who knows what for it in the hospital. Phil is naked and about to penetrate her when he asks her if she's OK. It is only now that she admits that she is not, that she is tired, that he should leave. A masculine readership may read this as standard practice, but today we would point out that the moment marks Phil's actions to this point as nonconsensual.

Flashback over, Drey calls a few days later to express concerns about the apartment on Visitation Street. When she visits, it is in shambles, and her Montreal friends counsel her on her deteriorating relationship with Mike. Sensing an emotional distance when she returns, Mike throws a public fit on a bus to try to keep her from visiting with a friend. Reminiscent of Louis from junior college, this time an emotionally needy man interferes not with her work but with her ability to surround herself with people she loves. Of course she goes anyway, and by the time she gets home, Mike is a wreck. His behavior escalates from jerk boyfriend to cult leader: he demands she stop taking her epilepsy medication, and belittles her work. His emotional stability is gone. A sobbing mess, kneeling on his own scummed-up floor, Mike fails to notice that Julie's eyes have sunken over the course of the storyline, and that his behavior at this point merely annoys her. She leaves. A final, three-page installment sees her physically improved, alone in a sparse room in Brooklyn. There's less clutter on the floor in this place—maybe the detritus was emotional, after all—as she packs her few belongings to head to her next destination, Seattle. She and her cat Charlotte are accompanied by a flock of men forming a rainy Good Friday parade, a fitting celebration of her own resurrection.

Without question the story is a feat, the subtle tale of a crumbling stability that never falls into self-absorption or cartoony satire. Critics tend to read it as her most "traditional" work of comics; certainly it is her best-known book.

A strange side-note to it is *My New New York Diary*, an awkward to downright bad 2010 Picture Box release, a collaboration with the filmmaker Michel Gondry. An unnecessary revisitation of *My New York Diary* told through Gondry's lens, the film and book build on all the most uncomfortable aspects of the

original long-form narrative: Julie-the-character's tendency to find herself suddenly under the sway of strong-willed men who discredit her sense of self. Gondry seems oblivious to his role in the scenario, introducing the project with a short text that describes Doucet as having "an uncompromising perspective on what is going on underneath a girl's skin," which manages to be both infantilizing and a questionable assertion on Gondry's part, who admits in the same voiceover that he doesn't have much insight into women's anything.

"[F]rom her work you would expect Julie to be confident, rugged, jaded, and covered in tattoos. Yet she is not—she is squarely the opposite," Gondry notes in his introduction, which might make you wonder whether or not he had read *My New York Diary* at all. He confesses that, to solicit her involvement, he "had to use inexcusable and manipulative means." But the project—his re-write of her autobiographical story—was necessary, he says, because his "concepts are like kidney stones to me: very painful to expel, but worse to hold in." That Doucet would fall ill during the project (with mononucleosis) and be bedridden for months, after which she refused to draw for seven full years, does not enter his realm of concern at all.

Doucet has disassociated herself from the project. Regardless, it did coax her out of comics retirement, so remains notable within her oeuvre—even if it then convinced her to stop drawing. Today, it stands as a particularly notable display of masculine overreach, worthy of examination.

The construction of the project is awkward, and its description forms the narrative of the project itself. In the animated film and a sequence of panels printed in the accompanying book, Gondry asks Doucet to visit him so that they can make a book and film together based on her return to New York. She relents,

and Julie-the-character—portrayed by live-action Doucet—and Michel-the-character have a few adventures in the city. They visit a film location, have dinner, go to a strip club. She returns to her old apartment in Washington Heights. Then she leaves.

The 17-minute film, described as an attempt to bring life to Doucet's work by casting her in the only acted role in an otherwise hand-drawn narrative, now animated, opens with Gondry's voiceover. As the film proceeds, Gondry grows aware that Doucet does not fit his vision of "the archetype of the female independent comic book artist," which he describes as "shy and egomaniac [sic], discrete and self obsessed at once." As Julie emerges as a character in his film, his own ego subsides. The audio is uneven and Doucet, as the only live actor, appears not to fit into this world of her own construction. The animation, stilted and unclean, is still thoughtful; Doucet's drawings are as vibrant and revealing as ever, backdrop though they are to an experiment that fails. The only moments of peace Doucet appears to experience are when she is drawing, drinking beer, or speaking French with Gondry. Her comfort in the language is noticeable.

My New New York Diary can't be read as autobiography, therefore, but the moments that shine through as autobiographical do matter. We see Doucet, in her current Montreal apartment. She owns plants now, and there is art on the walls in frames, not just tacked up. The objects littering the floor are envelopes and receipts, bits of cut paper. There is even a broom and, next to it, a tidy pile of dust. Do not overlook this indicator of change. Julie-the-character is more or less Julie of *365 Days*, an older, self-assured artist with square spectacles, wearing a couple sweaters, in full control of her environment and her career. When she visits the apartment in Washington

Heights, where she lived with Mike nearly 20 years beforehand, she draws the building from a comfortable remove, and finds she doesn't even remember which apartment was hers. To Gondry's credit, Doucet's objections to her prescribed role in the collaboration remain intact in the film.

More successful was "*The Madame Paul Affair*: A Comic-Serial in 40 Episodes," originally published from March through November of 1999, in the French-language Montreal weekly ICI, and collected later that year in D&Q's *The Madame Paul Affair*. The artist is at the top of her game, trading in visually unique characters with complex backstories. She's exploring a narrative quirkiness informed by her experiments in fiction yet retains control over the universe she's crafting. It's a 42-page black and white story; 40 of those pages are single-story, self-contained pages of narrative, followed by a two-page conclusion. The single-page restriction chops up the complex emotional build of the narrative, and the story falters a bit. Yet the project as a whole is quite thoughtful, with a strong and compelling narrative arc for a weekly strip that unfolded over nine months.

The plot concerns Julie and her boyfriend who move into an apartment overseen by bizarre superintendent Madame Paul. She pulls them into a world of intrigue, but also seems to want Julie to date her nephew Jacques, who owns the building. Madame Paul and Jacques' family is unconventional; they are either committing crimes or just extremely strange, and Julie-the-character doesn't much care to find out which. The story is most notable for its focus on an external storyline; events happen almost entirely around Doucet, but rarely to her, and she is left to stand nearly mute witness to them. She causes, in other words, none of the drama; her relationships aren't a source of

distress, nor her own actions, and the distance on the narrative
lets her craft a story that feels complete, if also disappointingly
unjagged. What we miss without the unwashed charm is made
up for in those characters. Julie's love relationship is not the
primary cause of her angst; Julie's co-conspirator in the affair of
the title is her female friend Sophie. (The two are even pictured
together on the back of the book, arguing in a bar, a rare full-
color color image rendering the skin tone of Madame Paul,
Sophie, and Julie as a deep, angry red.)

It is autobiography from a distance, then. Unfortunately,
The Madame Paul Affair suffers from inconsequentiality,
like a stunningly produced two-part *This American Life*
episode that leaves a mystery unsolved and unsolvable in the
end. "Disappointing," a critic called it in the *Village Voice*.
The cramped pages and sparse style—likely streamlined for
newsprint and to meet the publishing schedule—sweep a bit too
much of Doucet's signature clutter under the rug and readers
are left underwhelmed.

365 Days is far more gratifying, although it is probably
Doucet's most overlooked work. A square brick of a volume in
a white, collaged hardcover, the story is comprised of a year's
worth of daily comics pages that Doucet started in October
2002. It wasn't published until 2007, however, and I suspect
the book's been overlooked partially because of the five-year
lag between completion and release. There are other factors too.
Doucet had been out of comics for about ten years at that point,
and 2007 was one of the most devastating years on record
for the independent cultural underground in which Doucet's
work was so beloved. *Punk Planet* (where my interview with
her had appeared just a year before) shut down in 2007, one of
dozens of independent publications to close that year that had

emerged from the same self-publishing scene that Doucet did. There were few zine and comics festivals that year—they had been dwindling for a while—and mainstream media had not yet stepped in to cover the independent press, as they would just a few years later with the graphic novel boom.

Of the five-year publishing delay, Chris Oliveros explains via email that it was a production-heavy project that just took time:

> First, Julie had to translate it—I don't remember how long it took, but I think she worked on it little by little over the course of a year or two. But on our end, we realized that the lettering was taking much longer than we had anticipated, since there is far more text than in any other graphic novel, and in this case the text is also integrated within or alongside the actual drawings. Because of this we actually had our first letterer quit about half way through the job. Dirk Rehm [of Reprodukt] had hand-lettered all of our translated titles from about the mid-1990s through to this book, but he wasn't able to complete this without going crazy... Luckily Rich Tommaso agreed to hand-letter the rest of the book, but even then I think it was quite a few more months of work. If you look closely, you'll see that the lettering style changes slightly at about the half-way point of the book. Also, D&Q was a much smaller company at that time, and it was pretty much just Tom [Devlin] and I and one other staff member doing production (on top of balancing other day to day publishing tasks), so it went slower...
> Fun fact: Chris Ware had actually lettered a few pages, from a section that originally ran in *McSweeney's*.

Yet it is possible that *365 Days* gets overlooked due to its content. It is a deliberately banal but also totally revealing tale of an internationally successful mid-career woman artist who is single. The book lacks the bravado she'd earlier staked out—she no longer needed it—and seems composed on more consistent ground. The story is of a successful woman, entering her late 30s, unconcerned with men, happy to be making art with women—who are also her friends—while navigating a blossoming career. Certainly not, in the late capitalist US of A, blockbuster material.

Such stories, in fact, are so absent from our culture that I felt an acute sense of bereavement after finishing *365 Days*. One adopts the internal logic of a book, film, album, or comic while watching, hearing, or reading it, and my life bears some similarities to Doucet's to start with. Watching her respond to some of the same material struggles, publishing deadlines, financial quagmires, international collaborators, cultural frustrations, dating scenarios, and Big Life Questions like What Does It All Mean that I also face daily felt more like genuine friendship than the act of reading.

365 Days features the same Julie-the-character, a bit younger, who later shows up in Gondry's *New New York Diary*. She's a simplified, mullet-haired figure in a tight sweater—nipples evident, shorthand for sexual agency—and jeans. The physical qualities of the character change over the course of the book, beginning with a deliberately wretched figure with a bulbous nose and chapped lips, but gradually softening into something less cartoony. Given the romantic foibles we've watched Julie-the-character endure, it's freeing to see Doucet not give a shit about how she portrays herself. Her depictions of other women are kinder, loving; studio mates at the print

shop the artist joined upon her return to Montreal evolve into a collaborative team. They share jokes and labor, invest in and celebrate each other's career achievements. The women in this book form the same sort of comfortable background clutter we used to find on Doucet's floors, and their relationships are genuinely touching in a way that none of her stories about boyfriends have ever been. Stories of friendships fill out a year with few romantic interludes—well concealed if present—and tons of books.

365 Days notably lacks what the most vocal comics reader (male) demanded from Doucet. She doesn't fuck anything, instead devotes her time to intellectual pursuits and female friendships, which had to disappoint a few readers. In a world of Doucet's design, in which women were unrestricted in work or desire, this book would be considered a celebration of a woman's talents placed on raw display, minus the glitz of sexual titillation, told by a woman actually comfortable with where she has finally found herself in the world. It is why I have come to adore this book so deeply. Yet it goes largely unrecognized in her body of work, never acknowledged as one of the greatest long-form comics of all time.

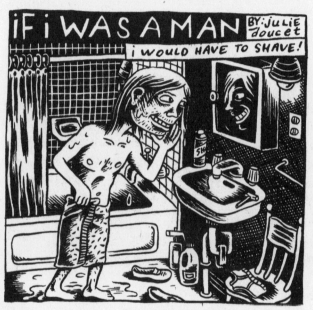

From "If I Was A Man," *Dirty Plotte* #6 (1993).

THE IMAGINED SELF

Critics never bothered to parse exactly how Doucet's work elicits its unique combination of wonder and calm, qualities that remain deeply and immediately gratifying to readers, but it seems to come from exquisite and off-handedly captured detail, crafted in joyous line, of both subjects and objects. Each is rendered not so tightly that it produces anxiety but not so loose that you can't discern its referent at a glance. Forms integrate organically into each other, conform to the shapes of others. A littered floor does not provide distraction but interest and comfort; people with real flaws become whole, magically filled out by the presence of an empty tin can or scrap of paper. Vignettes, and rooms, and apartments, and buildings, and entire cities are born under her hand, and readers watch them develop, grow comfortable with them, sink into them, and live in them. When they end, because the strip does, or the story, or the series, or the book, or the career, you are left bereft.

"She created a world that was easy to inhabit," John Porcellino commented in a discussion of the power Doucet's comics hold over readers. It may be a technical skill, but Doucet's abilities

seem to have been bestowed upon her rather than learned. What makes her work so captivating, whether comics or less narrative forms of sequential graphic art, is the use of that technical skill to make very real—viscerally present—the potentially real. For Doucet's signature work was never the autobiographical comics she's often name-checked for, nor was it her dream stories, or her fiction. Her very best work sits somewhere amid all these realms, the center segment of the Venn diagram that presents readers with a dream-like atmosphere, nonexistent but also not invented, rooted in the possibilities presented by Julie Doucet's actual life. These strips (for they achieve their fullest form in her hand-drawn comics) feature the fantastical adventures of Doucet's Imagined Self, an unwashed urban blonde in Montreal or Berlin (or Seattle or New York or Helsinki or jumping out of a plane) named Julie who transcends the boundaries of gender—although notably not class or race—to traverse a more or less realistic-ish landscape of her own design, blazing a path through the world from which all potential barriers to her pleasure, contentment, and success have been magically eradicated. Often, a trail of blood is left in her wake.

Explorations of the Imagined Self constitute just less than a fifth of Doucet's output, but the charge of this work ignited a generation of cartoonists. To create such work is no easy task; crafting a world that *feels* real but *is* imagined is care work of the highest order—which means that the intense craft it demands will necessarily go unappreciated. That Doucet's most whimsical work seems effortless is central to its attraction.

Do not overlook that Doucet is exceedingly good at creating a new and improved world from the one we already inhabit, a slightly better, more fun, mildly confusing near-off future that is still somehow warm, friendly, and inviting. The starring role in

these tales goes to Doucet's Imagined Self, Julie-the-character, Pippi Longstocking's cousin-with-a-fake-ID, who outlines a course of action in this weird near-future, allowing us to project ourselves into previously unseen and often unimagined environments. Collectively these works establish a semipublic imaginary that, once experienced, readers seek to foster in reality. For all her technical and storytelling abilities, Doucet's most impressive skill is her ability to craft an imaginary future that we not only can, but want to inhabit.

Take, for example, two signature strips that nearly bookend her comics career: "Levitation" (also known as "One Morning") from *Dirty Plotte* #1 (reprinted from the minis) and "Alone Again with Julie Doucet," from *Purty Plotte* (*Dirty Plotte* #12) seven years later. Both are black-and-white, two-page strips; both feature Doucet-the-artist bending the laws of nature to conform to Julie-the-character's bodily desire. In the former, the fourth strip in the floppies, Julie awakens with a full tampon, so levitates to the toilet by unexplained means to change it. This is a complicated procedure, as her apartment is small, and magical Julie must use all her powers of concentration to accomplish it. "Live better each day thanks to the power of the right side of your brain," runs the ad-like message that closes the strip, any inherent commercialism undercut by the panel to its immediate left: Julie, relieved, wiping her sweat-stained brow and floating about six inches above the rim of a toilet. Her continued levitation offers an impressive view of the clotted blood streaming from her vaginal opening and falling into the bowl with a neat "plich!" In the deceptively simple story, a single character faces and resolves a dilemma. Attention to detail and character development are both understated, and the lettering and line control are slightly uneven, although such

glitches only add to the immediacy and charm of the strip, and develop later into major aspects of her signature style.

The final strip in the floppies, "Alone Again with Julie Doucet," is the only story in the issue not part of the *My New York Diary* installments. Julie-the-character has matured a bit since her levitating days, but her hair still hangs in thick chunks, and she still sweats profusely under concentrated effort. She is in bed again, although awake, and horny. She calls forth a man from the ether with a massively erect member to come please her, but even fisting to his elbow doesn't satisfy her rapacious desires. An alligator's snout is considered next, but soon dismissed. Finally, an elephant appears in the doorway. It seems to do the trick at first—with the addition of eight guys of various sizes pushing it from behind—yet requires an imagined improvement: a tongued snout. This, finally, brings her to ecstasy. (It is only the second time we see Julie come.) The series ends with Julie riding the back of her new improved elephant friend, into the sunset, a hobo bindle over her shoulder. She has redonned the underpants we last saw hanging nonchalantly off the elephant's trunk.

In neither of these two narratives will Julie-the-artist allow her imagined body to be subject to inconvenience or discomfort over mere biology or physics. Indeed, Doucet leaves out any elements that fail to add to her convenience and pleasure, which is a physical delight fully and uniquely her own. That heterosexual cismale readers come away from such strips with the sense that Doucet is willingly subjecting herself to the male gaze or sexualizing herself for a straight male readership is both hilarious and awe-inspiring. "Time to saddle up my elephant lover and hit the road," was the artist's response.

Doucet's semi-imaginary realm tests the boundaries of science, logic, and physical reality, and expands or contracts based on

Doucet's own whims. It feels very easy to live in, sure, but that readers continued to want to betrays impressive skill, considering the subject matter she chose to explore: her ego, her bloodlust, her gender dysphoria, and her disinterest in basic hygiene.

I AM JULIE DOUCET

"When I came onto the scene—no, burst onto the scene," I recall Camille Paglia saying in response to a television interviewer's question around 1994. The original query had not been about Paglia herself, but about something else, and in her first attempt to respond to it, Paglia was tricked into answering the question in a way that did not foreground herself. When she catches her error, she goes back and begins again, re-stating her own minor role in an introductory statement to an interviewer's question that was probably about pop music, or contemporary art, or Hollywood movies.

It was classic mid-1990s swagger: Paglia seized every opportunity to recast even forgettable histories in her own image, crafting a dynamic, if self-aggrandizing, entity.[3] Doucet's authorial bravado is less laughable, more considered, rarely careerist, and absent the full-on antifeminist rants that

...................

3 In her hypermasculine demand for space in the hypermasculine world of cultural criticism (trust me), Paglia also seems prone to masculine overreach. In Ellen Forney's strip about approaching her for an interview, printed in *The Stranger* in 1993, Paglia rebuffed the request and demanded instead a date, which we now understand to be fairly basic sexual harassment. It's unclear how much Forney objected to the professional violation, but Paglia's disinterest in the boundaries established by women in a professional context is notable, and Forney's rare dip into reportage, reprinted in *I Love Led Zeppelin* (Fantagraphics, 2006) worth a review.

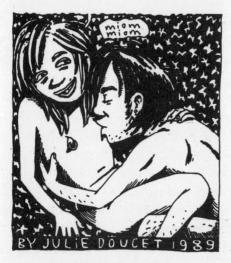

From "I'm Not Afraid of Cancer,"
Dirty Plotte #2 (1993).

Paglia seems ever ready to provide. She is, however, attempting to craft an equally impervious image. Take "I'm Not Afraid of the Breast Cancer," reprinted from the minis in *Dirty Plotte* #2. It's a muddy strip, the English charmingly stilted in that non-native-speaker way. Julie-the-character, drinking Pernod, imagines that she receives a cancer diagnosis, whereupon she opts to have both breasts removed but pierce her nipples. (That her nipple rings are then depicted as sexually fulfilling for a male partner lends some credence to the claim that Doucet was invested in fulfilling masculine desire, although a close examination will reveal that such moments in her oeuvre are rare.) The strip is grounded in youthful invincibility. Readers who felt similarly when it first appeared, and have managed to avoid cancer upon rereading today, might wince at the affront to a disease that has certainly affected friends. The lack of fear, the naiveté, the belief that there is always a silver lining, it's still bravado, minus the eyerolls that Paglia's version of it brings on.

For more bluster, we can look to "I am Julie Doucet" from *Dirty Plotte* #7 in 1993. The black-and-white, single-page strip has Julie-the-character tearing into a superhero comics shop and demanding to use the restroom after loudly declaring

her name. It's classic swagger—Out of my way, punk! I've got personal business to attend to!—but Doucet hoists her own petard. Although employees and customers do let her pass, they note while she's indisposed that they've never heard of her. It's a thoughtful and accurate reflection of the comic-book world at large and her role in an industry dominated by DC and Marvel. It's even labeled fiction, Doucet's reminder that she would never barge into a room with such aggressive demands.

Aggression, or something akin to it, is reserved for the letters column. Readers' notes start appearing in issue three, with nineteen letters, only one from an apparent female reader (way to go, "Katrina"). In this issue, Doucet, having recently discovered that men name their organs, asks penis-wielding readers to tell her what they call their cocks. "Frank," "Peter," "Erik the Red," and "Dink the Wizzard" are all submitted in response, in letters appearing in the following issue; Doucet also receives a 12-panel comic, each frame of which features a pecker berating her for withholding her sympathy for it. Her male readers (of 20 letters, only two appear to be from women) think it's flirtatious, an invitation to a long-distance sexual intimacy. The reprinted letters remain a sausage fest for a few more issues. Doucet has said that she just thought naming penises was funny.

"She's French," is how D&Q's Peggy Burns explains what was perceived as flirtation but was only ever curiosity. "It's a cultural thing."

STRIP TEASE

Doucet's bravado is an extension of her bodily agency, the knowledge that she alone has full control over her conscious

physical self. (She admits that she has no control over her unconscious, or unknown, self.) She uses bodily agency in a range of ways, from sexual to surgical, always tucked inside the joke: that she is also in control of the comic strip.

Art historically, we'd place Doucet's work in proximity to Frida Kahlo's, whose innovation in self-representation gets glossed over these days in attempts to make her relevant to The Selfie Generation. Kahlo's "selfies" were untethered, though, freed from the restrictive boundaries of photography, which can only ever capture light. They depict Kahlo's Imagined Self, straight from her mind to the canvas, the conduit her practiced hand and an extensive vocabulary of Aztec history, communist theory, and lived experience in a distressed body.

Kahlo was steadfastly political, and her iconography frequently reflected revolutionary desires; Doucet studied feminist thought—feminist novelist Cristiane Rochefort is one such influence—but avoids ideological pronouncements. The two are more strongly linked by the manner in which they depict their own bodies. Kahlo's paintings were often fantastical depictions of dismemberment and pain that she herself experienced—she had polio as a child and suffered an auto accident as a teen, both experiences leaving her physically changed and, for long periods of time, bedridden. Doucet writes of epilepsy in more traditionally autobiographical stories, waking up, for example, after a seizure with no recollection of it coming on. Her depictions of dismemberment are sometimes, but not always, limited to her own corpus; she also has strips that qualify her for membership in Valerie Solanas' (sadly theoretical) Society for Cutting Up Men.

There is, in both artists' depictions of disease and pain, a sense of the body as separable from the self, a notion that

the self might just be able to leave the body, and be another entity entirely. An Imagined Self can accomplish or experience anything without consequence.

In Kahlo's work, this is imaged almost directly in The Two Fridas from 1939. Painted shortly after her divorce from muralist Diego Rivera, the portrait features a modern, white lace-costumed Kahlo on the left and a traditional Tehuana-costumed Kahlo on the right. Both have exposed, connected hearts; they hold hands in front of a stormy sky. White-donned Frida has recently had surgery, and the pincers holding her artery closed still drip blood on her gown. The "two Fridas" offer each other support, but remain separate entities—past and present figures.

Doucet's "My Conscience is Bugging Me" from 1989 is a modern retelling. The five-page black-and-white strip opens with Julie-the-character complaining in her diary about her conscience, a sloppy, daring, pimpled woman with a boob hanging out of her shirt who likes trouble. Character development is sharp, the logical outcome of Doucet's interest in ontology; her conscience is fun-loving, bedraggled, and seems like a handful, while it's clear throughout the short strip that Julie herself has shit to do. The final panels have Julie coddling her conscience in her lap, in her scuzzy apartment, as close to holding hands before a stormy sky as dirty punks can be expected to get.

In a 2004 paper published by Halifax-based Dalhousie University called "Transgressive Bodies in the work of Julie Doucet, Fabrice Neaud and Jean-Christophe Menu: Towards a Theory of the 'AutobioBD'," researchers Ann Miller and Murray Pratt suggest that while "the permeability of the boundaries between the positions of author, narrator, and character is

indeed a source of jouissance in Doucet's work, the ease with which she inhabits these different positions will occasionally be troubled." Miller and Pratt point to Julie-the-character and her conscience, a relationship that could be fraught with strife. "This might suggest a certain Freudian structure of superego built on the repression of desire," the authors suggest. "However, her conscience indulges in much wilder and more uninhibited behaviour than Julie herself...." Even Doucet's Imagined Self has an Imagined Self, about whom Doucet appears to feel basically ambivalent.

Even more Kahlo-esque are Doucet's "The Artist," first published in the Montreal student publication *Tchiize* in 1986 and "Self Portrait in a Possible Situation" from 1990. In the first, a prototype of Julie-the-character, in an overcoat and hat, does a strip-tease and, once naked, pulls off her breasts and guts herself with a knife. In the second, one of her most reproduced and iconic strips, we are given three still panels in which Julie, adopting cheesecake poses, shows off where she has cut herself dramatically. In the fourth panel, she requests men contact her if they are interested in "modeling" for her drawings.

Two films come to mind, both French: *Dans Ma Peau* (*In My Skin*) from 2002 and 2016's *Grave* (*Raw*; actually French-Belgian). Both concern young women entering new career paths—one a student, the other recently promoted—who discover a hunger for blood. The protagonist of *Dans Ma Peau*, Esther, suffers a scrape in a dark field one night, thereafter becoming transfixed by her own body's ruptures. She begins cutting herself, first in small slices. Soon she is removing long strips of her own skin for preservation. The pleasure she gets from her own slow evisceration is both sexual and palpable, soon eclipsing her interests in her fiancée and her career. *Grave*'s Justine, a vegetarian upon entering

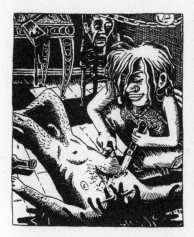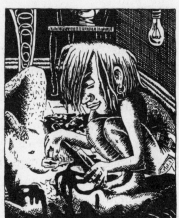

From "Le Strip Tease Du Lecteur," *Dirty Plotte* #3 (1993).

veterinary school, is forced to consume meat in a hazing ritual, and becomes obsessed with consuming human flesh. She soon finds a way to both do so and pursue a relationship and career path that will allow her to explore her bloodlust as a loved and respected member of a community.

Remarkably, neither film is mired in moralizing, in keeping with the French tradition; the taking of lives is not recommended, certainly, but both films staunchly argue that women must be granted the material resources necessary to pursue their pleasures, whatever they may be. (In my skin—when one feels most relaxed—is a linguistic nod to the protagonist's substance of desire as well as her own comfort in acquiring it.) The relationship of both these films to Doucet's work is more about a shared ethic than a shared genre. Doucet may use tropes common to horror, such as slicing people open, but her intention isn't to terrify. In fact, it's the opposite, it's to play—with whatever materials she desires. Similarly, despite the volume of onscreen blood, these aren't really horror films;

they're coming-of-age movies about the violence young women must wreak to pursue their own happiness.

Doucet has discussed these strips in relationship to cutting, the phenomenon of young folks, often women, harming themselves minutely as a reaction to trauma. (The 1990 mini in which "Self Portrait" first appears includes a "Do It Yourself: African Style Scars" spread, instructing users on cutting and scarification.) I tend to read them as inoculations, imaged depictions of self-harm to stave off real damage, whether physical or emotional. Doucet has also carved up male readers, however, in stories that are equally playful but appear to respond to different stimuli.

"Le Strip Tease Du Lecteur" from 1990, a collaboration with Steve, a reader, is a revisit of her earlier strip "The Artist," and stands as one of her more important works of art—indeed, as an important work of art by any artist, in any genre. It may call to mind *Unos Cuantos Piquetitos*, Kahlo's 1935 depiction of a man she'd read about in the newspaper who'd stabbed his girlfriend to death, defending himself by saying that he'd only given her "a few small nips." Kahlo's painting depicts the couple, one post-mortem, in a room; Kahlo is also said to have been inspired by the recent discovery that her sister was having sex with her husband. Mutilation is a common enough theme in Kahlo's work: as a deer she is pummeled with arrows; a face in close-up is pricked with small pins. Kahlo's Without Hope from a decade later places all the gore and viscera outside of her own bedridden body, although she's forced to re-consume it by way of a giant wooden apparatus and a funnel attached to her mouth. Kahlo is portraying her pain. Doucet may also be, but her quick turn of the knife in "Le Strip Tease" on a masculine reader could be seen instead as self-defense.

Steve, who had submitted a picture of himself to Doucet in response to her four-panel "Self Portrait in a Possible Situation," is drawn meeting the cartoonist in her studio, now stocked with knives, razor blades, scissors, hatchets, forks, and hooks. (Oddly, she seems to have cleaned for the occasion, as nothing clutters the floor besides a few beverages and an open book.) After seeking his explicit verbal consent, Julie-the-character drives an axe through Steve's skull and removes his head. This is cast aside—hung on a chair—so she can slice open his chest and mutilate his arms and stomach. Finally ready—she has been building toward it, almost erotically—she cuts off his johnson with a long serrated blade, and uses it to write "Fin" on the wall, shyly bringing a hand to her mouth as she smiles at her work.

Publication was a few years shy of Lorena Bobbitt's world-renowned performance of similar in 1993, when she cut off the prick of her sleeping husband, John Bobbitt, who had earlier raped her. She then fled, discarding the widdler from her car as she passed by a field. (It was later retrieved and reattached.)

"We belong to the gender of fear, of humiliation," French theorist and filmmaker Virginie Despentes observed in *King Kong Theory* (2006, Feminist Press). "The other gender. Masculinity, that legendary masculine solidarity is formed in these moments and is built on this exclusion of our bodies. Pact based on our inferiority." Despentes offers a corrective:

> [W]omen still feel the need to say that violence is not the answer. And yet, if men were to fear having their dicks slashed to pieces with a carpet knife should they try to force a woman, they would soon become much better at controlling their 'masculine' urges, and understanding that 'no' does mean 'no.'

Doucet's strip is less overtly threatening, certainly, and Steve's willing complicity in the depiction complicates the fear that Despentes calls for. But Doucet draws Julie-the-character sawing the ween off a male comic-book reader and then completes the strip with his still-bleeding dong. If that image hasn't popped into at least one cismale reader's mind when he's contemplating exerting his masculine urges over some real-life woman, I'd be floored.

Not, of course, that sexual violence ended when the strip appeared in 1990. Today, the second paragraph in the Wikipedia entry on the Bobbitts describes in mournful tones that John's phallus never regained full sensation. The rape charges that spurred its removal, however, are not mentioned until later in the article.

I WISH I WAS HIM

Of all Doucet's contributions to comics, her infamous "If I Was a Man" series and related explorations of gender disphoria are her most groundbreaking. They hold up well despite the two decades of gender theory and cultural conversation that have occurred since, which these strips helped to initiate. With the loopy panache of Katherine Collins' *Neil the Horse*, Doucet's Julie-the-man established a just-out-of-reach future where gender would be transitory and playful. Since then, Edie Fake's *Gaylord Phoenix*, Joey Alison Sayers (the cartoonist behind *Thingpart*), and *Elisha Lim of 100 Crushes* have significantly expanded our visual vocabulary of desires, interests, needs, and hopes for folks whose assigned pronouns at birth did not align with their gender identities.

In art history we can look again to Frida Kahlo, who, like Doucet, never expressed discomfort with her assigned gender identity, but did explore a plethora of gendered visual tropes. *In Self-Portrait with Cropped Hair* from 1940, Kahlo depicts herself in the close-hewn hairstyle she adopted after her divorce. She is also wearing an oversized men's suit and a dark red shirt. Her masculine haircut and clothing stand in contrast to her delicate, dangling earrings and petite high-heeled shoes. In the painting, Kahlo holds a pair of scissors in one hand and a lock of hair in the other, and her shorn tresses writhe around her like snakes. Above the scene, accompanied by a sequence of musical notes, are lyrics from a Mexican folk song that translate to: "Look, if I loved you it was because of your hair. Now that you are without hair, I don't love you anymore." It's an image that arguably depicts Kahlo's independence from Rivera; more interesting is how easily the artist slides into a masculine role herself. The painting offers a remarkably fungible take on gender roles in 1940, as, in the US at least, it would be another two years before women could join men in the armed services or take their places in factories at home. (Mexico, which at once held to more traditional gender roles yet remains consistently more willing to acknowledge women leaders, had passed a law giving women the vote in 1938 that did not go into effect until 1953. Mexico remained her home, although Kahlo had spent much of the last decade in the US, and continued to travel and exhibit internationally.)

Such a depiction in 1993, the flash-point of riot grrrl, the year Liz Phair's song-by song takedown of the Rolling Stone's *Exile on Main St.*, *Exile in Guyville*, was released, might make slightly more sense— although legislation lagged somewhat behind the cultural zeitgeist. (The Gender Equity in Education Act, for example, which trained

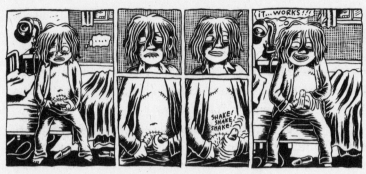

From "Regret," *Dirty Plotte* #6 (1993).

US teachers to offer math and science education to girls and secured sexual harassment and pregnancy counseling for young women, would not go into effect until the next year.) This was the year the "If I Was a Man" stories were published in *Dirty Plotte* #6, marking Doucet's foray into gender exploration, a significant hallmark of her work.

In keeping with her light-hearted line, tendency toward silliness, and grounding in personal desire, Doucet's strips on the gender transition of her Imagined Self are extremely playful, if not a hair dismissive. One does not arise from apparent surprise gender reassignment surgery with scars where breasts used to be and a newly attached, fully functional ween, as Julie-the-character does in "Regret: A Dream," also from *Dirty Plotte* #6. For even if there is no internal emotional struggle surrounding surgery, folks who gender transition tend to face disbelief, discrimination, harassment, neglect, and extensive financial hardship outside of potential medical trauma. Surgery is not necessarily an end-goal, at times the cost is prohibitive and at other times unnecessary to an individual's gender expression. These days, surgery usually follows a long series of hormone replacement therapies, not to mention time-consuming and expensive legal name-changes,

and isn't undertaken all in one fell swoop so that the body—as I am given to understand it—has time to heal between invasive procedures. (Perhaps this will later be revealed to be bunk, and the reason gender reassignment surgery is not an overnight process in the way Doucet imagines it is due to the gender normative bias of the medical industry. Who can say?)

But Doucet's genderbending strips are just that: a curve to the imagined binary on which culture, and particularly comics, rely to a shocking degree. The bend she describes is never so drastic as to create a permanent break between one gender or another, nor to the binary itself. The gender transition stories instead allow Julie-the-character to hop from one end of the gender continuum to the other, from Woman to Man, and back again at will, no real transition necessary. Voila!

Indeed her "If I Was a Man" strips from 1993 have something in common with the above-mentioned strip, "I'm Not Afraid of the Breast Cancer" from *Dirty Plotte* #2. Julie's imagined breast cancer diagnosis is the impetus for a double mastectomy (and nipple piercing), but there's no chemo, in fact no actual disease, no fear or concern about risks or body integrity. What we don't know when we are young is that desires change under physical duress. Plenty of people have no interest in sex for some time after a double mastectomy, for reasons that have little to do with shame or mistrust of the body. Many are just tired. Such physical consequences are missing from Doucet's work— recovery is not always funny—and bravado prevails. There were other attempts throughout the realm of cultural production at the time to reward quick and easy gender correctives. Riot grrrl bands were calling for girls to take boys' places at the front of clubs during performances, and charging attendees less if they showed up in a dress.

"I Wish I Was Him," Kathleen Hanna was singing on tour with Bikini Kill at the time, in a cover song released in 1994 on the Kill Rock Stars compilation *Rock Stars Kill*:

> I know it sounds stupid when I say it out loud
> Like I'm just jealous of his silver cloud
> He looks so good he drinks diet Coke
> He gets his magazines sent by air and not boat
>
> CHORUS: I wish I was him
> He gets the girls at his feet
> With all his cool friends
> He gets his records for free
> I wish I was him
> He has no enemies
> I wish I was him
>
> He's got six different flannel shirts
> Airwalks not thongs
> He even understands the words to Pavement songs
> He's got his new guitar toys
> He likes Smudge and the Beastie Boys
> [CHORUS]
>
> I feel much better now I've let it all out
> He's got big biceps and a masculine shout
> I'm not trying to sound like I'm trying to be mean
> But he thinks he can be a girl better than me
> [CHORUS]
>
> I wish I was him

Written originally by Ben Lee for his Australian alternative rock outfit Noise Addict, Hanna altered the song slightly. Lee's object of desire, Evan Dando of Lemonheads, played the guitar "faster" than Lee did; Dando received not all his magazines but "NME"—*New Musical Express*, a British newsprint rag that was at the time closely associated with punk rock—sent by air and not boat. Lee was 14 when he wrote the song's idolizing lyrics, and they are asexual and pure. No metaphors here. This is a song about wanting to be a successful, sexy, white, American alternative rock 'n' roll frontman, respected by the industry.

The original song attracted the attention of Beastie Boys' Mike D, who signed Noise Addict and brought them on tour. When the teen band broke up, Lee focused on his solo career. Lee didn't so much become the object of his desire (minus, maybe, the biceps and the shout) as he did achieve a more or less comparable standing in the field. Hanna, too, a few years after releasing her version of the song, would meet, start dating, and marry Adam Horowitz of the Beastie Boys. Her success and longevity in the field is largely attributable to the reach and impact of her band Bikini Kill, the riot grrrl movement, her other music projects, and the books and documentary films that have bolstered her status. These are all wholly separate from her husband's line of work, although the bouts of extended illness Hanna occasionally suffers would certainly have proven more difficult, and have been more difficult to recover from in the competitive music industry, without a well-positioned and economically successful partner.

"I Wish I Was Him" is a fairly safe stance, atypical of riot grrrl music in that it is a wholly non-aggressive, resolutely uncritical, in fact deeply flattering portrait of powerful male cultural figures. Both Lee and Hanna's deliveries—occasionally

wavering, genuinely wistful voices conveying a seemingly authentic desire—are catch-free, calculated to innocently proclaim the singer worthy of attention, whether of the object of desire, or as a (generalized) object of desire. (The song is particularly uncharacteristic of Hanna's songwriting. "What's Yer Take on Cassavetes," for example, with fellow Le Tigre member Johanna Fateman, asks whether the filmmaker is a genius or misogynist, alcoholic or messiah, thus offering a more complex and problematized view of masculinity in cultural production.)

Hanna's "I Wish I Was Him" is the terrain Doucet's "If I Was a Man" series is built on. In the mildest of the single-page black-and white stories, later collected in *My Most Secret Desire* in 1995, Julie-the-man shaves for six panels, and it looks like fun. In another strip, Julie-the-man unscrews the top of his "useful penis" and stores some stuff in it: a bouquet of flowers, a pen, some paper. Body integrity is breached, and Doucet's stance becomes slightly more aggressive. "The one-eyed monster could use an upgrade," is the unsubtle charge. Neither strip, however, goes too far beyond a flattering charm, "I Wish I Was Him" an appropriate soundtrack to the universe they inhabit.

The third strip in the series, however, adds ominous ellipses to the story title. (This strip opens *Dirty Plotte* #6, although appears last when collected in *My Most Secret Desire*.) In the second of six panels, Julie-the-man grabs a lady walking by on the street. (She happens to look a lot like Doucet's fictional character Lisa Biscuit). By the third panel, he's pantsless. Then he violently titfucks his captive with his monstrous dong on the hood of a car, slathering her face with cum. This is rape, no question, and Julie-the-man has just gleefully proclaimed a desire to try it, without consequence.

To a degree, the strip seems to be a response to her readers' overenthusiastic replies regarding the names of their pork swords. It's also a depiction, in her language and under her labor, of their expressed desires. "I wish the semen would stick her lips together like glue, then I'd be free," one fan writes of a schoolmate to Doucet, in a segment she includes in her letters pages. Then he asks what she thinks of the taste of semen. It's a dangerous game, to allow, even support, unfettered misogyny—a wish to silence women, an inappropriate sexual query, nonconsensual violent sex—in the pages of your own fully hand-drawn publication, particularly if one is, you know, against it. I recall suggestions that Doucet might not have been feeling the negative effects of misogyny at the time, and therefore wouldn't have known to link these events and respond to them protectively, and there may be some truth to such charges. Doucet herself says she never felt sexually harassed. Yet a slightly more interesting argument can be made that inoculating oneself against misogyny may require its advance exploration.

There is a fourth strip in the series, completed for men's magazine *Details* but never published, in which Julie-the-man muses on his relationship with his girlfriend. He spends all six panels describing the visual and olfactory experience of her pussy. It looks like "two thin steaks put together" and smells like "squid breath" and, as he blathers on about his obsession, his girlfriend—who neither dresses nor looks like Julie-the-character in any way—ignores him and reads a book. It's a fitting end-cap to Doucet's temporary gender dysphoria. If Julie was a man, he would still be intellectually obsessed with feminine physicality.

"If I Was a Man…," the darkest of the series, is also an effective piece of satire. It forms, for example, a mirror image of

Tig Notaro's explorations of molestation in the second season of her brilliant Amazon series *One Mississippi*. In the narrative, Notaro casts the traumatic, semiautobiographical events as true, in the past, and fully survivable; the protagonist who experiences the molestation also uses her experience to connect to others, drawing out the pervasiveness of sexual assault against women of all ages in the usually inhospitable context of a dramatic comedy. Whereas male-driven comedy shows may fail to mark non-consensual sex, depict rape negatively, or even punish aggressors, such storylines invariably end when the episode does. Notaro's depiction of sexual violence is gutting because it is cast as banal, an indication that the impact of sexual molestation perseveres, in comedy as in real life.

Doucet's imagined rape explains why: Julie-the-man's thoughtless sexual violation of a woman on the street appears just as inconsequential as in any male-driven comedy show— or, for that matter, comic. It satirizes not rape itself but thoughtlessness. The universe Doucet imagines here appears to be set in a man's world, and offers masculine players ample opportunity to see themselves as joyous figures delightfully shaving or pulling bouquets of flowers out of their wieners. But she does not let it escape notice, her's or the reader's, that that self-satisfaction sits along a continuum that includes the ever-present possibility of sexual violence against women undertaken for fun.

NEAT HOUSEKEEPING

Doucet's true perversity is never more evident than when she perceives an attack on her unwashed lifestyle. "Dirty Plotte vs.

Super Clean Plotte" is a 1991 strip from *Dirty Plotte* #4. In the four-page story, a prim-and-proper reporter for *Neat Housekeeping* magazine visits Julie at her home in the guise of her secret identity. Julie-the-character, reading a comic book (*ZOP*) and picking her nose in bed, is distressed to spot her nemesis Super Clean Plotte breaking in to tidy the house. When the "super bleach gun" destroys Julie's beloved comic, a battle ensues, which Julie wins by farting on the intruder. Super Clean Plotte is sharply rendered; her outlines are all smooth, and she does not hesitate with indecision as do so many other Doucet characters. Indeed, as the apartment becomes less cluttered under the supervillain's weapon, reader agitation grows alongside Julie-the-character's. The animated items in Julie's house, it seems, are grounding and significant, not merely familiar. A scuzzy-haired lifestyle worth defending to the death; horror vacui as diegesis.

There is, Doucet argues, a joy central to her chaotic, Pig-Pen-like existence, and the strips in which that feeling is made concrete start to appear more frequently in later issues of the series. Over the course of the floppies, discarded objects form a visual vocabulary, a comfy urban punk-rock quilt made from overly large tacks, discarded tin cans, bent forks, half-used tubes of toothpaste, headless dolls, bricks, coffee cups, rubber ducks, comics, still-stabbed dolls, letters, beer cans, ashtrays, syringes, boxes of cereal, single shoes, upside-down ice-cream cones, armless dolls, keys, paper bags, wrenches, pencils, tuning forks, and underpants. (One could argue that Doucet's post-comics work is devoted entirely to exploring the geegaws, tools, and trinkets she leaves unexamined throughout the streets and floors of *Dirty Plotte*.)

The grace that emerges from this careful pattern of hapless objects is on full display in "Rrrremix" from 1996, published

in *Dirty Plotte* #11. In it, our usually anxious Julie-the-character does regular house things (presumably in Berlin) with a newfound serenity. Julie, in a cold sparse apartment, reads her dictionary, then poses and prances about the wood-floor apartment dancing a Whitmanesque song of herself. The black and white two-page strip (with rare half-toning) includes deliberately poetic text, cast in a German-inspired cadence.

From "Rrrremixxxx," *Dirty Plotte* #11 (1997).

"An English Lesson," an early two-page strip from *Dirty Plotte* #2, explores linguistic play directly. Julie decides she wants to improve her English, so she pays a tutor in beer, but proceeds to get too drunk to remember anything later. It's a story anyone who's tried to learn a language is familiar with; studying and reading is a great way to start, but sitting around and drinking is how to get the job done. (I myself have awakened—in Vienna and Tbilisi and Florence—to discover that my thrill at having spent the evening in back-and-forth with interesting people has been obliterated from memory by a blinding headache and a stream of vomit.) Charmingly, as Julie's diction grows more refined and traditional, the text of her half of the conversation appears in ever more florid Olde English letterforms.

However frequently the stories descend into a beery haze, and despite how many references to alcohol abuse show up, Julie-the-character's addiction is always something of a joke about alcoholism. In "What an Intense City," first published in *New York Press* (November 20-26, 1991) and later appearing in *Dirty Plotte* #5, Julie visits New York and has distracting run-ins with several inanimate objects before Mickey Mouse ("Mike") invites her over for a drink. The short strip predicts *My New York Diary* in tone—the same "lost girl in the Big Apple" sense that underlies the tale grows into the more stolid "hapless girl in the world of men" of the autobiographical series—and establishes new boundaries for her ontological playing field. In three short pages, Doucet crafts a recognizable New York City from a combination of living beings, fictional characters, and fully sentient man-made objects who support or limit her freedom of movement. Worth noting is how the supposedly uniting force of beer also causes havoc. Although the strip ends with the satisfying clunk of Julie and Mike's beer cans, three earlier cans of beer steal a man's wallet on the street corner and run amok, yelling to each other, "Let's go get drunk!"

Julie-the-character's relationship with beer is examined in 1990's "Alcoholic Romance," first appearing in the minis. In the four-page story, a silly set-up for Doucet to play with the animus of inanimate objects, Julie meets a hot guy on the street and falls in love, so she takes him home and they fuck, and he happens to be a beer. His name is Bruce. Doucet's adaptable comedic sense here is largely focused on giving a human-sized bottle of beer enough physicality to entice the discerning Julie. His clothing—which he must have, so it can be seductively removed—is a toga, and Bruce has a gash for a mouth and only

one eye. Julie doesn't mind, for she is focused on popping his top and drinking his frothy liquid. Bruce fingers Julie (poorly, I'll be honest, literally pointing at her clitoris with a scrawny forefinger for two panels, whereas, in case you haven't had the pleasure, a more skilled lover would get all up in there); Julie gives him oral. Eroticism is downplayed, nearly eradicated; the joke rests on how one might romanticize and sexualize the material baseness of beer. What does it really mean, we ask, watching Julie-the-character's body placed in service to that joke, to love beer?

As self-revelatory (or pseudo self-revelatory, for by *365 Days*, Julie-the-character has grown bored of beer) as these strips get, Doucet seems to feel a growing need to protect her privacy. In "The Day I Can't Take it Anymore" from 1992 (*Dirty Plotte* #5) and its follow-up strip seven issues later, "The Return of Baxter," Julie-the-character moves to the desert. Her motorcycle gets her off, she stops taking her meds, has occasional epileptic seizures, and develops deep friendships with various animals and inanimates, including a frozen chicken named Baxter. "The Day I Can't Take it Anymore" is the first story in which a seizure is depicted, but the line work is muddied and grey, a side effect of the photographic printing technique in use at the time, which gives the strip more of a dream-like quality than was likely intended. In the follow-up, the character reminisces on her imagined future in the desert with Baxter, while cooking him up for a dinner party she's throwing for several of her more renowned fictional pals: Monkey the cat, Robert the Elevator Operator, and a mechanical ant named Andy who never participated in much of a narrative, but is featured on the cover of *Dirty Plotte* #11. (He is discussed more in chapter five). The mood of the strip is bittersweet. These are dead comic-book characters, appearing in what was to be the

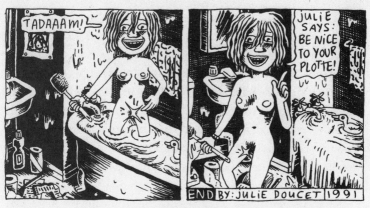

From "Clean Up Time!," *Dirty Plotte* #3 (1993?????).

final issue of *Dirty Plotte*, an inverse last supper in which "the creator" will be the only one to get out alive.

Doucet, and Julie-the-character, are both at their very best in the two-page "Clean Up Time!" from 1991. In it, Julie-the-character wades through the piles of discarded beer bottles, playing cards, open jars of jam, and a baby doll (?) with a knife through it (?) in her apartment, trying to find something to wash. She eventually settles on her own snatch. The comedic timing of the strip is central to its success. One panel outlines the plot (there is limited time available to clean something). Three panels present the problem to be overcome (nothing Julie can find seems to fit the bill; notably, the problem is not that she cannot find anything to clean). The final eight panels, or three-quarters of the strip, have Julie-the-character running a tub while waxing philosophical on the importance of vaginal self-care. (Some might note that Julie-the-character does not actually wax as a part of her hygiene routine; it's safe to assume that if she did I wouldn't be writing this book.)

First published in *Dirty Plotte* #4, I love this strip *so hard* I can barely write anything coherent about it. From the background clutter to the irreducible message (hoo-haw is "the only important thing to wash every day!"), the full scope of priorities of Doucet's Imagined Self are laid bare. Actually bare. For six panels Julie-the-character, uneviscerated, is buck-naked. Pleasuring herself. Mostly intellectually. This isn't sexually thrilling to me (although I am a fan of the poontang in general); I like it because it's silly as shit and smart goddamn comics. Doucet has created a world where you can and must choose between dishes, laundry, and rubbing your own cooter with suds. The last is obviously the way to go, in terms of personal fulfillment, and if her heterosexual cismale readers are enticed to watch and even cheer her on as she engages in a ritual of self-care, so be it.

BLOODLETTING

"The period stuff," is how Doucet refers to the strips that map an idealized environment where she, a ciswoman, is not made to feel othered, and in which menstruation and reproductive capacity and choice are unhidden, the oft-secret rituals of femininity very highly publicized.

Some strips that fit into this loose category aren't even about menstruation (although many, thankfully, are) but about concerns in the general category of "women's issues." These include "The First Time I Shaved My Legs…" from 1988, printed in *Wimmin's Comix* in 1989. In the page-long strip, Julie shaves her legs and discovers some jungle women living in her leg hair that she has unknowingly murdered. Why would anyone shave ever again after committing such an atrocity? It is unthinkable.

She doesn't. "HALT the GENOCIDES," is the strip's textual send-off. "Few artists or writers deal with the hassles and ironies of being female in such novel and bittersweet ways," Joy Press writes of the piece in the *Village Voice* in 2001.

Other strips relate more to the body's reproductive capacity than its material excess. "Julie in the Ocean" from 1988, first appeared in the minis and is similarly fantastical. A gaggle of mermaids bring Julie to an underwater abortion clinic. Here Doucet's Imagined Self is surrounded by women, an event that will remain rare in her work for two decades. It's still and quiet, an environment free from the harassment and violence of the above-ground world, symbolized by a gaggle of signs in the final panel that simply say, "pro-choice." "Down with pro-life," reads the accompanying text, one of a handful of red-meat political statements Doucet ever makes in *Dirty Plotte*. (We discuss an unpublished piece on the Quebecoise secessionist movement in our interview.) Recall that American abortion clinics were heavy targets of violence until about that year, when clinics in over half the states in the US were hit with arson or bombings. Deep under the ocean, however, Doucet—and her half-fish girlfriends—remain safe from such concerns in this early strip, a rare attempt for Doucet to reconstruct the world under a staunchly and identifiable feminist politic. (That the realm she envisions is so difficult for her to access might explain why she does not bring her readers there more often.)

"Heavy Flow" from *Weirdo* #26 explores feminine materiality with a slightly more vindictive tone. Cast in Doucet's early linework and lettering with a strong narrative arc, the now-infamous four-page strip depicts Julie-the-character on the most virulent day of her menses, frustrated to discover that she has run out of beloved Tampax. Fans will know

already that this a disaster none shall survive, as Julie grows monstrous and stampedes the town, Attack of the Fifty Foot Woman-style, gushing red from her gash onto everything in sight. The rampage ends when she receives a box of the menstrual product, whereupon she shrinks, and everything becomes fine. Julie's rage at the world for failing to respond to her natural bodily function is now under control: the blood stops flowing.

There is a tendency to consider these strips, and the previously discussed menstrual-adjacent content—"The Best Time I've Ever Had on Acid," "Levitation" or "One Morning," and "Charming Periods"—as typical late 1980s and early 1990s transgressive art. Indeed, that period of art and media-making was much more concerned with physical affect, materiality, humor, and the potential of the denouement than our current era seems to be, but the description isn't satisfactory.

Doucet's works sits awkwardly alongside other works from the late 1980s and early 1990s. *Wanton Carruba* from March 1989 is one telling example. The self-published minicomic from Aardvark Farms in Upstate New York features a devil drinking wine on the cover while two bare-breasted ladies and a skeleton tend to his needs. The interior offers more of the same: a reverend masturbating over a woman in fishnets; geckos fucking; complaints about the homeless and the Chinese; a doctored-up *Peanuts* strip where Linus rapes Lucy; and loads of swears, erect penises, and tidy piles of feces. "Heavy Flow," certainly included for its necessary gore, is a weird oasis depicting feminine desire. (The three Kirk and Spock strips are also included, discussed in the next chapter.)

Renee French describes that period in comics history in a 2012 interview with Mike Daws on the *TCJ Talkies* podcast,

expressing relief that Mike hasn't read her earliest work, *Grit Bath*. "You're just too innocent for that," she says of the three-issue series, published by Fantagraphics Books from July 1993 to August 1994. (It is brilliant.) "The subject matter," she explains, "it's filthy… There was this story, 'Silktown,' and in one episode there was a raccoon biting a guy's face off, then that guy biting a woman's nipple off, spitting it in the sink. That kind of stuff. A lot of gory sex stuff."

Times have changed, French goes on, and comics are less experimental now:

> There was a lot of underground, alternative… there were a lot of people doing comics… that had that tone. That kind of sex, underground, tone. Terry LaBan had a comic then. I don't know why I said him. There were a lot of people who were doing alt-comics: *Tits 'n' Clits*. Mary Fleener. That stuff. It doesn't happen now as much. … A couple people do [it], but it doesn't have that raw, rough, achy style anymore.

That "alt-comics" was a descriptive term for a post-punk, post-underground comics visual style that included as referents graphic sex (multiple partners, anal, or featuring housepets: all OK), physical mutilation, drug use, incest, and inflammatory political epithets speaks volumes. Transgression was a cultural mode that deliberately aimed to cross boundaries established by corporate or mainstream cultural production, an attempt to lay a groundwork for social interactions unrecognizable to the elder generation's *Leave-it-to-Beaver* mindset. Inspired by the punk-influenced Cinema of Transgression, a 1985 term

coined by filmmaker Nick Zedd to describe a group of New York filmmakers heavily reliant on dark humor and shocking images, mid-to-late 1980s transgression developed a vocabulary through the work of John Waters, Lydia Lunch, Richard Kern, and Kembra Pfahler (who would later bring similar sensibilities to her band, The Voluptuous Horror of Karen Black). In music and live performance, GG Allin was attacking audience members and eating feces in an attempt to make rock music "arousing" again. In the world of self-publishing and performance, Lisa "Suckdog" Carver was explicitly describing sex work and drug use. She used her fanzine *Rollerderby* to share early interviews with Zedd and Allin—not to mention comics creator/zinester/performer Queen Itchie (also publishing as Jennifer Nixon), performance artist Vaginal Davis, and comics creator/performer Dame Darcy.

From "Le Strip Tease du Lecteur,"
Dirty Plotte #3 (1992).

French theorists and writers like Georges Bataille, Michel Foucault, Jean Genet, and the Marquis de Sade had been thinking through the literary and social impact of transgressive behaviors for some time, and the American William S. Burroughs held near cult-leader status for exploring similar topics Stateside, where writer Kathy Acker

and visual artist Carolee Schneeman were exploring the transgression of boundaries sited somewhat differently. The most renowned transgressive figures were often masculine players, who seemed intent to tear down a world created by other men. It was a scene visually dominated by Allin, covered in blood, eating shit on stage, in front of an audience who paid to watch him do it and suffered occasional physical attack for their devotion. It is what a man looks like while reveling in his own cultural, economic, physical, and political dominance.

Transgressive art was arguably a leftist movement, theoretically aligned with freedom of expression and libertarian demands to keep the state out of the bedroom. Unless, of course, you talked to the women involved, who often expressed private concerns that demands often turned physical, and that the freedom called for was not always made available to them. The boundaries for women to transgress, therefore, were more plentiful, including at times just standing at the front of the venue at a show, or demanding to get paid for your transgressive cultural work. Acker's plagiarism of literary heroes, or Schneeman pulling a scroll from her vaginal canal and reading it aloud to an audience are thus more complex than the sticking-it-to-normies projects that captured the bulk of the media attention. They were opening up space for cultural production previously claimed only by men, in addition to widening the generative possibilities for content, material, and form. Even Dame Darcy, who created entire weird worlds in her earliest comics, was doing groundbreaking cultural work by demanding imaginary space.

It was common, in the late 1980s and early 1990s, to trade in transgressive imagery, but Doucet's intentions in

violating the corporal form seem to lie elsewhere. Consider again "Le Strip Tease du Lecteur," for example, the closest Doucet comes to Allin. In the strip in which she attacks her audience member, she seeks verbal consent from Steve, the reader, before she draws a violent act being committed against him, following the implied consent granted when she asked readers to submit photographs to the project. The violence she draws is extensive, but Steve remains a participant, with a name, throughout. Julie-the-character even hangs his head on a chair so he can watch her perform her mutilations. All of it, too, is built on a joke that is not only about traditional feminine roles in culture (a woman is coyly stripping, although skin, and from a man, instead of removing her own clothes) but also about the artform (it is a comic strip).

More helpful than mere transgression to understanding Doucet's work—particularly "the period stuff"—might be Bulgarian-French philosopher Julia Kristeva's notion of the abject. "The abject is not an ob-ject facing me which I name or imagine," Kristeva writes, and one can almost see the words in Doucet's lettering, against a backdrop of litter on a busy urban street:

> Nor is it an ob-jest, an otherness ceaselessly fleeing in a systematic quest of desire. What is abject is not my correlative, which, providing me with someone or something else as support, would allow me to be more or less detached and autonomous. The abject has only one quality of the object—that of being opposed to I. ...from its place of banishment, the abject does not cease challenging its master... It is thus not lack of cleanliness or health that causes

abjection but what disturbs identity, system, order. What does not respect borders, positions, rules. The in-between, the ambiguous, the composite.

Miller and Pratt explain that abjection is evident in Doucet's work, dividing a fully constituted subject from a partially constituted subject, the latter separated, "othered," delineated from the self but always available. "The boundary between self and non-self is comprehensively transgressed by Julie through her exuberant portrayal of bodily fluids and wastes," they write:

> She runs out of Tampax and her menstrual blood floods the whole city. Her cat dances to music and its movements accidentally entrap it in a cat's cradle made of her snot… [S]he enjoys a convivial meal with friends (all of whom are in fact wild animals rather than people). What they are eating is the dead body of Christ, laid out on a serving plate in the middle of the table. This is not the only occasion on which Julie eats human flesh. When, in a romantic gesture, Julie's boyfriend cuts off his penis and offers it to her, her immediate reaction is to eat it, although she is struck by a mild misgiving as to whether it will grow again.

Abjection in comics is evident in the work of artists like Aline Kominsky-Crumb, Esther Pearl Watson, and Lauren Weinstein. These artists employ the abject as a stylistic endeavor— there's a shaky line quality common to all three—as well as a consideration when choosing subjects and storylines. (Watson has even admitted to poring over certain popular independent

how-to-draw-comics guides and deliberately violating every listed precept.) Doucet, however, seems to have more in common with artists like Dorothy Iannone and Dori Seda, whose more traditional artistic styles belied an exploration of the abject that is comprehensive, reflected not only in the work but in the career that upheld it.

Iannone, a painter, turned to comics somewhat by accident, when she began writing and drawing the story of the sudden dissolution of her marriage and her relationship with Swiss artist Dieter Roth. These relationships and the sexual liberation she finds with Roth are detailed in *Seek the Extremes*, a catalogue put out by Kunsthalle Wien. The work, a series of decorative, naïve drawings with text, was originally included in the 1969 Kunsthalle Berlin exhibition *Austellung der Freunde*, until the museum made moves to censor the genitalia drawn in glorious and decorated detail. She pulled the drawings in protest. Roth pulled his work, too. Even the curator quit. The story of a woman's work crossing so many boundaries that it barely sees the light of day is a form of extreme transgression that we rarely hear about. (Iannone's work was finally exhibited stateside at the New Museum in 2009). That this story is rarely folded into a history of comics—despite that it is a hand-drawn sequential narrative in text and image—marks it as one that transgressed a few too many boundaries to even be considered transgressive.

Then there's Dori Seda, whose brilliant, hilarious, obsessive, and realistically portrayed semiautobiographical tales of her Bay Area shenanigans included a cast of characters just as bananas as Doucet's. Seda operated safely within the bounds of comics—she too was published in *Weirdo* and *Wimmen's Comix*, although earlier in the 1980s, and associated with

and eventually published by Last Gasp—and thus her studies of the abject took place mostly in the realm of content: Seda's Imagined Self, as depicted in Seda's oeuvre, liked to fuck her dog.

Seda's career was cut short by her death at 37 in 1988; the essential Last Gasp collection *Dori Stories* houses her complete works. Seda's ouevre has much in common with Doucet's, although the former is more overtly inspired by Robert Crumb in style, tone, and subject matter. It's also notable that her narratives focus on a place, the Mission District of San Francisco. Doucet instead displays the constant need to explore *places*, to cross boundaries of taste, genre, and geography.

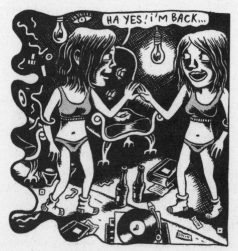

From "The Double," *Dirty Plotte* #6 (1993).

THE DREAMED SELF

A few weeks later, I went back to Doucet's house, and she'd moved
all the furniture around. It looked really bad. She'd stacked all
the couches on top of each other, I couldn't discern a reason—
and she had more couches than I remember, like seven. She'd
also gotten rid of all the books and wasn't at home, although I
had confirmed the meeting in advance. Her cat greeted me, and
explained that Julie would be back soon, but said that in the
meantime I could wait in the sauna if I wished. Of course I did.
It was an incredible sauna, had to be at least three football fields
long, but narrow, and entirely obscured by steam. So you could
walk down a long skinny room filled with heat, and you could
just keep walking, seemingly forever. Unfortunately it was
finished in a light-colored tile, more a North American sauna
than a Finnish sauna, and that made me deeply sad. Melissa
showed up with some dairy-free ice cream and we chatted gaily
about murderers, but it was very stressful because we had to eat
the ice cream so quickly.

What I like about dreams, and the conditions under which we share them, is how quickly they reveal, and deepen, intimacies. They can spur an old love to contact after years of silence or entirely change the way you view someone you hardly know. They uncover priorities and anxieties and desires, however temporary, all due to the brain's constant need to create narrative out of images culled from a body at rest.

For many, Doucet's dream comics are her most significant contributions to the form. The excitement this work generated around new storytelling possibilities in the mid-1990s, however, and the collection of many of these strips into the volume *My Most Secret Desire*, lend an inaccurate sense of their collective physical weight, as slightly less than a fifth of Doucet's strips can be considered dream comics.

What is remarkable about this work is that the dream strips exist in a lawless, but mostly friendly land, a place tangential to—or, say, the vacation spot for—Doucet's Imagined Self. It's not, clearly, consensus reality, Jim Woodring's term for the waking world (with its mild implication that we all might be rubes for pretending that anything ever actually gets done there). The term, used more commonly in media theory and sociology, neatly places responsibility for the sanctioning of an event as real on the humans who agree to it, making reality a contract, a relationship. (My editor points out correctly that in the age of "fake news," it also feels like a luxury to have more than one person agree that anything in particular has taken place.) Woodring's work, which explores a terrain unique to Woodring's mind, has little stake in consensus reality; Doucet's dream comics, on the other hand, seek to bring her subconscious experiences into the realm of agreed-upon truth. Rarely are her dream strips introduced as dreams; they

are stylistically undifferentiated from her other work. The dream strips do tend to stand out as joyful and silly, although somehow less significant than the more overt fantasy strips. Events have few to no consequences; the artist's subconscious mind is offered free reign to reimagine and/or react to the world as it could or should be. Doucet's dream comics often meld into her autobiographical work, as well as her fiction, and, even in moments of duress, offer readers a deeply intimate experience.

Like the time Julie died. We witness it in "Julie the Tough Guy is Dying!" from *Purity Plotte* (*Dirty Plotte* #10) published in 1996. (Appropriately, the strip also closes out *My Most Secret Desire*.) A black and white two-pager in her most polished lettering and drawing style, Julie-the-character—here a gunslinger—is caught in an old-timey saloon shoot-out. After consulting with fellow cowboy Joe behind a table, our tough guy catches a bullet in the chest from an unseen shooter at the top of a rickety wooden staircase. The character Julie is a man, although no drama accompanies the gender reveal, as readers at this point have conceded that gender is a construct (in large part because the artist's gender is never called into question). The strip is also set in an imagined realm that is distinctly American. The ambivalence embedded in the character and setting are less important, however, than the ambivalence that unfolds in the plot. As cowboy Julie dies—an action that takes nearly a full page—his panic and fear eventually give way to a state of euphoria. His grin and single bead of sweat are downright beatific; I'm not sure we see Julie-the-character in such a state of bliss again until she's brought to climax by an elephant and eight guys in the strip that ends the floppies.

Beginning in high tension and ending in serenity, the about-face takes a remarkably short two pages of newsprint. Still, what

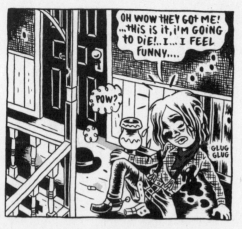

From "Julie the Tough Guy is Dying!"
Dirty Plotte #2 (1990).

is most noticeable is also what's missing. Standard wavy panel borders do not set off an ethereal state. No introduction to how we are to interpret this strip is provided, besides a small narration box at the base of the opening panel pointing to gunslingin' Julie that states, "that guy it's me." The character is glimpsed from the back as only a black hat and, under it, a shock of messy blonde hair before we are dropped into the thick of the shootout: *Pow! Cling! Pow pow!* bursts of white air in the chaos of broken bottles explain. Only at the conclusion of the strip, under the bottom right-hand signature line in the very final panel, does an explanation appear, unnecessary by then: the artist's initials (J.D.), year of completion (1995), page number of strip (2). Then the text: "Story based on a dream. Long time dreamt."

By this concluding panel, readers have already consumed—and relished—a beguiling if drastically revisionist version of the cowboy trope. There was no going back. Those as enchanted by the adventure, horses, and guns of the Wild West as I was as a girl, turned off though we may have been by the elaborate dresses women had to get around in, were already hooked; whether a dream or a fiction or an accurate rendering of history, we needed to see it. I needed to see it. Its validity was

not tied to truth, but justice; neither did the artist seem to think its demarcation as fact or fiction would matter much. "Julie the Tough Guy is Dying!" violates every boundary, including history and life and consensus reality, to craft an adventure that isn't denied certain readers on the basis of gender.

In the larger context of Doucet's work, dreams serve a secondary function for the reader beyond entertainment: these strips fit loosely into a constructed biography that fuels heterosexual cismale reader interest in her work. (This is why the oft-heard charge that she "made stuff up" in her dream strips is supposed to sting.) To the degree that certain readers want Julie Doucet at her most genuine—her authentic, Actual Self—they want that self to *be* her Imagined Self. This interloper, her Dreamed Self, is thought to be an imperfect version of that idealized character, a slightly less reliable manifestation of genuinely felt desires and fears. The dream comics therefore get read as semi-memoir in Doucet's oeuvre—or dreamoir, to borrow a term from the writer Wendy C. Ortiz. They add to and enliven the artist's biography despite that, in truth, we could just as easily classify them as fiction. (Of *course*, in other words, she "made stuff up," and you'd have to be pretty invested in feminine subjugation to suggest that for a woman artist to do so was somehow not the entirety of her job.)

Dream comics enthusiasts often draw a hard line between dream transcriptions and fiction, which is why many brief histories of the form leave out Winsor McCay's *Little Nemo in Slumberland*. The full-color Sunday newspaper strip that ran for over two decades beginning in 1905 was wildly inventive

and a very early innovation of the comics form. McCay's strip used the dream structure to create a single full-page story every week that ended with Nemo's awakening after some grand adventure or another, none of which needed to cohere, narratively, to the previous strip in the series. The genius of the Nemo strips (for they changed names over the years) was that, ostensibly, the same events occurred in consensus reality in every installment: an adolescent boy went to sleep for a few panels, and the strip ended when he awoke. The established introduction and conclusion never changed too drastically, leaving between them the perfect experimentation field. Many view McCay's dream explorations as anathema to a genre supposedly rooted in an author's remembered dreams.

In the early 1950s, Jack Kirby's "The Strange World of Your Dreams" took the cultural phenomenon of dreaming as subject matter. The title featured tales in which dreams figure strongly, often as premonitions, and handy (if brightly colored) guides to dream interpretation of the type that more frequently appears in books decorated with unicorns and butterflies. More recently, dream comics have been thought of as dream transcriptions, and there are quite a few examples. Jim Woodring drew dream comics for a time before developing his Unifactor/Frank-verse for the waking world, published (by himself or with Fantagraphics Books) starting in the mid-1980s. The establishment of his fantasy world meant his more straightforward dream comics ended. One senses that both come from the same terrain in the creator's mind, however—one where he seems, at least occasionally, to have "made stuff up," although I have come across no instances where this was considered a problem.

Slightly later, Rick Veitch's *Rare Bit Fiends*, a pamphlet series launched in 1994, then revived in 2017, presented the nocturnal

meanderings of the former Marvel and DC artist and paid tribute to the scourge of Little Nemo's nightlife, a surplus of Welsh rarebit before bed. Also in the mid-1990s, Jesse Reklaw's *Slow Wave* appeared, a syndicated alternative strip that ran in various forms until 2012. Former L'Association member David B.'s *Nocturnal Conspiracies* was published in 2008, a follow-up to the French artist's autobiographical graphic memoir *Epileptic*. In these same 15 or so years, Aleksander Zograf, Ariel Schrag, Adrian Tomine, David Heatley, Neil Gaiman, Mary Fleener, and Chester Brown all offered occasional (or copious) dream strips: visual, textual, and narrative representations of what our subconscious might offer the waking world.

The varied approaches to comics that derive from dreams are an indication that the delineation between fictional and accurately transcribed dreams may not be so easy to make in the first place. After all, who among us has never "steered" a dream, half asleep? Are those to be discounted as fictionalized dreams, since the conscious mind has emerged? In "The Double" from 1992, first published in *Dirty Plotte* #6, Doucet draws herself waking up mid-dream before willing herself back to sleep and then guiding the dream's plot. To distinguish between a made-up dream and a transcribed one denies that the artist, in committing their own dreams to paper under their own hand—no fact-checking possible, even if comics allowed for the journalistic tradition—may inaccurately remember, or more egregious, may inaccurately depict a dreamed sequence.

What we can say with certainty is that the conscious mind seeks always to make sense; it is humanity's greatest flaw and kindness. Crime scenes go misremembered because a bizarre detail didn't conform to events as recalled; even the supposedly truest possible dream recoder, the dream journal (in which one jots the

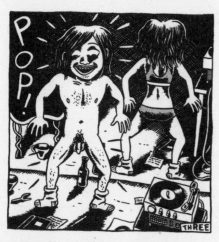

From "The Double," *Dirty Plotte* #6, (1993).

primary events of the subconscious mind's projection immediately upon waking) has no failsafe. I can't name a nocturnal cataloguer of my acquaintance who can decipher every single word scrawled in dream journals by the light of day. Presumptions are made based on context, in the rereading and in the retelling. Are the dream transcriptions that result somehow less accurate, less authentic, or perhaps even less interesting because we acknowledge that they do not precisely reflect the dreamer's true subconscious? And who could or would bother to judge that?

After all, even the means by which we believe we dream has changed over time. Prior to the Enlightenment, nocturnal imaginaries were considered messages sent straight from the divine, unfiltered by the dreamer who received them. The Age of Reason imposed a new order on the acquisition of knowledge, however, that didn't allow deific meddling in human affairs. In Western cultures, dreams then became tethered to their dreamers. Shakespeare's *Macbeth* set a literary standard for the significance of dreams: suddenly they offered insight into the haver's horrible psyche, but still retained the capacity to *foretell*. Freud rose to popularity largely because he offered a new way to think about dreaming, as clues to an individual's unexpressed or even inexpressible desires—the more salacious, he suggested, the more likely.

Our understanding of dreams may be about to change again. Current scientific inquiry into human behavior—and how much of it, which is *most,* is actually dictated not by unconscious desire, or intellect, or god, but by the activity of single-celled organisms—seems likely to shift how we think about dreams once again. Already we are learning that how food tastes, what smells appeal to us, and who we are physically attracted to are all determined by these little microbial buggers. The plots our nighttime minds devise cannot be far behind.

This all makes any adherence to dream "veracity" seem a bit beside the point, particularly in relationship to Doucet, who was doing dream comics earlier and more consistently then many of her peers. That the arbitrary rules that seek to outline the loose boundaries of any given form can become less arbitrary for certain players, who are then held to a strict standard against which they invariably fail, is a story exactly as old as Adam & Eve, who were given absolute free reign in the garden until Eve got snacky. If we factor in reader desire to know the artist herself, not as a creative figure, but as a person, we can begin to perceive what was felt to be at stake. For only if we place stock in the Freudian notion that the subconscious is revelatory, and if we also feel invested in the outcome of those revelations, which are more likely than not sexual, does it matter whether or not one's "dreams" are "true." It will be clear to you by now that I don't care. Doucet's dream comics contain a logic uniquely their own—likely reflective of both the collective unconscious and her own subconscious, and perhaps, to boot, a little bit invented, since that is the nature of both memory and art.

Formally, strips like "Julie the Tough Guy is Dying!" are reminiscent of the dream stories of writer Lydia Davis. In 2014's

can't and won't (stories), dreams, fiction, tales from Flaubert recast in Davis's tongue, and what seem to be particularly well-crafted notes to self all intermingle, differentiated only by a single italicized line, either preceding or following each (very) short story to describe its origins.

"We are in a clearing at night," one tale begins. "Along one side, four Egyptian goddesses of immense size are positioned in profile." The story proceeds for another six or so lines before concluding in a vaguely unsettling manner. It is marked, as are similar tales, as a "dream" only at the conclusion of the paragraph. The events described are unusual to a greater or smaller degree, depending on the story; Davis is a writer of concision and thoughtfulness, not elaboration. We are told no more than what we must be told, and in this her work is also reminiscent of Doucet's: stark details, while far from minimalist, establish a scene concisely. The checked wallpaper above the stairway on which Julie the gunslinger meets her demise, for example, is not elaborately detailed but perfunctory. The blacks are black, the whites are white, this story does not need to be any longer than two pages, regardless of subject matter. It's just a gunslinger's death.

Yet Davis's dream stories, both on the page and in the act of creation, reflect the author's experience, emotional state, or desire hardly at all. This is not because Davis does not wish to be forthcoming, for when she does express her innermost self, she does so as cleanly and thoroughly as she does everything else. I mean to point out that Davis's dream stories are not always derived from Davis's dreams. "Certain pieces which I am calling 'dreams' were composed from actual night dreams and dreamlike waking experiences of my own; and the dreams, waking experiences, and letters of family and friends," she

acknowledges in the Picador edition of *can't and won't*. I found this jarring. I had sunk so deeply into Davis's thought process by the end of the book that it had never occurred to me that the source material would not consistently have been her own mind. Yet it is what concision allows for: a writer to present a dream without clarifying that it may not have been *her* dream.

Doucet might prefer an ambiguity positioned somewhat differently; she wants to present her reality without clarifying that it may have been dreamed. However much she may or may not be fictionalizing her autobiography or her dreams—a question I have never considered asking because I do not care about the answer—we are given to understand that what Julie-the-artist puts on paper more or less derives from her own experience. Later in the *Dirty Plotte* comic book series, though, Doucet does invite others in to her venue, through collaboration or by turning over full pages of the book to their work. Unlike Davis, she grants credit immediately when others are involved. (She even credits Steve, whom she murders.)

This is to say that Doucet's dream comics are read, always, as Doucet's dreams. Part of their value lies in the intimacy they extend from creator to reader.

Standard dream fodder appears in Doucet's work, expanding our understanding of the artist's interior life and offering her the opportunity to explore new worlds without the pressures of fiction. Of course there is a back-in-school dream, wherein Julie-the-character is seated at a desk growing frustrated by her lessons. When she finally remembers she's "a professional cartoonist, goddammit!!!," she evacuates. (The flash of ego is

rare in Doucet's work, as is its treatment. The four-page, full-color strip—one of only a few, and thoughtfully done—first appears in *My Most Secret Desire* in 1995.)

There are also generalized anxiety dreams: about a day job (her last); about the stress of trying to find a bra that fits (which we know is a dream because Julie-the-character informs us she does not wear bras); about scary occurrences happening in her own home (like the sudden appearance of guillotines everywhere); about maternity (although usually Julie-the-character is giving birth to cats). These are differentiable from her other comics by their sudden moments of brutality, clarifying the dreams described as, if nothing else, authentic-feeling representations of Doucet's fears. They also strike me as remarkably familiar. In my own dreams, I never chastely drown, or fall off a cliff to my death. I am chopped in half by a previously unnoticed machete, and conscious for long enough that I can ponder my fate as I watch blood gush for a bit.

In "Poor me!," dreamt in 1989, drawn and published in 1993 (first in *Dirty Plotte* #7), Julie-the-character dreams about a demanding copy-shop job and her nightmare customers who show up as disembodied heads in the Montreal roadway. She smashes them in her dream, in a rage, then explains to the reader that she eventually quit that job. The art is clean, although panels are cluttered with heads that bleed through indistinct borders—an infrequent concession to what would later become more standard dream comics convention.

In "The Recurring Dream" from 1995 (published in *My Most Secret Desire*), Julie dreams about becoming pregnant with cats, or with humans that have or grow cat features. The first title panel of the six-and-a-half-page strip is offset by the abstract

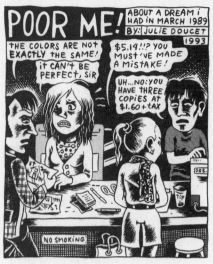

From "Poor Me," Dirty Plotte #7 (1993).

designs that would later become central to *365 Days* and the artists' books. The panels are numbered awkwardly and wavy panel borders are again used, but this time only to indicate a dream within a dream.

Another anxiety-ridden three-pager, "So Why I Had That Stupid Dream?!" starts in the late 1970s waking world with Julie's mom, who is trying to convince 14-year-old Julie to purchase a bra. It is an idea teen Julie soundly rejects in the second panel, explaining in the present-day third panel that her breasts are "small and round," for which she is (of course) catcalled in the fourth panel. The fifth panel begins several years later, in a dream about trying to find the right bra.

It doesn't take any psychoanalytic training whatsoever to tell you that this is a stress dream about conforming to traditional and impossible beauty standards, typical to women who work and hang out mostly with men, although (as indicated by the presence of Julie's mom) often policed by women. (I have had 8,000 of these dreams.) This message may have been lost in original publication, however. The strip first appeared in *Rip Off Comix* #28 in 1990, a special dream comics issue that included work by Ed Brubaker, Richard Sala, Steve Lafler, Sharon Rudahl, R. L. Crabb, Mary Fleener, and all three

Hernandez Brothers. With few other women's voices providing context, the strip's subtle charge that cookie-cutter feminism wasn't properly supporting Doucet's healthy self-image may have been interpreted more bluntly as a hot girl talking about her boobs. This, too, is predicted by Doucet; Julie can't buy a bra, in the end, because a nuclear holocaust has liquefied the town, and her waking confusion over the events is met by a man, already in her bed, leering at her. No individual actor is charged with oppressing women, note. Doucet's subject here is how a generalized misogyny impedes her public life (via the catcaller), her healthy self-image (via the ostensible requirement to procure a gendered item of clothing), and her personal relationships (via the man in her bed).

That nuanced work would suffer from a lack of contextualization was precisely the problem Diane Noomin was seeking to address by putting out the groundbreaking *Twisted Sisters* anthologies with Penguin. These collections went a step beyond other gender-exclusive projects by relying on high-caliber contributors and solid production values. "So Why I Had That Stupid Dream?!" is included in the first volume from 1991, although that environment didn't do justice to Doucet's work either. Julie-the-artist staunchly rejected all the trappings of femininity offered protection in such spaces. The babies, the boyfriends, the baubles: Doucet's work didn't address any of that, and worked best when left alone.

"So Why I Had That Stupid Dream?!" would only find appropriate context in *My Most Secret Desire*. The linework was very quickly becoming her mature style, and hints of her later masterful lettering are beginning to appear. Perhaps because original publication was outside of her own series, and due to the diegetic inclusion of Julie-the-character transitioning from

a waking state to a dream state, fluted panel borders are used to distinguish sleeping from waking life. ("dREAMT," which follows it in the 1995 collection, also depicts both consensus and uniquely experienced nighttime realities, but uses straight, hard-edged panel borders throughout.)

The early stress dream-inspired strip, "At Night Coming Home," was drawn in 1989 for the minis. Expressive as heck, Doucet uses no formal approach to lettering, and the story dawdles on the macabre in a manner characteristic of the early fiction that Doucet will soon abandon. Julie-the-character comes home to her cat but realizes too late that there are suddenly guillotines everywhere. They chop up the cat and then catch Julie, even as she attempts to escape by jumping out of the window and falling, perhaps to her death. Since cats are the closest Julie-the-character ever gets to maternity, we are to read this as a real loss, and the unusual black background to the three-pager grounds the retelling in an unusual darkness. Sound effects, too, underscore the unusually nightmarish narrative: the mewling of her bifurcated cat Charlie, who bleeds to death in her hands; the SSSCHLACK!! of the blade as it claims another victim; the persistent ring of the telephone, a distraction; and the VLANG as the window closes on our heroine, mimicking— or has it turned into?—another guillotine.

A far happier dream features Julie-the-artist's mom in her most famous appearance, 1991's "Oh La La What a Strange Dream" (*Dirty Plotte* #3). In the five-page strip opener, Julie-the-character is boarding a spacecraft, her home for the next three years. Rushing to say goodbye, Julie's surprisingly fancy mother gifts her daughter a box of cookies—"for masturbation purposes," she explains. Julie nibbles one later, then masturbates with another, finally waking up and looking sheepishly at the reader. In addition

to the goofiness of the tale and the ineffable image of a woman, free of Earth entirely, getting herself off with some snacks, this strip is notable for its semi-realistic depiction of a space shuttle launching pad. (Doucet further explores space in a couple unpublished strips from the same time period, both of which concern the imagined effect of weightlessness on menstruation.)

The dream comics offer a catalogue of anxieties focused on men, femininity, and maternity. (That Doucet professes in interviews not to have gotten along with her mother as a girl complicates somewhat the image the reader may have of the woman as a kind-hearted masturbatory enthusiast.) Yet more basic human concerns around trust and its loss are also frequent themes—particularly in Julie-the-character's interactions with men, whether famous, of her personal acquaintance, or wholly invented. "Do You Trust Me?" from *Purity Plotte* (*Dirty Plotte* #10) is a cleverly unpolished six-page story in which the musician Nick Cave chooses Julie out of the crowd at a concert and selects a schlubby man in attendance for her life partner. In

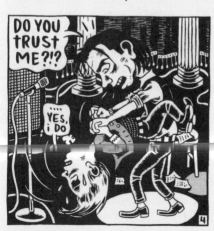

From "Do You Trust Me," *Dirty Plotte* #10 (1996).

a five-panel concluding section set in Julie-the-character's waking life, Julie interprets the dream from her messy studio as a warning to never trust anyone.

"The Syringe" from *Dirty Plotte* #2 is a black-and-white, four-page strip. Dreamt in 1989, drawn in 1990, and published in 1991,

the strip depicts Julie, in a skirt (the feminine apparel marking the experience as not real) going to her one-and-only job at the copy shop. She meets a former coworker along the way, who stabs her in the eyeball with a syringe, then gets super high before realizing she is having a dream. "The Jack Knife" (*Dirty Plotte* #6)—dreamt in 1992, first published in 1993—explores

From "The Syringe," Dirty Plotte #2 (1990).

similar terrain. Julie sees a crazed man being led away by hospital attendants. The man breaks free to present her with the gift of an open jackknife, which he then closes on her fingers, slicing them off in the final panel of the black-and-white two-pager. "The Offering" (*Dirty Plotte* #4) images an opposing reason to question the trust placed in men; in this dream, Julie and a male friend (presumably former pen pal and future boyfriend Mike, although the character remains unnamed) meet up in New York. He also presents Julie with a gift, although in this case it is his penis, which he has cut off and handed to her. She eats a bite of it before becoming concerned that it might not grow back, then sheepishly returns what is left of the organ to her friend. The question of trust here concerns her own behavior. Might she not act impetuously with men and come to regrets? "The Fever" (*My Most Secret Desire,* 1995) is a 12-page story wherein Julie-the-man goes to the hospital with a fever and the doctor takes him to her lakefront home for a rest. There, weird worms

start popping out of his skin and make a mess in the house before turning into flies. It's a looping narrative, mostly gross, a fulfillment of the promise first laid out in the booger-eating cats story "At Night When I Go to Bed," and entirely expected from someone who read Lautremont as a young woman.

The strips about untrustworthy men, or mistrusting one's own reactions to men, build a cohesive picture—one that, if nothing else, begins to point to the need for pieces like "Le Strip Tease du Lecteur." The kneejerk Freudian tendency to analyze dream strips about men in terms of Julie's relationship with her father (who does not appear as a character in her work until *365 Days*), and thus in terms of her relationships with all men (difficult, in her own depiction), or in terms of her mother and other women, is strong. (One male reviewer at comixjoint.com, writing on "Why I Had That Stupid Dream?" in *Rip Off Comix*, gives in, complaining that her disinterest in brassieres is clearly due to "mother issues" and failing to note the catcalling or the leering of the man in her bed, both of which seem more plausible explanations for why Julie-the-character, if not Doucet herself, might appear disinterested in conforming to the social construction of femininity.) Yet psychoanalysis is primarily useful if we are interested in the artist herself, as opposed to her creations. (I am not.) What I suggest we consider instead are the breadth of things Doucet may have had anxiety about in the late 1980s and early 1990s: personal finances, unhealthy or unsatisfying relationships, lack of emotional support, a crumbling economy, and a changing world. Plenty, in other words.

Underpinning these seems to be a more fundamental anxiety, which tends to go unmentioned in the critical response to Doucet's oeuvre. Medical and health-care imagery shows up as a

visual theme surprisingly frequently in the dream comics, yet we don't think of Doucet as an artist who addresses the navigation of disease and medicine in the same way we do David B. or Ellen Forney. Yet hospitals appear in "The Jack Knife, "Regret," "The Recurring Dream," and "The Fever." ("The Syringe," after all, is not called "The Knife"—the implement of choice for many a stabbing drug dealer.) And although "Missing" from 1992 takes place in the subway, the long expanse of tiled walkway calls to mind a mid-century medical facility. (Even my own dream of visiting Doucet's house featured ambiguous, neutral colored tile, not unlike the hallways of Presence St. Joseph's Hospital in Chicago, Illinois.) All of this occurs alongside the several scenes throughout Doucet's comics in which Julie-the-character slices herself, or others, open, with or without medical assistance. (Steve the Reader and Andy the Ant both suffer this fate.) Seizures are only described a handful of times in Doucet's oeuvre, but, as I understand the condition, *actual* seizures are not a daily feature, whereas the fear that they might occur is constant—sometimes too consistent to even mention. Same with daily pill regimens, which take up time, sure, and can easily fit into a tearjerking film about a musician with a degenerative condition or a child with cancer, but hardly show up in art otherwise.

There is a unique fear that underscores the day-to-day experience of managing chronic illness, and an unpublished five page strip from 1987, "The Girl Who Was Elsewhere With Whom, Who Doesn't Exist," credited to "Gulie Bloucet" captures it succinctly. Poetic text and an uncharacteristically dark mood follow a depressed woman as she muses on her life. She expresses concern about her illness and becoming mad; she fears "crossing over to the other side," and, most

significantly, of losing "control over my body." Friends with epilepsy express similar fears in daily conversation, for epilepsy, a neurological disorder that causes sensory abnormalities, convulsions, or loss of consciousness, can trigger seizures at any time. Epileptics are encouraged not to operate heavy machinery, travel alone, or carry a pregnancy to term, as the stress of performing these activities could cause a seizure, harming the epileptic and others.

To me, it sounds prohibitive and relentless, yet the clarity with which Doucet depicts these anxieties, big or small, generalized or specific, and the emotional realism these strips explore are remarkable, if too often unacknowledged.

Doucet's dream comics don't display terribly unusual anxieties. They do, however, contribute a distinct allure to Doucet's work. They offer readers an unprecedented degree of night-time intimacy with a particularly beloved creator, one who was frequently sexualized and about whom readers want to *know more*. I believe what made the dream comics so captivating were the clues readers felt they might offer to her autobiography, or the degree to which they function as "dreamoir," the term Wendy C. Ortiz uses to describe the stories collected in her book *Bruja* (Civil Coping Mechanisms, 2016).

"At my mother's house," begins one such story, "monstrous disembodied hands reached through walls. I repeated the 23rd Psalm over and over. Nothing stopped the scaly claws that reached into the bathroom, grabbing at me and the white cat." It is the entirety of Ortiz's story, although other tales fill out details about her mother's house and her own fondness for cats.

Ortiz is a memoirist and psychotherapist based in Los Angeles who, like Doucet, started in self-publishing. Her zine *Freefeeder* was put out in the Pacific Northwest in the 1990s. She's published several memoirs since, but wrote the experimental *Bruja* as a different variety of self-exploration. "Readers will get an idea of Ortiz's life," the literary magazine *fields* explains, going on to assert that her skills as a writer come through the worlds she shows us that are "populated with recurring characters and fraught with danger, emotion, and hidden insights into an everyday life we as readers never see."

Bruja is a fascinating work in which Ortiz sets readers up as intimates, although not friends, and guides us through her subconscious. We are not asked to relate to the exact lived details of the writer's life, which we never learn. We are only offered vague outlines onto which we can project our own real-life lost loves, awkward acquaintances, or here too, mothers who meddle with our sex lives. Over the course of the book, a cast of characters forms, but it is possible that we know as much about them as the author does, for although to her they are figures from her waking life, their dream motivations are equally obscure to all.

Doucet's dream comics, I suggest, function similarly. They employ a set of characters and symbols (her coworkers, her friends, her mother; and cats, men, and medicine) that clearly hold meaning for Julie-the-artist, and remain recognizable and significant to her readers, too. Yet they function most strongly not as pseudohistories of a real-life individual, but as symbols of how well we know the person who shares their doings with us. These stories, as a body of work, tie together her autobiographical work, her fiction tales, and the stories of her Imagined Self—in fact, they seem to situate that Imagined Self

as one with its own preoccupations and desires and abilities to influence the world, granting it an autonomy it's not clear that Julie-the-artist ever feels she achieves.

Formally, Doucet's depictions of dreams were markedly different in style and in tone from her contemporaries. Mary Fleener's "Rock Bottom, pt. 2" in *Life of the Party* (Fantagraphics, 1996), for example, is introduced as a dream, verbally, by the protagonist. It's a sex dream, and the figures are exaggerated cartoonishly (specifically, the guy's dick is). Panel borders are formed from the leafy vegetation of the dream's setting—it is a jungle-themed sex dream and, yes, dabbles in racist stereotypes—but otherwise events unfold in images as described in words, as if the character sharing the dream had told it many times before, not as if we are meant to be pulled into the narrative of the dream and experience it on our own terms. What's remarkable about this is that Fleener's depiction of altered states is usually visually pronounced: characters on drugs or in the throes of orgasm or sickened melt, or go cubist; faces elongate and drip after the ingestion of a pill; a naked female form is triangulated, half black and half white; we are meant to see the physical sensation of a clitoris properly fondled at the moment of orgasm; we are granted the sensory effects of the drug without taking it ourselves. Yet Fleener does not extend this courtesy to dreams, which seem in her oeuvre just another story to tell at a party.

Ariel Schrag gives slightly more weight to the sleeping mind. *Potential* includes five dream sequences, each of which offer the

main character further perspective on the relationship troubles she, a high-school junior, is having in school. Drawn in 1997 and published in 2000, Schrag's work offers thrilling insight into young white queer life in the Bay Area. She was, at the time, a young talent with a clear drive to tell stories that surpassed, perhaps, her interest in developing her drawing or lettering skills. Which is the point: Schrag's drawings throughout *Potential* range from good to good enough to definitely uneven. Most of the care in rendering, if not also in writing, goes into her dream sequences, which are often also frustrated sex scenes. They, in fact, carry the bulk of the story. Potential is largely a book about Schrag-the-artist's youthful attempts to get laid.

For Doucet, too, the most interesting dream comics are about sex, the body, and physical mutability. In 1993's five-page "Regret" (first published in *Dirty Plotte* #6), Julie-the-character wakes up in the hospital with a brand-new wang and saunters around town with it until a girlfriend hits on her. Then Mickey Dolenz does too, but Julie is left wondering if she will miss her vulva.

Julie-the-character receives her first schlong in *Dirty Plotte* #4 (she takes a bite from it), but in *Dirty Plotte* #6 she finally gets one to use for her own purposes (she starts with rape). While the D&Q volume *My Most Secret Desire* doesn't distinguish between Doucet's Imagined Self and her Dreamed Self, it is interesting to note that the first appearance of Julie-the-character's gender dysphoria is in a waking fantasy—not couched in a dream, where it could be dismissed as meaningless. Doucet, in other words, has no desire to distance herself from her occasional masculine aspirations (nor should she). But for all the talk of transgression in the 1980s and 1990s, and the often inane swears, acts, and bodily functions that tended to characterize art billed as such,

Doucet's most—perhaps only—truly transgressive moments are when she, a straight, white, educated, upper-middle class woman in North America, professed a genuine, if occasional, desire to also be a man.

The appeal wasn't just freedom from persecution and handy storage solutions, though. In the dream comic four-pager "The Double" (*Dirty Plotte* #6), Julie becomes bored at a party so tries to leave. Instead, she finds herself in a mirrored room. After a brief intermission where she begins to wake up, a captivating short series of panels seemingly inspired by both Fleener and fellow Canadian cartoonist Fiona Smyth, she instead turns into a man. Her reflection remains a woman, however, so the two start making out. Who wouldn't. The lettering is janky, but the linework is sharp as hell, and the title panel collaged in Doucet's clean-cut style.

What made Doucet's genderbending strips truly transgressive—more so even than most of what passes for transgressive art—is that they established a realm where a general (if comics-reading) audience was able to disregard gender but remain engaged in supporting a woman in the field. The easy slide of Doucet's tales of the Imagined Self into those of her Dreamed Self helped dull the sharpness of the charge that it wasn't enough for her, that neither the all-boys' club she played in nor the feminist movement that should have welcomed her membership were making it any easier for her to move about the world freely.

Still, readers at the time loved the dream strips; creators, too. "Julie Doucet's work in *Dirty Plotte* was probably my most direct influence for doing a dream comic," *Slow Wave* creator Jesse Reklaw tells *Electric Dreams* in 1996, a now-defunct publication devoted to exploring the nocturnal imagination. "Hers were the first illustrated dreams that I can recall reading/absorbing."

Other creators have expressed similar sentiments, describing how Doucet's dream comics opened up new possibilities for storytelling—new ways, in other words, to dream on paper. Yet Doucet's dreams, at least as depicted in her dream comics, are never aspirational.

Back to "dREAMT: FEBRUARY 17 1990" from *Dirty Plotte* #1 for a moment, and my favorite-ever comics panel. In this five-pager, Julie and a friend go out for a picnic away from the city when a group of naked men come and accost the group. They leave, but upon their return, one has placed a croissant in his underpants, which for some reason he has also donned. Despite anxiety and misgivings regarding the intruders, Julie-the-character eats and enjoys the croissant. When she wakes up, her small appliances try to murder her, but she fails to notice anything amiss.

The mood established in this strip is wholly unique. More hapless than hopeless, the physical danger Julie-the-character faces comes from her own trusted home goods, yet the fear she feels takes place in the dream, over which she holds little sway. The irony of Doucet's dream comics is that they seem never to have contained her hopes or wishes—her dreams, in the sense of aspirations, were relegated to other realms.

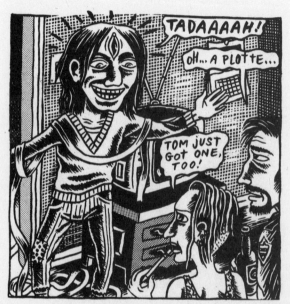

From "Are You Plotteless?" *Dirty Plotte* #6 (1993).

THE NOT-SELF-AT-ALL

"I wish I could write fiction," Doucet tells fashion and lifestyle magazine *Ladygunn* in an April 8, 2010 interview. "It's very difficult. For me autobiography is a disease."

For one so afflicted, it is admirable that Doucet pursued the task so ardently. Over half of Doucet's English-language output—in terms of numbers of individual strips, although not in terms of page count—can loosely be categorized as fiction, or is set in a fictional realm. (I include here her non-autobiographical experimental forms, such as collage and portraiture. These occasionally included portraits of known figures, often from the comics community, never identified by name, and other portraits wholly invented from text descriptions.) Strangely, the fiction stories also attracted the bulk of critical attention ultimately paid Doucet's work in the US. By far the majority of full-length reviews in the English-language press are for 2016's *Carpet-Sweeper Tales*, a fumetti-collage work of experimental fiction. While this is attributable to the growth of D&Q's PR team and the increasing attention paid to graphic novels in the press in recent years, the central place fiction holds in her

oeuvre may surprise readers. Even Doucet doesn't think of herself as a fiction writer.

Portraiture, collage, games, fan fiction, single-panel images, and lengthy narratives with established casts of characters, although divergent forms, all seem, under Doucet's pen, of a piece. The plane on which they are set is wholly imagined, unique environments each crafted separately, although by a single author. These imagined realms become evil, at times, or fantastical—larger than normal animals and insects appear regularly, or humans with animal characteristics like an extended proboscis or a tail. Humans without such features are also present, although their animal instincts are often exaggerated: many are lustful, some are brooding, and a great many dance instead of walk. A surprising number of inscrutable gadgets populate these environs, objects that perhaps serve no function, unless they are simply imaginary forms: readers trust Doucet's creations to matter, even if they do not technically exist, or complete no known tasks.

The plane on which these are set is still governed, more or less, by the rules of comics, so superheroes will occasionally pop in, to solve a crime or right a wrong. Yet because this is the realm of *independent* comics, the superheroes will meet untimely demises. (Superheroes in alternative comics generally suffer bitter ends, but superheroes in comics from anyone affiliated with punk are treated brutally, usually for the hubris of donning the attention-seeking outfit that becoming a superhero requires, a clear indication that someone has "sold out.")

Even these imaginary realms are not safe from the misogynistic ravages of the world, not a space where female bodily agency can be assumed or will be protected. The realm in which Doucet's fictions takes place is therefore a space distant from, but still

adjacent to, the real world. Weirdly, however, it has little in common with the world that Doucet's Imagined Self inhabits. Doucet seems, in other words, to have less control over the entirely fictional universe she crafts than the more realistically inspired one she pushes at from the inside.

At times, her fiction appears set in a world not too distant from those constructed by Jim Woodring and Charles Burns, creepy lands where objects ooze or meander of their own accord, where swamps seem common and polluted, and kids or other youthful beings are constantly getting into trouble playing in or near them. Doucet's realm, however, is purely urban, the creepiness all man-made. Literally. The comics that emerge from Doucet's fantasies, the world in which her Imagined Self holds sway over even the laws of science, feel free in a way that her fictional works, set in spaces still governed by male building owners, architects, city planners, and mayors do not. (More formal experiments, also discussed herein, may be an exception.)

In the US, at least, Doucet's fictional tales were not popular. My journalistic instincts recoil to suggest they may be "underappreciated"; more than one devoted reader nearly went into a rage recalling the work. "I *hated* it," several stated outright, suggesting that the artist did too, forwarding the evidence that her longest-running fiction story ended with the needless and needlessly violent death of the protagonist. It's not a strong argument, since her readers, several cats, a variety of characters, and Julie herself on multiple occasions also suffered particularly gory episodes or ends, which seems to have had no impact on their future roles at the center of other narratives. More telling is Doucet's own assessment of the work. "It was so bad," she tells me in her kitchen, laughing.

The most traditional comics—multiple panels, hand-drawn images and lettering—do lose a cohesiveness of purpose in being largely untethered from the real, or feel trapped by reality, strangled with it. Occasionally, however, some stories offer the genuine and genuinely touching insight into the real that only fiction does. In addition, "half" is no small portion of any creator's output. Doucet was clearly devoted to fiction—in fact, she stopped making comics to pursue more wholly experimental modes of bookmaking, loosed from the structures of non-fiction, autobiography, or anything so mundane as "reality." And so, from short to longer works, the made-up stories and experiments in form.

EXPERIMENTAL FORMS / SINGLE PANELS

Doucet's formal experiments tend to come very early or very late in her publishing career to date, and the stylistic difference between the two periods is obvious. Her early experimental forms show the clear influence of late 1980s and early 1990s zines, a messy, cut-and-pasted language that often skews lewd. Her later work, in contrast, fits into the mature world of "art books" without qualm. Both are works of independent or self-publishing, clearly not intended for mass-market bestseller lists. Yet the aesthetics and language of a photocopied, hand-distributed publication, crafted at a kitchen table or silkscreened sometimes in a bathroom, differs from the pristinely crafted lines of a perfect-bound book devoted to images of invented and possibly useless tools, or a match-book sized series of drawings of women, printed atop found text.

A found ad and the single-panel comic drawn in response to it is an example of this earlier style. "LOST," from the minis, first appeared for wider publication in *Dirty Plotte* #1 in 1991. Below an advertisement requesting his return, some cats mourn a lost friend, named Lucky, who suffers a great many disfiguring ailments. (Doucet will later respond to personal ads using this same technique, in the richly printed hardback *Long Time Relationship* from D&Q.) Too, a silly maze called "Labyrinth" from 1989, reprinted on the inside back cover of this same issue, features several potato chips traversing bowels to become poop. "Mama?" one says to the reader, brightly.

"Do it Yourself: Laugh!" is reprinted on the same page in the first issue. Four panels, reprinted from the minicomics, point directly to Doucet's roots in the world of fanzines. Zinesters, in an attempt to translate the vocabulary of above-ground publishing into something recognizable to a politically disaffected, culturally antagonistic, creative audience, often take standard magazine tropes such as kids' games, ads, how-to columns, or word finds, and recast them, a mild perversion of their original intentions. "Do it Yourself" is a take on a how-to column, whether one found in a kids' comic or a ladies' magazine. It shows a woman laughing in four easy-to-follow steps: attentive listening, grinning, a surprised intake of breath, and a sudden expurgation of sound. Under Doucet's hand, it's a spasmodic and unnatural response—our laugher's pupils are crosses, as if she is dead, and volumes of liquid emit from her mouth. It is awkward, and this is the point. How-to columns of mainstream magazines were always instructing you how to do things that thinking people had figured out how to do on their own long ago. This is often cast as a class divide, revealing that mainstream or corporate published

magazines spoke to a bourgeoise readership, or at least an aspirational one, and sought to instill upper-class values in a class-striving public. Yet zines, for all their roots in an aesthetic of accessibility and autonomy, tended to be read and created in the 1980s and 1990s by folks in urban centers, from upper-middle class or middle class backgrounds. I don't mean to be dismissive of the snark to which I owe my own career, nor of my previous work on the subject, but the ease with which zines of the era ridiculed mainstream culture was clearly born of comfort, not banishment.

"Do It Yourself: Laugh!" however, was only partially reprinted in the D&Q series. In the earlier fanzine version from 1988, we are treated to four more panels that extend the joke well beyond a swipe at a bougie how-to column. Following the original four steps, our model acts out two increasingly ridiculous tips for laughing, including "You can tap your knee" and the particularly charming "You can hold on yourself to your ears." The third-page strip ends with two final panels, one atop the other. "You can piss your pants or shit, why not," read the instructions on the first. Our model has fallen to the floor now, rolling in a puddle of urine which continues to emanate from her with the sound effect, "psss" and surrounded by several full mounds of poo. The concluding panel has our model, now wrapped in white and mummified, standing against a plaid background, single finger raised to the sky to make her point: "I laughed." Doucet's message? "Make maximum noise and damage," is the text the short strip closes on, a far more satisfying conclusion in form and content than the more widely distributed version.

Two smaller illustrations from the late 1980s appearing in *Léve Ta Jambe*, "Try It!" and "On dit que les chiens

sont heureux y s'font branler la queue" ("It is said that the dogs are happy that wank their tails"), are silly pages with little to indicate Doucet's hand besides the presence of peckers. Originally appearing on the cover and back cover (respectively) of the *Dirty Plotte* fanzines, the first features men, loose togas unfurling or buck naked, playing on a pre-industrial version of a unicycle, a glass of wine leftover from the bacchanal spilling in the background. The second is dogs, just dogs, gathered around the perimeter of the white-on-black text. Dogs never fare well in Doucet's feline-friendly world—they are too big, or consumed as food, or eat young women. These dogs masturbate their long, stretched-out dongs, humanoid but wiry, wanking without shame or concern for the way their own actions may inhibit the comfort or freedom of others.

The two unflattering depictions foretell the harshness of 2001's "Men of Our Times" in *Long Time Relationship*. Drawn in 1997 Berlin and 1998 Montreal, and first published in an expanded version in France (as *Les homes d'aujourd'hui*), the series of portraits features single images of men at their most slovenly. Many of her subjects are from the comics industry and labeled by profession (fan, editor, publisher, etc.). One has "bulging eyes, chipped teeth, and knee-high pants [that] give him the look of a serial killer," as Joy Press describes in the *Village Voice* in 2001. The images document, for art history's sake, an industry steeped in self-obsessed masculinity by a leading creator on her way out of it, and stand as charming studies of disaffection on their own.

More relevant for our purposes is that the accompanying "Ladies Section" (described only as "six dissatisfied girls") features mostly underclothed figures, except for Doucet's self-

portrait, wherein she sports a sweater. These figures seem to have less personality than their companions reprinted in the same volume, in a section drawn in Germany called "das Herz." Certainly these "Ladies" have less color, for the drawings from Berlin are gleefully colored, wild experiments that combine German vocabulary with distinct personality types. A hapless woman in skivvies and a hat eats peas while a worm crawls out of her ear; we are introduced to prepositions. A man in striped pants without hair on his chest (with a reasonably long "schwanz") is introduced as Der Mann Meiner Träume, or The Man of My Dreams.

Long Time Relationship is a collection of self-published reprints and print experiments made after Doucet's announced departure from comics, as a member of a printshop in Montreal the artist joined (and visits frequently in *365 Days*). The lengthy self-titled section *"Long Time Relationship"* that forms the backbone of the book is inspired by and includes personal ads plucked from the *Village Voice*. "This was just an excuse to draw and try something different: to draw directly with a brush with no previous penciling," Doucet writes in the notes that accompany the collection. The final section of the collection, called "Lost and Found Photos," treads similar territory. Created between 1997 Berlin and 2001 Montreal, Doucet uses found photographs to inspire linocuts, presenting both to the reader, a juxtaposition that highlights sequentiality. Regular people transform, before our eyes, into more satisfying Doucet characters.

It is not until later in the 2000's that Doucet's experimental work achieves a sense of congruity on par with her more traditional comics. In the *Sophie Punt* minis, Picture Box's *Elle Humour*, and her various "Slow Action" projects—attempts to

visually and verbally articulate a theory of slowness that would be nice to see collected, drawn out, and translated into English in a single volume—Doucet's wordless vocabulary is clearly, finally set. Her mid-1990s strips set around dance, usually Lisa Biscuit or Julie herself leaping or shimmying around a room completing a banal task like fetching groceries or answering a phone, grow in influence. In the 2000s, we see only an object, unmoving but emanating pristine grace. The Sophie Punt series, originally self-published as standalone mini-books, hand-printed and silk-screened in small batches of less than 50 and reprinted in *Lady Pep,* features built contraptions and weirdo abstracted organic-ish objects that could also be machines, or fun if mysterious little tools. Some books were originally published in a business card- or matchbook-sized format and sold in automats in Helsinki, Finland. Grey-brown objects perched on color or text backgrounds, for example, Doucet's delight in shifting foreground with background pushing us to ask how we read. The high production-value book versions of this work—*Elle Humour, Lady Pep*—give up some of this charm in favor of uniform page sizes, bound by machine.

Distinct from her text-based fiction works, which are comics clearly under the sway of consensus reality, these silly and often formal experiments emerge from the same wackadoo realm that Doucet's Imagined Self roams. They do little to establish narrative vocabulary or investigate story structure—there is no plot—but exist as joyful little things, the culminating product of several years of study of the sentient objects that cluttered the floors and alleyways of her earlier comics, an attempt to appease and honor her murderous, fictional iron.

SHORT FICTION (1-5-ish page, one-off stories)

Categorizing short fiction is always a bit of a gamble. We'll include herein stories from less than a page to five pages in length that do not rely on previously established original characters or characters that reappear in later strips. Borrowed characters—fan fiction, homages, etc.—fit in here too, because there is no reliance on the creator to do the work of character development, and due to the history of using pre-established characters in zines and comics to comment on previously built worlds as an original creation. For the most part, these shorter works appear early in Doucet's career, and can be read as brief epistles on themes that are more thoroughly explored later. They have been divided into loose categories by subject matter.

DOGS, CATS, AND NAMELESS YOUNG WOMEN

"Dog is Truly Man's Best Friend," drawn in 1987 for the fanzine, is from early in Doucet's career. A woman reading a picture book in the park is murdered by a white man whose dog then eats her. (Admittedly, the drama of the story works slightly better in the stand-alone, self-published format it first appeared in, rather than in conversation with other works, as it appeared in the floppies.)

The story is inspired by Comte de Lautréamont's *Les Chants de Moldoror*, which was published (originally anonymously) in 1868. *Moldoror*, the first of Lautremont's two books, heavily influenced the Surrealists and Situationists for its uncanny, waking-nightmare depiction of contemporary life. Little criticism of Lautréaumont appears in English, even in

translation, but he seems a fitting read for an artist who would go on to mine the abject. In fact, Lautremont's first canto (Editions Sirène, 1920), stripped of the gender-specific pronouns, could read as an epigraph to Doucet's early work:

> May it please heaven that the reader, emboldened and having for the time being become as fierce as what he is reading, should, without being led astray, find his rugged and treacherous way across the desolate swamps of these sombre and poison-filled pages; for, unless he brings to his reading a rigorous logic and a tautness of mind equal at least to his wariness, the deadly emanations of this book will dissolve his soul as water does sugar. It is not right that everyone should savour this bitter fruit with impunity. Consequently, shrinking soul, turn on your heels and go back before penetrating further into such uncharted, perilous wastelands.

By the time this strip is reprinted in *Dirty Plotte* #2, readers have already witnessed the medical illustration of a vagina, copious Tampax, beer made from dirty bathwater; Julie-the-character tearing off her clothing in public; a six-foot-long dog doink; cat masturbation and, later, birth; poop; a suicide attempt; the KKK; and Julie menstruating (twice). The perceptive may already have surmised the connection to Lautremont.

The evil-doer drawn in homage has deep, blacked-out eyeholes and an uncomfortably close relationship with his dog; the shading and linework of the strip are reminiscent of Nicole Claveloux's figures and their stark shadows, each of which seem always to have separate intentions. On display is one of the

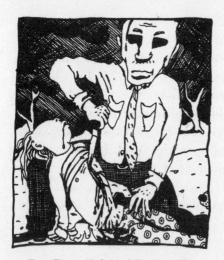

From "Dog is Truly Man's Best Friend,"
Dirty Plotte #2 (1990).

more vile animal-human partnerships to be found in Doucet's work (we are more accustomed to her own cats, a friend's dog, an imaginary pal who is a frozen turkey, or an elephant paramour). "Dog is Truly Man's Best Friend" also sets readers up for Doucet's pending explorations of gore.

"Que Merda La Vie" heads down similar terrain (and is printed directly before it in *Dirty Plotte* #2) but is sidetracked by Doucet's playfulness. A woman attempts suicide by jumping in the path of an incoming train, but hits the side and bounces off with only a bloody nose. There are a number of observations we could make about the difference in tone between these two pieces, each of which concern the pending death of a young woman. Doucet may be playing with themes in an effort to find a comfortable path to tread in the future, perhaps, market-testing her approach. But the most obvious plot element here is that the male entity—Doucet does not often draw evil but this guy *looks evil*—proves the only figure capable of ending a woman's life, in consort with his trusty canine companion. (I'll note again his lack of a cat.)

Less consequential but equally formative are the strips "April" and "Month of October," both drawn in 1988 and printed for wider publication in *Dirty Plotte* #1 and *Dirty Plotte*

#4, respectively, both fanciful pen-and-paper takes on student life. In the first, a half-page black and white piece from the minis, a stereotypical bohemian dude explains that he found an aquarium in the garbage and filled it with fish-sticks, but the spring thaw has him concerned. In the second, a half-page strip, a nameless woman (likely Julie, unidentified) in a noir-like atmosphere, counts days off on her wall by drawing Kotex. It is sketchy, the character filled out in awkward lines, and calls to mind the abstracted forms of Mark Beyer in tone and form.

An untitled strip from 1989 published first in the minis and then in *Léve Ta Jambe* describes a girl with a very high body temperature and her boyfriend, who sleep on a block of ice together. She later sells this ice, as a painting—the pubes, dead skin cells, old fingernails, and grime creating an abstract if ephemeral composition—and she uses the money to buy her boyfriend a fancy coat. It's a rough and sketchy early three-page strip; the characters are emaciated, there is little technical accomplishment on display besides the nuance of the story, which is more intricate, certainly, than her other works of similar length.

Where this easy-to-miss story becomes significant is in how central gore is to the unfolding of the narrative. Similar in subject matter and approach to 1988's "At Night When I Go to Bed," the inquisitive autobio exploration of what happens to Julie's bedside booger collection: at the heart of this piece sits the grit and grime of everyday life. Note that "At Night When I Go to Bed" could offer the same narrative with another substance—tiny scraps of paper, balls of lint, various sundries—but the reason we feel agitation around Julie's stated intention to clean is because readers instinctively grasp (or remember) how embarrassing it might be to store nose waste somewhere and have it later discovered by an interloper. Body-waste storage

habits can give rise to a unique mixture of shame and indignation when seen for what they are in the light of day, and in "At Night When I Go to Bed" we are all-in for the mystery of the disappearing boogers. Similarly, I suspect readers are a tad disgusted by the mattress in the untitled strip, and the proof it holds that we are all animal; its material evidence of our hidden nature gives the object more intrigue than it otherwise has right to claim.

Renee French's *TCJ Talkies* interview points out how many other comics of the time mined similar themes. These most usually involved masturbation, and (besides her own) were penned by cismen. In these, the intention to genuinely share a human experience with a reader often gave way to a Crumb-like pride in divulging unpopular desires. Point is: Doucet's aim in her studies of the abject never seems to be to disgust readers, but to use degeneration and waste to connect to them, to engage them in her narrative.

"A Blow Job", drawn in September 1988, first published in French (as "La Pipe") in the minis, is a muddy, three-and-a-half page strip wherein a woman—perhaps a sex worker, although no money is exchanged—seduces a man outside a seedy hotel. As he removes his clothing, she removes hers, first revealing a penis under her skirt, and then unzipping the skin to reveal a wolf, who also has a pecker. The seducer finally transfigures into a snake, who writhes up the still-human male leg and sucks on his cock. It's unclear what the gender switching here is supposed to indicate—it's Doucet's first—and the setting of the story in a grungy hotel decorated with pornography but absent any financial exchange seems to leave us with a simple story about unwitting masculine desire. There is no moralizing about sex work, or lust, just a man concerned about his physical needs. There is, however, a stunning panel where our male protagonist removes his shorts in the foreground and the wolf-

snake, mid-transformation, having grabbed the tip of its tail from the inside to reveal its serpentine self, struggles to complete the change in the background. Our potential John is only concerned about his desire; he does not care what extremes his partner goes to in order to respond to it.

The Cat Canaille strips from 1987, first printed in the student publication *Tchiize*, aren't dated, and the two reprinted in *Léve Ta Jambe*—"Mais C'est Cat Canaille!" and "Mamma Miaw it's Cat Canaille"—leave out the introductory information necessary to give the story much heft. Alone, the two strips fill two black and white pages in an early, sketchy line. Two cats prepare for a night on the town, and end up at a strip club where they drink too much—a theme picked up again in "Monkey and the Living Dead," although slightly less successfully. Somehow the all-feline world of Cat Canaille takes fewer leaps of faith than the multi-species world of that long-form work, in which one is constantly wondering why some cats enter establishments through front doors and others jump through windows. The first strip, however, "Who the Hell is Cat Canaille," answers any lingering questions. Cat Canaille, we learn, is "peculiar." He talks, for one thing, and smokes, and eats "only fresh carcasses," in addition to shitting, pissing, puking, and fucking. He's "a real canaille," we're told—a dishonorable lout—in a panel that features Cat Canaille, tail lifted, from behind, proudly displaying his asshole.

THE LORD, THE FROG LEGS, AND THE KKK

Thirty years can be tough on an artist's oeuvre, but Doucet's holds up remarkably well. A scant few strips might raise the eyebrows of a politically astute reader today, although some

explore themes that thankfully disappear from later work. "The Lord's Supper" from 1988, for example, reprinted from the minis in *Dirty Plotte* #2, in which a male character says a prayer and then offers for consumption the cooked body of a slain man, penis intact, at a dinner. Seated at table are a female character (which could be Julie) and a variety of animals. It reads as underconsidered teen angst, the simple rage of a girl who spent too much time in Catholic school. Even when Doucet slices herself open, she does it for fun, but no one here seems prepared to enjoy their meal.

More troubling than juvenile are two strips from the late 1980s: "Let's Eat Dog with Chinese Sticks" from September 1988, reprinted in *Dirty Plotte* #1, and "Today We're Gonna Eat Frog Legs!" from 1987, both self-published and later included in *Léve Ta Jambe*. In the first—which features almost nothing that would come to be seen as Doucet's signature style—a group of Klansmen decide to roast a dog and eat it with chopsticks. The same youthful mind that crafted "The Lord's Supper" noted above may conceivably have intended the strip as a comment on racism as opposed to what it is: confusingly racist. Are the Klansmen supposed to be Asian? Are they, somehow, the ones performing the oddly low-key (for them) anti-Asian racism? Has there been a mistranslation of "chopsticks" somewhere? Is there some reason we are supposed to care about either the dog or the men eating it? Nothing is clear, and there are too many presumptions about nationality, race, and food cultures to read it as anything but a rare misstep. A two-color panel in the *Tchiize* from 1987 answers some questions. "Let's eat your pussy with Chinese sticks!" has an early male Doucet character tending a fire and a spit in a bedroom, while an underclothes-clad woman waits on the bed, two plates and chopsticks ready

for her meal, in the background. On the spit is a cat, one of three in the frame, steaming and nearly ready to eat. The double entendré ("your pussy") better justifies the ambiguous story, and we're not left wondering why we're suddenly sharing a meal with the KKK.

The slightly earlier "Today We're Gonna Eat Frog Legs!" is more apparently Doucet, the artist's hand particularly evident in the charming curlicues of the title. The three-page story concerns a group of folks preparing the traditional French dish, frog's legs, but with cat. The group includes a couple women who are not wearing much clothing and a dark-skinned man referred to at one point as a "cute little nigger." Despite the gory premise, a sketchy hand and chaotic panel composition gives us characters that feel "cartoony" and emotionally underdeveloped, on top of alarming.

It's not so much that these works—whether they participate in derogatory stereotypes about Asian cultures, normalize the KKK, loosely employ a term wielded since the development of the English language as a tool of racial oppression, show too many ladies in too little clothing, or depict a character as permanently blackfaced for laffs—have violated some list of acceptable behaviors. (And let me be very very clear: while there are Asian cultures that eat dog in times of duress, there also turn out to be a great many European ones that eat cat when money gets tight.) To a degree, an easy affinity for hate speech was simply part of the transgressive culture Doucet's work seems at a distance to fit into. Jim and Debbie Goad's *Answer Me!*, for example, is advertised on the back of *Dirty Plotte* #7, a four-issue zine that regularly ran interviews with pedophiles, murderers, Satanists and was, in 1995, at the center of an obscenity lawsuit. To another degree, however, Doucet's work goes beyond reactionary libertarianism: it's just smarter.

Yet unexamined racist content limits who can look at work and feel the same limitless potential as the creator does, whether in the story or in their own work or lives. And it strikes me that the particular variety of unhindered freedom Doucet always seemed to want for herself, and offered Julie-the-character at every turn, is here denied certain readers.

KIRK AND SPOCK, WOMEN, TAMPAX, AND PETER

"Kirk and Spock In a New Spot," three strips from the minis that appeared together in the fourth issue of *Dirty Plotte* (and have more than a little in common with the line quality and emotional atmosphere of Mark Beyer's *Amy and Jordan*), offer tiny morality plays about two dude-bros visiting a new realm. In one, they decide to pee on the new planet, which quickly fills with their urine. In another, their weens become gloopy and their hands stick to their dicks. In the final, when they begin pissing, all the whizz goes up into the atmosphere and seems to solidify. In fanzine culture, strips like this serve to carve out a creator's stake in a certain realm of popular culture: I watch Star Trek, the creator is saying—something men tended to publicly proclaim more often at the time—and I, too, can make sci-fi. Female creators have a long history in sci-fi, of course, and an equally long history of being written out of it, which is partially how fanzines got their start in the first place: women who weren't seeing work published in aboveground spaces flocked to their mimeographed brethren to share their own invented futuristic stories. If you are not familiar with Joanna Russ's work in the sci-fi realm or outside of it, you should be. The fact that you may not be is a symptom of the exact problem

that her multi-genred investigation into the suppression of women creators (particularly her just re-released tome, *How to Suppress Women Writers*) elucidates. All of this is to say: these three strips seem silly, and later appear to impact her body of work hardly at all. Yet by doing them, she claimed a small bit of acreage in a field that could otherwise appear to have been dominated by men.

Indeed, Kirk and Spock are possibly the first characters subjected to slash fiction, or "slash"—that is, the first corporate-owned characters that fans cast in independently written tales, expanding on their on-screen partnership with explicitly homosexual storylines. (Kirk and Spock shared many moments of intimacy in the TV series, and slash writers argue they are simply drawing out the subtext of the series.) In Doucet's world, however, the two are not engaging in sexual play, they're just sharing space, two dudes, with their schlongs out. They perform masculinity in its most animalistic sense: they pee on stuff to claim dominion over it.

Plenty of writers (Henry Jenkins, most famously) read in the re-use of corporate owned characters an underlying, renegade anti-copyright motive, and see the refusal of copyright holders to prosecute these technical crimes as a testament to the flexibility of existing copyright law. I'm less convinced that this seeming benevolence can be read as a concession to fan power; in fact, that the right of consumers to make occasional use of their own visual culture without punishment seems to me a further expression of corporate power. Copyright holders could, at any time, rally for the dissolution of corporate-friendly copyright laws and handily install a regime that acknowledges, in legislation, the power of viewers, readers, and independent creators to make use of the images and storylines they are

given to consume. They do not, but Doucet is not concerned with intellectual property rights anyway. Slightly more relevant might be Russ's 1985 look at the genre, "Pornography by women, for women, with love," from the essay collection *Magic Mommas, Trembling Sisters, Puritans and Perverts*, in which she suggests that women's frequent creative roles in slash were attempts to reimagine and upend more basic gender and power relations. (The Kirk and Spock strips' appearance in *Wanton Carruba* from 1989 bear this theory out: Doucet's trio of strips about men claiming dominion over space via trouser snake in fact grant new territory to Doucet.)

Her short fiction more often explored femininity, although not at all the demure variety that we might expect would fill up the spaces left between such displays of masculinity. "On the Road," "Charming Periods," and "Tampax Again" all offer magical realist takes on daily life as a woman in North America. In the first, a character named Miss Jones runs out of beer and, in a three-pager from the minis, a mysterious gentleman knocks on her door to take her for a motorcycle ride. Character development is advanced for coming so early in her career, and the strip shows how much Doucet could have accomplished in fiction by removing herself a bit further from the narrative earlier on. (I personally remain thankful she did not.)

The half-pager "Charming Periods" from 1987 is basically an ad for Tampax that envisions a wiener yearning for, and receiving, a small bite of the menstrual product. The body horror/comedy comes out of the same self-publishing ethos that her early experimental work and the Kirk and Spock strips do, an ethos that hints that culture should be owned by those who consume it—technical copyrights over characters and trademarks over brand names be damned.

(It's the same ethos that would inspire samplers and remixers in experimental, techno, hip hop, and Canadian industrial music genres then, too.)

Yet most borrowed elements of mainstream culture, remember, presented a wide array of stolen goods: Doucet just liked Tampax. In the fictional story "Tampax Again," the boy on the beach describing the joy of the menstrual product looks suspiciously like later Julie-the-character, which leads readers to wonder if she may have been drawn to self-depiction not out of an innate fascination with her own life but through a stylistic quirk: she was just good at drawing characters that resembled herself. (A half-page illustration from self-published *Dirty Plotte* #3 is heavily ornamented and labelled, "Tampax Forever." It depicts a giant tampon labelled D. P. zooming through space, filling out an issue that carries the Kirk and Spock strips, as well as a two-pager on menstruating in space.)

A slightly more aggressive look at gender roles appeared in 1993's "Aaah Women!" from *Dirty Plotte* #7, a two-pager that features two fancy and well-made up women. They go for a drive, fight, and then crash their car. If the Kirk and Spock strips are cautionary tales about masculine overreach, this is a feminine counterpart; conspicuous consumption and bickering is punishable by death. Doucet in a few issues will grow more tolerant of women, even coming to find some joy in their pettiness, although this strip reads like it was written by someone who doesn't know very many of them. (Interestingly, it appears to take place on the same busy urban street corner as the Lisa Biscuit strips, wherein ridiculous shopping women are, later, celebrated.)

Immersed though we may become in Doucet's scuzzy cityscapes, there will always come an interruption. *Dirty Plotte*

#3's "Interlude" from 1991 is a one-pager replete with gorgeously intricate early Renee French-like cross-hatching on the brick wall in the background, in front of which stands an unnamed man. In the second of six panels, he calmly unzips his fly; by the third panel his third leg is out and we're told its name is Pete. While passersby go about their business, Pete's unnamed companion becomes incensed at the thought that we might hurt Pete. His eyes bug out and he shakes a fist at us—"Don't ever hurt him!!! Or else, LOOK OUT!" the man says, sweat and aggression flinging off his face from the effort. It is a violent (and for many of us, needless) reminder that the feelings of the penis of an unnamed man on the street may be more important than your own.

MARTIN, RALF, AND CASPER

A small handful of stories begin to pull threads together to weave longer and more substantial works of fiction. The earliest of these, in the minis and *Dirty Plotte* #1, features Martin, a fictional character based loosely on a former boyfriend of Doucet's. "A Washing Day With Martin," "Martin Makes Beer," "Martin's Success," and "Let's Visit Martin's Factory" are spread over four pages, and all tell stages of Martin's entrepreneurial rise from a slovenly pig who soaks his dishes in, bathes in, and then makes beer, all from the same water. This works fine until the business scales up, whereupon Martin must also develop a laundry facility to take in clothes from the public so he can keep up with demand for his product. The strip is playful; Martin's characterization is inconsistent, although his janky body movements perfectly mirror the early lettering of the series.

Most charming is Doucet's uneven English: "Montreal's gonna crave for it!" Martin says of his beer. "The dishes is coming from my restaurants… and the clothes from my many launderettes." The accidental poetry sings when the malformed linework rubs against the improper English. Such moments were a large part of the initial charm of Doucet's work.

"Are You Plotteless?" from 1992 (*Dirty Plotte* #6) is a four-page strip about Ralf. After meeting a man who has had labia inserted where his dork used to be—not, seemingly, for reasons of gender identity but because he could—Ralf decides to have a set installed on his forehead. When this alone fails to impress his friends, he studies ventriloquism and learns to speak out of the new hole, which finally merits him the respect he feels he deserves. Pan back to Julie-the-character, speechless in the final panels, unable to voice the indictment she has just made so utterly clear to readers: that vag-having is not impressive on its own, although if you go to great lengths to procure one, and then use it to entertain your pals, it acquires a sheen of usefulness. The warning shot is clearly stated by context, for *Dirty Plotte* #6 is the issue in which Julie becomes a man.

"Casper the Friendly Alternative Ghost" from 1994's *Dirty Plotte* #8 was drawn while living in Seattle, and is only notable as a rare collaborative offering, this time with Seattle artist Brian Sendelbach. It's a story about a roommate named Casper who moves in with Julie and grows progressively more obnoxious until she slices his throat with a broken bottle, whereupon he complains about her from the afterlife. It's a dumb revenge story, but Doucet tells me her time in Seattle wasn't so much about skills-building, or showing off. "It was not like in New York. In New York the atmosphere is so competitive so it was not that nice. But in Seattle, it was really cool to be around so

many cartoonists and have new friends. It was very friendly." Friendly enough, she says, to include other artists in her solo-authored book, a project she had already tried, unsuccessfully, back in the fanzine days. "People hated it," she says. "I don't know why I tried to do the same thing with the comics... I guess probably it was just to share with the other guys."

CHU TANNEY & LISA BISCUIT

Doucet's short-lived character Chu Tanney faces a crisis of conscience regarding her enrollment in art school in a 1993 strip that spread out over two stories. Is the endeavor a waste of her time? Chu gains inspiration when she comes across the superhero Toff Girl beating up some good ol' robbers, but her good mood doesn't last when the talented student gets hit by a car. In the second installment, the strains of Chu's life come together as she emerges from her hospital bed to self-publish a magazine that she peddles on the street corner.

Published in *Dirty Plotte #8*, the stories—"Chu Tanney the Art Student" and "Chu Tanney at the Hospital"—are technically accomplished: the narrative structure isn't quite as dramatic or deep as it could be, and the story remains a bit too reflective of Doucet's own art-school frustrations, with which readers are already familiar. The lettering is slightly uneven, while inks are solid, although this feels not quite as tight as her later work. But the character feels fresh, remains sharply rendered, and her concerns seem worthy. It's just clear by this point in the series that Doucet's storytelling interests lie elsewhere.

The Lisa Biscuit series benefits from more developed characters. Not that Biscuit, a fancyish lady carting around a

dog named Fifi, does anything particularly noteworthy, or has traits or concerns that readers can connect with. In fact, she shops and generally displays character attributes that Doucet elsewhere appears to find objectionable. Yet she's given a life of her own, and, in "I Was Dancing My Way to the Mall" from *Dirty Plotte #7*, she brings her dog to the cash station, dancing through the cityscape, and ends at a shopping center. Doucet rightly credits herself as choreographer; the charming strip is an exploration of movement. Lisa struts, cartwheels, and vogues through the streets with Fifi in tow, cash from the ATM playing along as it flutters to the sidewalk. She's dancing so hard the panel borders cannot keep up with her: her leg extends beyond its line several times, scurrying Lisa's tempo toward her destination. The following year's "Lisa Biscuit & Fifi In: Enough Shopping. Let's Go Back Home," from *Dirty Plotte #8*, is only a single-page strip, but this time Fifi gets in on the action, holding a bag of groceries above his head and doing his best impersonation of a Rockette. This time Lisa is the lead in a full-on (if soundless) dance number; passersby mirror her body movements and even distant figures step in line. The two cha-cha home until Lisa Biscuit gets hit by a tiny little car that stubs the toe of her sparkling white boot. She calls it a "brute," it apologizes, and an off-panel figure pops his head into the strip to say, "ain't that cute!" This is mature Doucet at her short-fiction finest: crafting a world in which a silly woman and her even sillier poodle dance along the city street, and everyone around them joins in.

Doucet will explore movement again in "horoskop: self-defense," from *Dirty Plotte #11*, a single-page strip that runs along the bottom quarter of the final three pages of the issue. Julie, in a karate outfit, speaks in cursive and shows off defensive

moves against her German-language horoscope. Aggressive and sharp, and published in short bursts that conclude each page, these strips are the antithesis of Lisa Biscuit's movement-for-pleasure aesthetic. This is movement for survival, a feisty celebration of continued existence despite the disaffection Doucet felt in Berlin.

LONG FICTION

More an emotional measure than a page count, long fiction includes serial tales, substantial stories that are longer than three pages, or stories with recurring characters. These are organized by character.

ROBERT THE ELEVATOR OPERATOR

Robert the Elevator Operator appears in "Robert the Elevator Operator" from 1992 (*Dirty Plotte* #6) and "Robert the Elevator Operator Goes Back Home" from 1993 (*Dirty Plotte* #7). A later strip is set in his universe but does not actually include him, called "Furry Tail," drawn in 1992 but not published until *Dirty Plotte* #11 in 1997. The first two strips are largely wordless and involve complex shading techniques and accomplished art. They seem mostly an excuse to draw elaborate cityscapes, and to explore the potential of this *strange* character. Robert boasts external features that seem, in his species, to be largely defined by gender—males tend to have long, hairy noses and females long, floppy ears—and whose tactility owes some gratitude to the unique stock of

characters in Jim Woodring's Unifactor. In the first story, Robert goes to work, saying "hello" to people he knows along the way. The undulating lines of the city bend to meet the enthusiasm of the characters he greets. Later, the hairy nosed-people return to populate a story about the elevator operator, Robert, returning to his extremely small house after work. This time, the entire city reshapes itself around his journey and his house, which he must kneel to

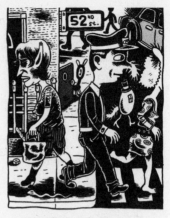

From "Robert the Elevator Operator Goes Back Home," *Dirty Plotte* #7 (1993).

unlock and features a front yard filled with the houses of other, smaller creatures. There is something captivating about this world, and it is obviously significant to Doucet; when she pictures herself on the cover of *Dirty Plotte* #7 as "a real woman" she has the tell-tale fuzzy nose. "Furry Tail" is our final glimpse at this world, a single-page strip in which a long, hairy-nosed character robbing someone at gunpoint is stopped by an older gentleman in polka-dot boxers and a regular nose, but sporting a three-foot-long hairy, erect penis, which pokes the criminal in the eye. Justice!

MONKEY AND THE LIVING DEAD

By far the most substantial of Doucet's works of fiction, "Monkey and the Living Dead" is a multi-part tale inspired by real-life Montreal alley cats. The story starts when Julie the character's cat Monkey and a tom-cat named Living Dead

become acquainted. Monkey has spotted the Living Dead's ween and becomes obsessed with it; her journey, this tale, is a search or it. In the second installment, Monkey searches for the mysterious tool in a plumbing supply store where she is sexually harassed, then goes to a strip club ("clitofun"), where she is given a job. Meanwhile the Living Dead wanders into the same bar. Monkey soon performs onstage, in a (surprise) live sex act, finds the Living Dead, and seduces him in the alley. Julie and Charlotte the Cat wander by and discover Charlotte's newborn kittens, who had gone missing; then they find Living Dead, succumbing to Monkey's wiles. Charlotte kicks his penis off, dragging Monkey back home. A sixth strip, "The Return of Monkey" in *Dirty Plotte* #7, seems to resolve any open questions about the story, or the authorial intent behind it: Monkey is hit by a car and immediately decapitated, whereupon all bystanders solemnly agree that she is dead.

Improvised throughout the early 1990s, and collected for distribution in France but never in the US, the linework throughout tends toward sloppiness, as if Doucet herself is impatient with the strip. Characters occasionally have missing pupils. The lettering is weak throughout, lines unnecessarily wobbly. Some characters suffer from personality lapses—one in "the Return of Monkey" is even an actual white blob—and the reader is sometimes left to wonder if the story was just a vehicle for Julie to craft a semi-raunchy tale for readers without putting herself any further on display. *The Madame Paul Affair* suffers less from a similar conundrum: all the action is witnessed by Julie, but never perpetrated by a character quite as interesting. Yet of the various damages inflicted upon her array of characters across all her stories, the perpetrators are fairly limited: an evil man and his dog, two women who don't seem terribly bright,

and Julie herself, who carves her own body up out of joy but somehow reserves her truest anger for this curious sex-working cat Monkey.

The only other time Doucet introduces an initially sympathetic character later killed off with apparent malice is in "Mein Allerschönstes ABC" (part 1) from 1996 (*Dirty Plotte #11*). Andy the Ant appears at Alexanderplatz; he is granted pride of place on the cover of issue #11. Julie meets him and prepares to make an announcement to her readers—she has a speech in her hand on the cover that begins, "Dear Readers"— but then Andy gets hit by a car, so Julie amputates his head. Readers aren't given some vital information—Julie-the-character has been unable to deliver it—but there isn't enough action in the four panels to make the violence seem necessary. That below it runs the first three panels of "horoskop: self defense" may hold a clue to the events in Doucet's biography that led to the strange, and strangely prominent, story, but the general reader simply doesn't have enough information to fill it out. The primary concerns are narrative. Hasn't Doucet learned by now she doesn't need to draw characters only to decapitate them? She could just as easily craft a horrible scenario for him to fail to survive due to his own lack of foresight or intelligence.

MRS. JONES

Carpet Sweeper Tales from 2016 is a clever, conceptually driven project. In it, mid to late 1960s-era Italian photonovellas are re-ordered and re-narrated with text pulled exclusively from vintage magazines in the home repair and home making categories—a metacollage about love and gender roles in the

postwar boom. "Read it loud" is the instructional text, and it's true that the collaged vocabulary works best as declarative statements. "The trouble is," Nicole Rudick notes in *The Comics Journal*, "that the dialogue is nonsense." Until, at least, you respond to the inflections intended by her careful selection of re-used typefaces.

Largely a visual sound poem, then, the narrative concerns relationships between men and women, and sometimes nuns and sanitary products. (Tampax, of course.) The stories, Rudick argues, "function as comics in the best possible sense: images and text so reliant on each other that one cannot operate fully without the other; and out of that interworking, narrative is born. Amid a kind of stuttering bewilderment, Doucet's stories make sense."

They are also stunning formal accomplishments. Technically skilled hand-cut images, brilliantly composed, with little distracting image loss even in the 5" x 5" format, and given the newsprint and aging glossy magazine stock originals. The challenge to readers is welcome: to establish meaning through the vapid language of the Golden Age of Advertising, when the number-one rule was David Ogilvy's "If it doesn't sell, it isn't creative." The stories are fresh and silly. Considering, in other words, how very dirty her source materials, Doucet has crafted a remarkably pristine, even shiny book, that both upends and pays homage to the regressive norms under examination.

With *Carpet Sweeper Tales*, Doucet has done something truly innovative, and received no small amount of press for it, in both review and interview formats. Yet the critical dialogue it inspired seems stuck mourning Doucet's announced exit from comics 15 years prior, with little acknowledgement of the body of work completed during that time. It is as if her proximity

to a particularly traditional view of comics were at stake, and not her own skills or talent. "In the years since the end of her landmark series *Dirty Plotte*, Julie Doucet has rarely strayed far from comics," the *Globe and Mail* notes as just one example, "so long as you're generous about what you call comics." The (male) writer seems put out by the mere thought of extending such generosity, and questions not at all his right to police the borders of the form.

If we compare press reaction to Doucet after *Carpet Sweeper Tales* to that granted any of the various figures breathlessly acclaimed for innovating comics, we note a distressing tendency: the cismen (yes) all praised for revolutionizing the form are doing the same sort of deep, thoughtful work that Doucet is. They are just rewarded for it.

Despite its clear merits, and its predominance in critical reactions to her work, *Carpet Sweeper Tales* remains unsatisfying to me, simply because it fails to do what Doucet does best: cast the real world in a supporting role in the fulfillment of her own wacky interests, desires, and experiences. What I crave is a world that Doucet has crafted, a world in which real-life elements cave to her demands and reflect her ridicuous desires. What I suspect is that Doucet is no longer interested in placing herself at the center of this world, and hasn't yet found a way to disambiguate from her Imagined Self. What I choose to believe is that, eventually, she will.

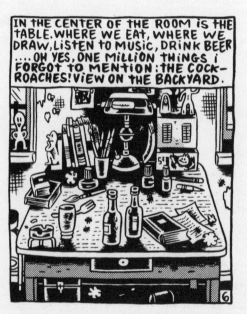

From "My New York Diary," *Dirty Plotte* #10 (1996).

THE UNKNOWN SELF

Comfortably tucked into her Montreal kitchen, Julie Doucet seems surprised to hear that she has any lasting influence on the world of comics, indeed anything resembling a legacy at all. I suspect the reaction is genuine, and I gain the impression that Julie Doucet doesn't really know much about the figure we talk about as Julie Doucet.

The latter does cast an unfathomably long shadow. "Julie Doucet is the female Crumb," Joy Press writes in the *Village Voice* in 2001, further describing her as "Kathy Acker meets *That Girl.*"

Let's overlook that the combination doesn't call to mind a Crumb of any gender, while acknowledging that the mélange is apt. The plucky Marlo Thomas broadcast television sitcom could almost have starred Doucet's hand-drawn, wide-eyed ingénue humuncula, the dirty-haired smiling post-punk Pippi who communicates in stilted English. She is, more or less, a simplified version of the woman I sit with in the Montreal kitchen, where her uneasiness with the foreign tongue seems more an issue of comfort than of knowledge. It is the Acker half of the mix, however, that takes more explanation.

Kathy Acker herself was not easy to place, despite her devotion to autobiography. Her forms of first-person narrative were every bit as complex as those Doucet crafted, for Acker, alongside her Semiotext co-conspirator Chris Kraus, sought to expand the potential for women's narratives through autobiography, thus expanding the potential for narrative. That is, both Acker and Doucet are dedicated to ontological explorations of the self, but draw a pretty fuzzy border between the self and any number of others.

This is a complicated maneuver, particularly in terms of traditional gender norms. To limit one's explorations of the self, the ultimate domestic chore, fits neatly into both the popular conception of femininity and the legal sphere to which women's creativity has historically been relegated. Yet to presume that the self might not be preordained, and might even embody many different states of being—that is a more masculine presumption, if not a downright colonizing one. What saves the project from the white capitalist supremacist trappings of that term, however, is that no material resources are depleted, or even used: only generated. (That Doucet, Acker, and Kraus are all white, yet not able-bodied, may be a good topic for your dissertation.)

Chris Kraus's *I Love Dick* is a 1995 novel in which the main character, named after the author, chooses and pursues a lover in the same manner in which she has been pursued in previous heterosexual relationships; she grants her object of desire, a famous and respected man, as much say in her decisions as women have traditionally been given in that role, which is to say, she behaves as if decisions could only ever affect her public life, but never his. The brilliance of Jill Soloway's serialized version

of the story for Amazon is that it couches this tale in the visual vocabulary of early feminist videography dating back to the mid-1960s. Works by Chantal Ackerman, Cauleen Smith, Petra Cotright, and Carolee Schneeman have investigated subjectivity and desire for half a century, and so are thematically relevant, but also ground the contemporary story in a rich history and limitless future for nonmasculine authorship. (The chronic illness described in the novel, sadly, fails to emerge onscreen.)

Similarly, Acker's fiction works include a 1982 retelling of Dickens' *Great Expectations* (also titled after it) through experiences in her own dirty punk life, and an extremely critical chapbook published in the same year called *Hello, I'm Erica Jong.* Her 1990 nonfiction work *In Memorium to Identity* looks at the concealment and revelation of identities both social and literary; even a book of published letters exchanged with Mackenzie Wark, released by him in 2015 nearly two decades after her death from cancer, explores these ontological obsessions and her intention to foreground them in her literary work. The correspondence, published under the title *I'm Very Into You*, makes explicit Acker's own performative identities and their relationship to her physical, eventually ailing, body.

Doucet's work fits neatly into this tradition of women's autobiographical performativity, the foundations for it in comics having been laid in the jokey first-person stories of Aline Kominsky-Crumb, the sexually frank and occasionally distressing tales from Phoebe Gloeckner's childhood, the altered mental states that inspired Mary Fleener's experimental cubism, and the wide cast of fictional and nonfictional characters employed to convey the autobiography of Diane Noomin.

Unfortunately, few critics seem capable of properly contextualizing Doucet's work, and her readers could be forgiven for ignoring the critical response to it entirely, or finding so little in it of relevance that it fails to register at all. Male critics often seem stuck in a quandary of needing to acknowledge her popularity and talent but being unable to articulate, at least on the page, the precise nature of their feelings about it. *The Comics Journal's* 1999 inclusion of her work in its 100 best comics of the century list (*TCJ* #210) at number 96 is typical: writer Bart Beatty uses various forms of the word "accomplished" to describe her work no less than three times in the short blurb, and it is the highest praise he offers in a piece that otherwise focuses not on her technical skills, but on the "confessional" nature of the "pitiably wrong" life choices explored throughout *Dirty Plotte*. The review's heavy reliance on Doucet's "accomplishments" lends the distinct sense that the artist—just then growing frustrated with the industry's limitations on her career potential, its drain on her time, and its impact on her social life—had already achieved everything she could hope for. Indeed, since only three women's names— Debbie Drechsler, Lynda Barry, and Françoise Mouly—are granted places above hers on this list (Carol Tyler is the other woman listed, at #97), this unfortunate presumption may have been correct.

Other critics tend to be less disparaging of her potential. "Julie Doucet looms large in the pantheon of contemporary cartoonists," Hillary Chute proclaims in a 2014 issue of *Artforum*, noting that her work "ushered in an era of comics as a feminist art form." Some would disagree with this last comment, like Press, who identifies correctly for a popular audience that Doucet is "a loner, her anger disconnected from

any feminist politics." Catriona MacLeod similarly argues to an academic readership that the artist gravitates only toward situations that aid her own ability to create work. Yet casting Doucet as a careerist loner does a grave disservice to the impact of her work and ignores the milieu she inhabited and the history she responded to. After all, "careerist loner" is a reasonable description of precisely 100% of the comics industry—and a necessary mode of defense for any woman working in it in the 1990s that hoped to retain a sense of self-respect.

That women critics—and artists—perceived a liberatory potential in the work of Julie Doucet that may not have been intentionally placed there in an act of feminist solidarity is probably central to its success. Doucet was unwilling to plant her feminist flag in the internationally distributed comic-book series, even though the term "feminist" appears on the cover of one of her fanzines. This suggests that Doucet's refusal to identify as feminist may have been, at least partially, a marketing gimmick: not only was Doucet uninterested in acting as a spokesperson for the reviving women's movement in early 1990s North America, but *pleeennnnnttttyyyyy* of readers both woke and oblivious avoided work so blatantly labeled.

Nonetheless, the work itself acts as a tool that has become vital to understanding the role women can play in comics, or rather, has become vital to understanding that gender does not need to be a factor in determining creator potential. This still matters to the degree that the industry remains gendered—and gendered, so often, masculine.

Which brings us to Kominsky-Crumb's husband. Contemporaneous to the *Dirty Plotte* fanzine, Robert Crumb put out *HUP* with Last Gasp as a four-issue miniseries, and today it stands among his few works that have never been

collected. *HUP* pledged itself an "adult comic" with the first issue, and a bulbous-nosed, blond-wigged character named Stan Shnooter, purported editor of the line, leered from the cover, shouting, "Hey fanboy, grow up!!" while clutching a woman with shiny coiffed hair, perfectly spherical tits, and an extremely tight plaid skirt notably close to his groin. "Don't be afraid!" she says, although she seems a bit wary herself. Her head's turned slightly away from the reader—we're meant to read this as coy, although she's also pulling away from both Shnooter and whoever is holding the comic—and both arms are behind her, useless and weak. On the inside front cover, Shnooter laughingly promises readers "thrilling adventures and recreational sex," "spectacular inking," and "emotional maturity." The issue features five stories: "The Ruff-Tuff Cream-Puffs Take Charge!" in which a rhino-snouted military brigade stages a coup and forcibly ejects some "mealy-mouth liberal wimps" from government but, once in power, can't keep themselves from unthinking self-destruction; "Uh Oh! He's Back" about faux-guru Mr. Natural's return to disrupt witless Flakey Foont's peaceable middle-class lifestyle; "My Troubles With Women Part II," Crumb's autobiographical tale about persecution at the hands of high-school bullies and the sexual fetishism that arose from it; "Here He Comes Again!" in which Mr. Natural introduces Foont—and readers—to a woman named Cheryl, Crumb's infamous Devil Girl; and the back-cover monologue on white middle-class cismale anxiety, "Don't Worry About It!"

There are two sets of actors in the world of *HUP*: muscle-bound, beer-swilling, gun-toting thugs and their opposite, frumpily clad pencil-pushers, the meek who always inherit. Indeed, Crumb, and his devotees, read this as a wide gamut

of people, and no amount of explaining that two kinds of white, able-bodied, middle-class heterosexual cismales fail all diversity tests has yet managed to sink in. In Crumb's *HUP*, the essential morality play pits a self-aggrandizing and strangely incurious form of intellectualism against loutish physical prowess, and the muscle-bound—a reversal!—are outsmarted every time. Women are corollary to the action, objects of desire, quite literally: they are only ever objects whose sole function is to behave, in some way, desirable.

Devil Girl is our shining example. An independent, sexually provocative, unusually large-framed and physically strong woman, Mr. Natural presents her to Foont in *HUP* #1 as "bad" and, shoving her abnormally long tongue back in her mouth with his finger, says she "needs taming." (For her part, Devil Girl goes down on all fours and capitulates with a "RAAHRRR.") In "The Meeting," from *HUP* #2, Mr. Natural brings Foont and Devil Girl together again, this time because the bearded guru has tired of her endless sexual demands. Mr. Natural hypnotizes her, sending her into a paralytic state he describes as "neutral." (Notably, Crumb uses the same graphic tropes to image her mental disaffection as those that indicate when Krazy Kat is hit by a brick: shock waves, tiny rounded pops of pain, and large smoke rings about the head, the combination a cartooning shorthand for blunt-force trauma.) Mr. Natural leaves Devil Girl in Foont's care and toddles off to bed, and the hapless schlub tests her physical responses, at first by kicking her—growing increasingly angry over slights she had made against him while conscious—but soon by toppling her over and rubbing himself on her, a sexual assault. She begins to awaken in something like an epileptic fit, choking on her own foot and seizing while Foont cums in his pants. She is presented to her sexual assailant a final

time in "A Bitchin' Bod" in *HUP* #4 (subtitled "The Comic for Modern Guys"), when Mr. Natural delivers Devil Girl to Foont, having stashed her head inside her neck and bound it with a metal fastener. "She had such an irritating set of sensibilities!… And such a nasty mouth! Oy! It was vicious! The constant bragging, the lame sense of humor, the combativeness… Let's face it, she was obnoxious!!" says the pseudo wise elder when Foont balks at the cruelty. Foont's qualms ease once alone with the headless figure, which he shoves against a wall before removing its pants. He becomes sexually excited while punching her in the ass, and his recognition of his behavior as socially inexcusable only heightens his titillation. But the torment and nightmares grow, and Foont returns the body to Mr. Natural, who then pulls the head back out again. "That was SO-O-O WEIRD!" she yells, revived and happy, rushing to the mirror to do her hair. She is unperturbed, even asking Mr. Natural to return her to a headless state, until she discovers that he had granted Foont access to her headless body. The comedic "who, me?!?" shrug Mr. Natural evinces, a few beads of sweat flying off his brow, indicates that we're supposed to read her protestations as fickle, and roll our eyes at a woman who has clearly laid out the boundaries of her consent as limited to Mr. Natural several times throughout the course of the storyline. Crumb depicts her, arms up in silly rage, stomping "BLAM" and "CRASH BANG" with both feet—camel-toe-free crotch somehow fitting into the frame—making silly threats while the bearded guru leaps out the window on one side of the panel and Foont escapes with an "EEEK!" on the other.

No question is Crumb's linework crazy brilliant here, each rounded form creating a believably rock-hard surface. Lettering and speech bubbles fill out the composition of each

panel seemingly effortlessly, with crosshatched backgrounds always situating the reader in real-ish space, real enough space. Crumb, too, created immediately inhabitable worlds; it's just that a lot of us are left wondering why we might want to visit them.

Such work was far more socially acceptable thirty years ago, when it offered a stabilizing framework for transgressive culture in all forms. Last fall, however, while I was reading "My Troubles With Women" over breakfast at a crowded diner in Providence, Rhode Island, I was asked by a young woman to put it away. "It's Crumb," I said, not to argue with her, but to see if it contextualized the two-thirds-page-sized panel, of a sexually excited man strangling a woman from behind, that I was lingering over. It didn't. "I'm just trying to eat my breakfast," she responded wearily.

Some weeks later, the cartoonist Jessica Campbell would pen a comic for *Hyperallergic* describing students' similar disinterest in the master of the form. The comments section quickly filled with angry detractors claiming Campbell doesn't understand Crumb.

I'd suggest that she does. And, although I balked at her at first, it's possible that my Providence breakfast companion did, too. After all, the current president of the United States has admitted to similar behavior and desires as those depicted in Crumb's oeuvre, in statements that have appeared on the covers of newspapers and magazines fairly consistently throughout his administration. Folks nowadays are perfectly capable of comprehending Crumb's deep mining of the masculine Id, in other words: they might just be bored by it.

Still, the unfettered release of Crumb's extremely elaborate fantasy life all over the page—and industry—has doubtless

helped to advance both the narrative possibilities of the form as well as the aesthetic ones. In many ways, in other words, the feminist problem with Crumb does come down to jealousy. In no arenas of our culture are women (or people of color, or folks with disabilities, or nonbinary people, or queers) granted the latitude and monied adulation that he, even today, receives for his (frustratingly narrow) brand of transgression. Whether expressing sexual fantasies, deviant or vanilla, or more mundane desires, few other figures are as rewarded and acclaimed as Robert Crumb for depicting their interior wants and needs, in comics or elsewhere.

For a time, however, we had Julie Doucet. What she and Crumb have in common—if we set aside career longevity, industry clout, economic comfort, and personal relationship stability— is remarkable, owing in no small part, I am sure, to the fact that she read a lot of his work. Looking closely at the background of any of her mid-series strips will give you a sense of just how strong that influence was. It is evident there that Doucet studied Crumb's shading techniques to craft her immediately inhabitable worlds. Beyond technique, the influence extends to Doucet's choice of subject matter, as well as her on-page bravado. She reads in Crumb an encouragement to depict her own joy, not a gendered prescription against its expression, which remains the traditional feminist interpretation of his work to this day. We can begin to see, then, that a claim toward feminism on Doucet's part may have limited not only her audience, but also her imaginative potential. (Few self-proclaimed feminists of my acquaintance would, for example, express a wish to rape someone.)

Let's look at the dance strips. When Lisa Biscuit and fluffy pup Fifi return home after a routine trip to the grosh, a

celebration unfolds. Biscuit struts and juts her chest, arms free
from her sides if slightly beleaguered by the weight of her sack.
Her legs bend in ungraceful positions, although it is because
she is trying something new, and she wants them to move that
way. In comparison, Crumb's Devil Girl—or we could call her
Cheryl—merely undulates, displaying in one panel spread legs,
limp hands, hard nipples, and bouncing, thick thighs and in
the next her ample, tight ass, clenched for the viewer, back
arched so that breasts, from the quarter view, are still visible,
and the long hair covers her boring, useless torso. (Merely
housing her heart and lungs, this body part, from the back, is
useless.) Three men on the cover of *HUP* #4 also do a sort of
dance, one snapping his fingers while the others scat or vocalize
meaningless dude things. They're middle-aged white cismen,
plump and comfortable, in baseball caps that display what we
might presume to be their places of employment. It's a Saturday
morning, probably, and they're supposed to be completing
household chores, but they've escaped from their wives just
long enough to have a bit of fun. Cheryl, in contrast, always
dances alone, performing for Foont and Mr. Natural, seemingly
pleasuring herself by moving only slightly and by being on
display, a fully privatized subject. Their pleasure—Foont's,
Mr. Natural's—is her pleasure, and *our* pleasure comes from
perceiving the depth of their erotic enjoyment. Lisa Biscuit,
however, delights at her own movement, and the resulting joy is
uncontained, contagious. Her dog catches it, and soon the city
is following her lead, a musical number we don't even have to
hear to start tapping our own toes to. It is a remarkable feat to
accomplish in a single page of newsprint.

 We could also compare how the incapacitated are treated
in each author's work. The loss of Cheryl's head, for example,

bothers Mr. Natural and Flakey Foont not at all, and even Cheryl's OK with it for as long as she believes she's been in the care of someone she trusts. Julie's epileptic seizures, however, are an ongoing cause for concern. In "The Day I Can't Take it Anymore," they are part of the reason Julie moves to the desert, so she can abandon her medication and have fits a safe distance from harm. In *My New York Diary*, Mike's lack of concern for her epilepsy (he refuses to accompany her to the hospital, begs her to stop taking her medication, and his foremost demand after she has a massive seizure is that she acknowledge that he saved her life) is a significant plot point and leads to the breakdown of their relationship.

Or housework: Doucet is all for it, or rather, is all for acknowledging that housework is a necessary task while simultaneously refusing to do it. When Super Clean Plotte breaks into her house and starts scrubbing, for example, Julie-the-character is left with no choice but to destroy her. And when she has a free moment, Doucet's Imagined Self is happy to wander about the place, as in "Clean-up Time," and show off all the items that require cleaning in her apartment, knowing in the end that what she will suds is her cooch. In *HUP*, housecleaning comes up exactly once, in a string of complaints on the back page of issue #2, when Flakey Foont arrives home to his beleaguered and unattractive (read: glasses-wearing) wife. Covered in scratches and bruises from his molestation of the unconscious Cheryl, but trying desperately to hide his infidelity, Foont asks his wife Ruth to grow her hair out, to look more like the Devil Girl (in the scenes in which she has a head). Ruth fires accusations back at him, and complaints, none of which suss out his betrayal, culminating only in the nagging demand that he hire a housecleaner. This, she says, would give her "time

for long hair." It is the only time in the four-issue run that housework—"the work that makes all other work possible," as domestic labor organizer Ai-Jen Poo calls it—is acknowledged.

Not that men, in Crumb's work, are ever really let off the hook. They're all degraded to some degree in his depiction, whether obsessed with regular girls, cast as boring, or sexually excited by larger women and humiliation (a preferential status Crumb reserves for himself or stand-ins like Foont.) The back cover of *HUP* #4 even features an "R. Crumb Dartboard," with a central self-portrait leering and deranged beyond the usual, with a bulge in his pants and a long trail of saliva dripping from his lower lip, mirrored in eight beads of sweat that glop down his wrinkly forehead.

Doucet's men are treated with more compassion. Even Louis, a provable lout, is sparkling and clean in his final appearance in "Julie in Junior College," when only Julie-the-character grows shaded, angry, and hard as she spots him. "ASSHOLE!!!!" she thinks—but only thinks it, her anger fully internalized, as Louis wanders the hallways of the school totally unimpeded, looking well rested and content if unshaven after a night spent tormenting Julie with a suicide attempt. Even Mike from *My New York Diary* suffers the comparatively mild humiliation of sweat beads—rarely more than four—that leap from his head when he is at his most slimy and manipulative, as when he demands recognition for saving Julie's life. When he is also crying, in a scene of unmitigated self-pity instigated by an eviction notice that he blames, for a moment, on his hairdo, Mike's posture, seated on the floor, is wilted, but hardy. He leans on Julie, seated in a chair above him, and although she grows angry at his narcissism, her support of him is never withheld. Not even when he calls later, sweet-talking her with elaborate

dinner plans, aware that she is displeased but unaware that she is packing to leave him at that very moment (the skeleton tacked to the bedpost leaps into the frame only when she answers the phone). Even then Julie-the-character is still pliable. "Yyyes ... sure ..." are the last words she says to him. (It is possible that she let him off too easy. The real-life Mike contacted her some years later, Doucet tells me, to forgive her.)

Crumb's aware of the criticism of his female characters. "Have at me, girls!" begins the text under the "R. Crumb Dartboard." "Simply cut out and mount on any dartboard or a plain piece of corrugated cardboard. Do you know how to do that? Or is it perhaps too technically demanding for you? Maybe your boyfriend will help you with it, or that big butch lesbian down the street." *HUP* #4 came out in 1992, the year even *Newsweek* ran a story on riot grrrl. Women, and their rights to self-representation, were literally all over the news.

Crumb didn't care that he may have been, even then, horribly out of step with the times. (Less kindly we might call this regressive.) *HUP* glories in its deliberately hypersexualized depictions of women—all of them, regardless of race or creed or color—so enthusiastically that to suggest that Crumb might glory in his hypersexualized depictions of women is absurd, the ur-example springing to mind of deliberately hypersexualized depictions of women *being* a female R. Crumb character, subjected to one or another of his erotic humiliations. This is *his thing*, and if we have stepped away from it at any time in the last thirty years and then returned, we may find ourselves surprised by how much of *his thing* it really is. (Certainly, if you have never spent time with his work, and it takes you by surprise at breakfast while the news is blaring reports of sexual harassment at every level of government and in every field of employment,

you can be forgiven for preferring to view something else.) *HUP* #4's "You Can't Have Them All: Magnificent Specimens I Have Seen" is Crumb's recollection of women he has desired from his daily life over the years. *HUP* #2 also features "The Mighty Power Fems Versus the Horrible Homonculi," in which a group of women bodybuilders-slash-crimefighters are called in by the District Attorney to capture some male evil-doers who barely come up to their knees, yet somehow overpower the lot and put them to sexual service. Also appearing in the issue is "If I Were a King," a twelve-page fantasy of the blow-job-replete lifestyle the author suggests would be his as a monarch. (To be frank, my primary reaction to Crumb's work thirty years on is how tedious the sex becomes, as if his drive was to crank out predictable pornography and not to explore much of interest. When Doucet's fantasies get repetitive at least she calls in an elephant.) Women, under Crumb's pen, are huge and thick and rounded, with wide mouths and wild hair and thick ankles. One imagines that if you touched them they would feel like metal, or a hard wood, more sculpted than organic. Their most interesting bits are always missing, too. Breasts are evenly weighted and perfectly rounded, no asymmetry to draw the eye from one to the other. Scars are absent and hair wavy and full and predictable. None of these women exist, outside of this panel or this moment in Crumb's imagination. Their cunts are always bulbous and ready and—surprise!—hair-free, and of course they all have the same taste in shoes. Sometimes, sometimes, a hat tip to biology: a small slit in the underwear or weightlifting costume or spandex leisure suit—just big enough for one scrawny cartoonist's cock to fit inside.

If you imagine that Doucet would have cared much more than Crumb did about women's representation in 1992, though,

you may be disappointed. She didn't often draw other women, with only a handful of female characters appearing in all of her comics, total, at least until *365 Days* was published fifteen years later. "At that point I had quit comics," she tells me. "And I started to have women friends." Doucet was never involved in riot grrrl, the young feminist movement Bikini Kill helped foster. When Kathleen Hanna and Joanna Fateman wrote the song "Hot Topic" for Le Tigre in 1999, they weren't bothered by her disinterest.

"You're getting old, that's what they'll say, but don't give a damn I'm listening anyway. Stop, don't you stop. I can't live if you stop. Don't you stop," they sang, injecting into the song a stream of names of cultural producers and thinkers central to contemporary feminist thought. Julie Doucet was among them. For when she did depict women—herself, of course, in real and dreamed and imaginary forms, as well as a handful of friends in the autobiographical tales, and later, in portraits—they were complicated, raw, awkward, and true. In the "Ladies Section" of *Long Time Relationship*, their ribs show and their breasts are uneven. They are too skinny, or their hair sticks out. They have unshaven, out of control, pubic hair. A sex scene in "Das Herz" in the same volume shows a woman entirely obscured by the man fucking her. Das Arschloch, it's titled, The Asshole, and indeed both his and her assholes are clearly visible, body hair intact. An upskirt shot in "Today We're Gonna Eat Frog Legs!" shows a crop-haired young woman, miniskirt hoisted, the weight of her vaginal lips heavy in her visible underpants. Several full-color pregnant women appear in *Long Time Relationship*, rounded bellies, blissed out if unshaven, and women's pussies from the Sophie Punt series and elsewhere are cavernous. Labias swing to upper thigh in some cases, and readers catch the barest hint

of what the world of cartooning might look like if any female cartoonist were ever offered the latitude and monied adoration that Crumb receives.

But it is far more than Doucet's depictions of women that resonate today. This is made all the more clear in comparison to Crumb's objects of desire. Doucet doesn't image a one-sided sexual agency through carefully crafted line and polished, rounded objects: she *performs* it, each gleeful mark a testament to her independence and ferocity. The question of what a "female Crumb" might really look like—even if we pretend the concept isn't wholly dismissive of the incredible cartooning talents of Aline Kominky-Crumb and Sophie Crumb, who actually exist, making the question essentially misogynist in construction— isn't at all the point. Like Crumb, Doucet constructed narratives that did, occasionally, relay sexual themes *or actual sex*, but this remains secondary to the establishment of her full bodily agency, on page one, a demand for recognition of the validity of all her choices.

And when those choices went unvalidated, she walked away. Despite the interviews, despite the thousands of other women's voices demanding the same thing, and despite that it was evident in the work itself, people still ask why she stopped making comics. "She told them," John Porcellino says. "And they didn't want to hear it,"

"Stop, don't you stop. I can't live if you stop. Don't you stop," Le Tigre sang. It was right around the time Doucet stopped calling herself a cartoonist.

But if there is one central lesson in those hand-drawn, panel-bordered narratives, it is that Julie Doucet is beholden to no rules.

Interview 1, *Punk Planet,* 2006

Ask most people to name the greatest working female cartoonist; and they'll reply, "Julie Doucet." They're wrong—Doucet stopped cartooning close to seven years ago—but their hearts are in the right place. Her comics are uniquely expressive, immediately recognizable, and provide instant, easy access to a compelling moment in history. Perhaps unfortunately, the "greatest female cartoonist" description follows her around US cartooning circles today. Ask most people to name the greatest working cartoonists, and you might hear Robert Crumb, Harvey Pekar, Peter Bagge—men to whom Doucet's work has often been compared. It is only when you add in the issue of gender that her work receives the recognition it is due.

This is partially because Doucet's comics, rooted in autobiography, are uniquely feminine—and by that I do not mean frilly, pretty, or giggly. They are dark and rough and bloody. They depict drug use, psychosis, cutting, sex, and even motherhood as visceral, bodily experiences replete with complexities and deep emotional tolls. Also they are hilarious. Created alongside the unbordered, barely definable milieu

of the riot grrrl movement, her twelve-issue *Dirty Plotte* series captured Fuck You, Fuck Me Feminism in a manner only rivaled by the slip-dress/Doc Martens outfit pairing so common at the time.

The wildest and most prescient of these *Dirty Plotte* strips were always the dream sequences. In these, Julie-the-character was constantly enacting the oft unspoken fantasies of my generation: to meet Mickey Dolenz and Nick Cave; to have a penis, just for a little while, to see what it was like; to birth a baby that was actually a pet kitty; to experience the life of a shoot-'em-up cowboy; to masturbate on a space ship; and to be handed someone else's cut-off penis, just for a little while, to see what that was like. These stories were originally collected into *My Most Secret Desire* in 1995, and the recent reprinting of this collection, in April of 2006, serves to remind readers how ahead of its time Doucet's comics were.

Foretelling the recent hot-topic issues of gender dysphoria and cutting, *Dirty Plotte*—regrettably, the Canadian artist's only major contribution to the medium to date—even earned Julie-the-cartoonist a spot in the 1999 Le Tigre song "Hot Topic." Alongside artists as diverse as Yoko Ono, Faith Ringgold, Gertrude Stein, Carolee Schneeman, Angela Davis, Dorothy Allison, and Joan Jett, Julie Doucet is honored as one of our most beloved cultural revolutionaries, even as the media proclaim the death of feminism. "You're getting old that's what they say but / Don't give a damn I'm listening anyway," Kathleen Hanna sings, underscoring that, while the days of a comprehensive women's movement may be past, the vital work of individual women still demands our explicit attention.

It is in this context that Doucet's comics must be viewed. (And really, they must be viewed.) Sure, the work fits into a feminist

movement—quite easily, in fact, even despite her protestation that her aims were never specifically feminist—but it also explores more resounding artistic questions. "How important is physical health to art?" her comics ask, and, "Do successful portrayals of sexuality rely on the gender of either the artist or the main character?," and "How important is success, if it impedes personal happiness?" Like the questions raised by the work of Gertrude Stein, Angela Davis, and Joan Jett, these are universal concerns, not feminist ones.

And so we come to the second reason most people are wrong when they proclaim Julie Doucet the greatest working female cartoonist: because she was simply one of the greatest cartoonists. No further description necessary.

Yet the reasons Doucet left cartooning are not widely discussed, probably because the isolation she felt in the field, partially due to being a woman in the masculine world of comics, may be a point of shame for other cartoonists. But also, she's fairly shy, a pretty, quiet-voiced, French Canadian-accented woman not quite as bold as her linework (and with hair not quite as messy). Moreover, she's left cartooning for the less nerdy and more gender-aware environs of the general art world, and she's happy there. She's also successful, in part because her cartooning past gives her current work a strong narrative and autobiographical core people seem drawn to.

Doucet spoke with me over the telephone on the eve of the rerelease of *My Most Secret Desire* by Drawn & Quarterly, the Montreal-based comics publisher that got its start by putting out Doucet's work. For the most part, we limited our conversation to comics, which may seem a strange choice since she no longer works in the field. However, she's profoundly influenced by her experiences with the medium, remains a strong influence in it,

and as you will see, still makes a living from it. She just isn't going to go back. I was honored that she opened up to me about her former work and current passion, as those of us who still work in the field can still learn from the experiences she had while she was there.

As I was rereading *Dirty Plotte* the other night, I realized that we had corresponded in the mid-1990s. I came across a note you'd written in one of my books: "Anne, This is the one I was telling you about. Julie."

That's funny. Were you drawing comics or anything like that?

I was not, but I reading them voraciously: everything by you, Chester Brown, Ellen Forney, Peter Bagge, Mary Fleener. But you aren't drawing comics anymore.

No, it's been almost seven years. Six years and a half.

What was the last comics work you published?

The Madame Paul Affair. That was the last thing I did pretty much. It was running in the newspaper. And the last of it was published in November '99, something like that.

Do you miss anything about it, or are you simply glad to be done?

Oh, I'm glad. I'm so glad. I was sick of it, I mean, it took me three years to find a way to get out of it. Because I was making just enough money to be able to live, but not enough to be able to take a break. You know, I spent [*exasperated sigh*] twelve years drawing comics and only comics, not even a sketchbook. So I'd be working like a dog all the time. And it was just no fun anymore. And the crowd, it started to drain. I couldn't take it anymore.

Your particular fans, or the readership of comics in general?

Oh, no no. It's about—it was like an all-boys crowd. Which I was really comfortable with when I started. But then it changed. I guess I changed. You know, all they talk about is comics, comics, comics. And they are not interested much in anything else. Not very open-minded, I feel. I had enough of the comics-nerd attitude.

Hmmm. I've experienced that, too.

So I'm not crazy? I don't think I suffered from sexism, like I never had problems to be published or anything like that. Was I being paid less? Who knows—certainly not by Drawn & Quarterly.

Then how did the all-boys crowd come to affect you?

Most of my problems came from the love relationships, the fact that I was the successful one. Since I was in a men's world it took me quite a long time to get to talk about that with other women who had the same type of experiences. I can tell you, that really poisoned my life. And in a way that is what I am most resentful of, when I think back, of those comics years.

And what have you been working on since?

I'm mostly writing now. When I quit comics I became a member of a printing studio. My specialty at the university was printing, and then when I quit the university I never ever thought about it again, until now. And so, when I quit comics and I did my first print, I was completely shocked. It felt like, "That's what I was supposed to do all that time." So I did *Melek,* a linocut book, and the *Long Time Relationship* book. And then I did some screen-printing, objects and books. Mostly variable experiments. Collages. A lot of collages. I write with—I cut out

words in magazines and I have been writing small text parts to go under the collage. Then I wrote my autobiography from zero to fifteen years old with cut-out words. It's 208 pages, it's been published in France. That is a really funny one. The way I did it was, I had a general idea of what I wanted to say, then I'd look around in old magazines for the words that could express what I had in mind. Or segments of sentences. I'd use old French '60s magazines, *Elle, Paris Match* ... because the typography is more interesting, and the vocabulary more colorful... Now I'm writing poetry with cut-out words. Bad love poems. [*Both laugh.*] Yeah, they are pretty funny. Very cynical, but cynical and funny. All in French... I am sorry, French is my first language!

So I've been doing a little papier-mache sculpture and woodcuts. There is also the journal project. It comes very close to comics. For one year, I drew/wrote one page per day. Comics people would say, "Oh, this is not comics." But modern art people would say, "Oh, this is comics." I didn't feel I was drawing comics when I did it. Probably because I intended to do something closer to a sketchbook. No penciling, lots of texts, and no narration between the images.

Is this how you are making a living?

Well no. It's very, very ironic. I'm making more money with comics now than when I was drawing them. Because of the royalties and also from selling comics originals. I've been doing some illustration work. Somehow, it's amazing, but I'm able to make a living out of that.

Well, this doesn't surprise me terribly much. Your renown as a comics creator is fairly overwhelming. You've been compared to Crumb ...

Oh!

You sound surprised, but you must have read these reviews, too.

Yes but, it's always, uh. I dunno. I still can't believe it. I will never get used to that. The other day I was in a bar with a friend and when we got out, this guy comes out and he wants to talk to me, and he was like, "Are you Julie Doucet?" It turned out he was a guy from Chicago, and he just wanted to say, "I love your work." That doesn't happen too often, though.

How does it feel to be placed among the comics greats? You're obviously still flattered by it.

Uh-hmmm... yes, of course, it is very flattering. Especially Crumb, he is such an amazing artist.

Your renown as a feminist in the wider culture, however, is almost stronger than your renown in comics. It sounds like your status as a comics icon still surprises you, but does your status as a feminist icon?

Yeah, in a way that surprises me even more. Because I never intended to create that identity. Like I said, in those days I didn't hang out with women. I had such a low self-esteem. I thought I was ugly, not feminine enough, that I didn't fit ... and saw the other women as competition. That's why I was more comfortable with being with men only. So I was very far from thinking that any other women could relate to what I was doing! I did whatever came to my mind, I was just being myself. And obviously, I am a feminist. It's very strange to see what people see in my work.

Do you feel like you were a part of riot grrrl? And what did you think of the Le Tigre song?

At the time I was not very interested in things like that... I knew riot grrrl existed, but had no idea what they did exactly. Of

course, I did hear the Le Tigre song. Once again very flattered, but that is very, very weird to be in a song of a well-known band. I didn't buy the CD, I can't deal with it. I mean, I love it when I hear it, but wouldn't listen to that at home. Too much.

Has your work has been misinterpreted?

No, no. But I didn't really mean anything special [by it], like I said. When the work comes out, it's not my business anymore. I mean, people should … everybody should have their own interpretation, their own experience with it.

As you prepared for the rerelease of this book, what struck you about this work now?

Oh, I didn't know it was out of print. [Drawn & Quarterly] proposed it, thought it could be a nice edition because it was first published 10 years ago, sort of an anniversary … It was a popular book. I guess I don't have a notion of how popular I am.

Do you want to have a notion of how popular you are?

Not really. Well sort of, but I am rather naive about it, I think. That's what it is. [*Laughs.*]

What was it about collecting the dream comics that appealed to you originally? I mean, some of them were done fifteen or sixteen years ago now.

It was not my idea.

It turned out to be an interesting way of compressing some of your most feminist work into one single, dream-like narrative. Throughout *Dirty Plotte's* entire twelve-issue run, in fact, you addressed issues that have really just come to the fore in recent years. Transgender issues, body image issues, cutting. Can you talk about those some?

Oh. The cutting stuff. Well, very quickly I realized I was not alone. There were quite a lot of people doing that around the same time. I guess it was in my surroundings. I mean, it was strange, but I didn't make it up.

How closely did your comics mimic your real life, and how much were you exaggerating for the sake of telling a story?

Ah [*laughs*]… it was fairly realistic. Yeah, that was my way of life at the time.

So do you honestly think that your appliances hated you?

Oh… well…

I mean, they might have… like that damn iron.

Oh, I didn't even have an iron. Maybe it was not that realistic.

The other question that arises when we talk about realism is, was it difficult entering the all-boys' club of comics while attempting to represent your own sexuality?

I never felt like it was a problem. They all loved it. [They] were uncomfortable with the periods stories, which I thought was funny, silly. But told a lot. At first I could never imagine I would ever be published, so it was not a big issue. It was very much about myself, my own sexuality … exploration, acceptance. You know I have my own limits, of what I would never put in my work, I have my taboos. You can say it was also a little therapy for me.

Epilepsy was a big issue in your life while you were drawing comics, and a subject for your autobiographical pieces. When did you first realize you had epilepsy?

I had my first seizure when I was about 14. I didn't realize it because I lost consciousness and when I woke up I was walking

on a dirt road with one of my aunts. I didn't know; she didn't tell me anything.

Did she know something was going on?

Yeah, of course. But nobody told me anything. So when eventually I went to the doctor's office with my mom, the doctor told me, "So, you lost consciousness." And I was, "Whaa?" [*Laughs.*] My mom said, "Of course you did, Julie." So that's how I learned.

That's a pretty fragile age to be told you have a serious health issue.

At the time they said that I would be taking medication for four years and after that there would be a good chance that it would change back. My reaction was like, "Oh, this makes me special!" My mom cried. I was really shocked, at the same time, but it made me special and I loved that.

But you ended up taking medication for much longer than four years.

Oh yeah, I'm still … at this point, I'm 40 years old. It's going to be for the rest of my life.

And you are back in Montreal now.

Oh, I lived in New York and Seattle and one year back in Montreal, then in Seattle once again. Then I lived in Berlin for two years. Then I came back to Montreal in 1998. Montreal is probably the only place in the world I could live and be able to live off my comics. 'Cause it's so cheap, compared to the States and also to Europe. And it's French-speaking here. It's a very comfortable place. The only thing is that I don't meet that many people who have this emergency of doing things, who are very

passionate about what they do here. Which I miss, but at the same time, it is a very good place to work. I am a member of a printing studio which is very cheap and I would never find that anywhere else.

You're more comfortable in a French-speaking environment, it sounds like.

I guess so, yeah. I'm also able to buy French books. Very important. And I have friends here I can talk to about literature and exchange books.

And those grants …

I got one in 1999. I was able to quit comics when I got this second grant …

The first you had used to support your work *in* comics. What was that like?

[*Chortles.*] It's nice …

Did you get the check and just laugh for six months until the money was gone?

Oh, you're not really supposed to do that. The first one I used to get out of Montreal. [*Laughs.*]

I have this Swedish cartoonist friend, Gunnar Lundkvist, who got a lifetime grant! They had that sort of thing in Sweden. They give you money every year. Can you believe it? It's crazy. But it was bad for him because he couldn't work anymore, he lost all his will, couldn't get himself to sit down and draw. It took years but now he got over it. Yeah, when people are too comfortable, it seems they lose all motivation.

Here in Chicago we tend to have the opposite problem. We work and work and work, and often fail to seek recognition

when we should. It's equally unhealthy, but at least we're getting stuff done.

Yeah, I couldn't live without work. That's one thing. I became so passionate about what I'm doing since I quit drawing comics... I didn't think I had it in me, to be that passionate about—anything.

Interview 2, *2017*

So. You're drawing again.

Yes. But. I don't have any goal. I don't know what to do with that exactly.

I didn't want to draw the same thing I used to, like my comics style, and so I just took anatomy books and tried to retrain myself, teach myself to draw another way. I sort of succeeded. There are a lot of portraits, from pictures in magazines. But whenever I don't look at pictures like that, I go back to my old style. So it's a fight. It's a battle.

Do you foresee in the future that these two styles might merge?

I hope, but I'm not there yet. And I really, really don't know where it's going. I can't wait to figure it out.

For an artist who publishes so frequently, I imagine it might be hard to work without a deadline.

Yeah. But then again, I'm really tired of having deadlines. And making art for a living. I've been doing that my whole life, since I started to make comics. It really got to me at some point. It's a

lot of pressure. You have to come up with some project, to make a book, to always have something to do like that. I just can't take it anymore. [*Laughs.*] I just wish I could do whatever was going through my mind.

Be a farmer for a little while?

Yeah, or make furniture. I tried to quit at some point, making art, but it didn't work. What I did was I said, "OK, that's enough, it doesn't make sense to me anymore." So I decided to make a fanzine about it.

"Here is my piece about not doing art anymore"?

[*Laughs.*] Yeah. My friends laughed at me. It was a fanzine in bad German, too. *Der Stein.* Apparently it was funny enough. It could have been just bad, but it was good-bad. I did nine issues and it was pretty much all about art, and about how art is bad and meaningless now.

Then at the end you put on an exhibition?

I did a small exhibition at the Goethe Institute here in Montreal.

You said you feel like you've been working on deadline since you started making comics, but you started making comics right out of junior college, is that right?

Let's say I started when I was at university. OK, maybe the first pages were in junior college because when I was studying, I think that year, they created a comics course. But it was not really about drawing comics, it was more about the theory of comics.

Oh, is there a theory of comics?

More or less. The woman who was teaching that course—for some reason, a woman! Which, I mean, at that time … she

didn't seem to have that much of a theory. But I think that first course was their laboratory to figure out the class.

Did anything stay with you from that course, good or bad?

The course was taking a very mainstream direction—French mainstream, so lots of science fiction—

—preferable to the American mainstream, for sure—

—Yeah. But this girl who was in the course, on the first day, she just raised her hand and said, "OK, no, but there is this and that and that and that that exist. Let's look into that." And the course was complicated then. She really had a … I mean, I discovered work I had never known existed, like women cartoonists from France that were doing some pretty rough stuff. Like Chantal Montellier. Super good drawings. Ligne claire. Very cold.

I recently got a … there used to be an anthology magazine in France in the '80s, *Ah! Nana*. So I have five issues.

So you walked into a formal education in comics thinking about gender and maybe sexuality, day one.

It wasn't really about sexuality at all. It really didn't go in that direction. I remember Chantal Montellier because she was one of a kind. Nothing compares to what she was doing.

I will admit that my knowledge of French comics is hampered, compared to other European scenes. Do you situate yourself in French comics history?

Oh of course, yes.

And yet the North American/US pull has to be kind of strong.

Well, at the time there was really no way you could get published in France. That's why L'Association was created. I discovered US underground comics very late, let's say in 1987. So I started

to do that fanzine, *Dirty Plotte*, and I put an ad in Factsheet Five, and that's how it started for me. I ordered a lot of fanzines and I met a lot of people that way. Lots of pen pals. I met John Porcellino that way. I got published in magazines and then, *blah blah blah.*

I was talking to John, and he remembers writing away for your early issues of *Dirty Plotte*. I was doing fanzines and reading *Factsheet Five* then, too, but one of the most important ways that I found new fanzines was through other fanzines. As I look back at some of them now, one thing I'm struck by is how many folks working in similar modes never seemed to come across your work. A lot of the young, really radical women artists I was corresponding with didn't seem to catch on. I'm not sure if it was linguistic, or if the Americans I wrote to were just weird about Canada. I feel like I had to go through comics circles to find out about your work, not other women doing awesome shit. Does that seem to fit with your career path?

Yeah. It was a real big boys' club, comics. And because of comic books, with the readers pages, people would be writing to you—to me. And eventually, women started to write to me. But mostly it was men. Eventually it grew to half and half, women and men. But it took some time. It was probably '93, '94, when I was publishing the women's letters. Ah! Women!

I was talking to Chris Oliveros yesterday about how significant your work was to the growth of Drawn & Quarterly. He came across your fanzines, yes, and wrote to you?

Yes, he wrote to me. At that time, it was *Drawn & Quarterly Magazine.* But by that time I had been published by *Weirdo Magazine*, so maybe that's where he saw my work? But of course, we were in the same city.

Because of the book with Drawn & Quarterly [*The Complete Dirty Plotte*], I looked at my old diaries from those days, and I was amazed. I mean, I started to do that fanzine, I distributed it, I gave it away to friends who were cartoonists as well, and it was like an explosion. It got popular very, very quickly. I didn't quite remember that, but it really did. Even in this city. People would be asking me, "Draw a page for my fanzine," or "Do an illustration for this or that." So I was super busy.

Looking back, now, is there any part of you that questions how much you put into it? Or how much you were asking in return?

No. I was selling the fanzine for 25 cents. Everybody was telling me, you can sell that for one dollar, come on! No no, 25 cents. It's funnier, it's nicer, everybody will buy it. It didn't matter to me. Even now, today, when I make my own books and print them and all that, I sell them very cheap. I just want to be read! It doesn't make sense to me to try to … art prices. But the thing also is that in Montreal, people don't have money. So you just can't have anything that's just a little bit too expensive.

These ideas both come out of the DIY punk ethos—the idea of keeping prices low to ensure as wide accessibility as possible, and this deliberately anti-capitalist notion of acknowledging that the system sucks so only playing that game as minimally as possible—but is there one or another that you feel more aligned with?

Oh. Both, I guess.

There are ways that your career can be looked at as a rebuke of capitalism.

Oh that's good. I'm happy to hear that. That was not intended. I'm not someone who is very articulate. So I would have loved to express that more, but it's not my voice. I know it wouldn't work. I know it would just be bad and not—how do you say, not help the cause, but do the opposite.

In an interview for *Carpet Sweeper Tales,* the interviewer asks you about identifying as a feminist.

I'm happy that [people read my work as feminist] but at the time I didn't realize it. As a woman I felt very unfit, I was very self-conscious. I thought I was ugly and I don't dress properly for a woman, I didn't put on makeup, I wasn't wearing a dress. I just felt I was not proper. I was a tomboy. I didn't have the same interest as lots of women around me. So in that sense, what I drew was expressing that in some ways, but also, because I didn't feel like a proper female, I could never ever imagine that another woman could ever relate to what I was drawing and talking about. So in that sense I didn't think it was feminist in the sense that I didn't think it would, that anybody could relate to that. Most of my friends at the time were men, cartoonists, of course, so I didn't really have that feedback that much.

Of course, you know, I was a feminist, but feminism at the time was something else, you know?

What didn't help was that I was distributing my comics in bookstores and record stores, and I went to a bookstore—La Librairie Alternative, something like that, a feminist bookstore—and I gave them *Dirty Plotte* to read to tell me if they wanted to sell it, and I came back and they just told me no. No thank you, it's too violent against women. And I thought, OK, this is just not it for me. I don't fit. So I couldn't really identify as a feminist in so many words.

Not that, to my mind, identifying as a feminist really holds much weight, when we have mainstream media superstars using it to boost careers but changing nothing about their hiring practices for young women in the field, or when T-shirts come out emblazoned with some lady-forward slogan printed with global women's underpaid labor. What I found interesting in re-reading all of your work beginning to end over the summer was that it wasn't until *365 Days* that we really see you navigating female friendships.

Pffft. It's because at that point I had quit comics. Probably three years before that. And I started to have women friends. I became a member of a printing shop, and since then, most of my friends are women.

Last time we spoke, over a decade ago, you were quite articulate about how your relationships were affected by your work—negatively. Where are you at on these matters now?

When a woman has more success than her mate, that screws everything up. And since the beginning I was getting a lot of attention. And right away—right away! I had problems in my relationships with men because of that. Jealousy. Competition.

Do you remember any specific incidents?

Yeah. There was a free newspaper at the time here, the *Montreal Mirror*, and I thought, OK, I'm gonna try. That's when I wrote my first comic strip in English. And I told my boyfriend, and I showed him what I was going to do, and he said, why bother? I mean there are a bunch of good men cartoonists in town.

Did those moments affect your career?

No, not my career. But relationship-wise, it's been pretty tough.

That is certainly a theme that runs through your work, but the only project that seems to be negatively affected by such tensions is *My New New York Diary* with Michel Gondry.

That's my biggest professional regret. It has nothing to do with my work. It was supposed to be very small in the beginning, just to try out something, but it ended up being so much bigger. It's his film.

Are there any other works that you question, or that would go about differently now?

The story, "My First Time." That got too personal. I had done too much autobiography, at that point. Why tell everything? A few people also told me it made them uncomfortable, and looking at it now, I think: Oh! Why did I do that? You don't put everything in a comic. That was too much. Too many details. And maybe because it was just such a sad story.

You're often described as an autobiographical cartoonist, but it's hard to read more than a fifth of your strips—in terms of number of strips, not page count—as autobiography. You did develop all these ways of protecting your privacy, while still letting your character drive narrative. I was surprised to discover that about half your stories are fiction.

People think it's autobiographical because I use my own character to tell stories. But the first part of my work, it was not autobiographical. It's like fantasy. And the dreams, I mean, a dream is a dream. It's not autobiography. It's a made up world, in a way.

Is there anything you would be interested in going back to, or exploring in another form?

The more wacky stuff, I guess.

What is wacky to you?

The strips about having my period. I mean, I wouldn't do that, but that voice. I wouldn't do autobiography. Never again. Impossible.

What about some of the fiction strips, "Monkey and the Living Dead"—

Oh that was so bad. It was improvised. It didn't really turn out good. I know lots of people loved it, and some others just hated it.

How much do you think your work is affected by health issues—your epilepsy?

You know, something like epilepsy, it's part of you, but you don't really live with it every day. And when you have a seizure, at least with me, I don't see it coming. It's like a big void. I'm just not there. So it doesn't really exist in a way. It's not something that I think about all the time. Maybe more when I was younger. When it first started, I was taking four tablets a day. That makes you think about it quite a lot.

And you had mononucleosis while you were working on *My New New York Diary*.

That was special because—it was a burnout, basically. Since I don't really want to draw in the first place, after that I just couldn't draw anymore. And for years. At least seven years.

I've been wondering lately, in the wake of the Harvey Weinstein allegations—

—oh there have been a few scandals here, as well!

Every day there are more! Someone losing a job over an extensive history of sexual harassment! In comics, of course,

too. It's been making me wonder what my career would have been like—or what your career would have been like—if such allegations had been heard and properly responded to years ago.

I didn't suffer from that [directly] so much, I guess it's because I was drawing things that were so sexual and so not what you expect a woman to do. So in some weird way I was respected. I think I impressed the guys because of that, so I think I didn't have a lot of problems that other women had in comics.

I think that's probably true, that you had stunned people into engaging with you in a different way. Was there any part of that that was a strategy?

No. No.

Let's talk about your process for the collage work.

For the autobiography I had a general idea of what I wanted to say, but I didn't really have the words, so I would have cut out pages from magazines in advance where the vocabulary was either interesting or funny or both, that I knew I could use. I'd be looking for words that could fit in whatever I wanted to say, and sometimes I'd find one that was not quite what I wanted but that would make an accident, that would make something funny or something poetic.

But in other cases I would just pick one word and build something around it. It's all about constraints, so in the case of *Carpet Sweeper Tales*, because I have done so many projects with cut out words, I keep some sort of trays with leftover cut-out words with verbs, nouns, or sometimes just syllables. So whenever I start a new project I take some of the words from the previous project and I start with that and I have to use all of

that. That's the constraint. So it was the case of that for *Carpet Sweeper Tales*. I had leftover letters from a previous project and I was very interested in sound.

For the text it was *Good Housekeeping* and *Better Homes and Gardens*. And the pictures come from fotonovellas.

Are you excited about the Drawn & Quarterly compendium?

I don't know exactly what will be in those texts. I know a few of the people who are going to be writing about my work so I trust them, but there are a bunch of other people that I don't know. The thing is that my eyes are really bad and I can't stand the light of a computer, so I tend to not [look at it] if I don't have to. So that was just a little bit too much work. We'll see when they're written. Maybe they just won't go in the book. They [Drawn & Quarterly] are very respectful.

How do you feel about your role in making Drawn & Quarterly what it is today?

Oh. It goes both ways. It's equal. [But] I was never a commercial success. And I quit almost twenty years ago.

At some point in the floppies, you began printing the work of other people. How much of that decision was to lessen our workload and how much of it was to share your platform with other creators?

Pffft. Yeah, it was too much work. [*Laughs.*] And at the same time, it was a good occasion to show other peoples' work that was not published as much as me. I mean, John was making *King-Cat Comics* but was not really being published anywhere else at that time. When I was doing the *Dirty Plotte* fanzine, I was putting out a new issue every month. I did fourteen issues. At some point, it got to be too much and I decided, OK, from

now on, there are going to be other people in the fanzine. But people hated it. So it just went back to being a solo fanzine. I don't know why I tried to do the same thing with the comics.

Well as a reader, it's jarring, to have to jump out of your specific language and universe, which really is unlike anyone else's, and to jump into someone else's. But I also respect it as a creator, that you were willing to share your space with others.

I remember when I did that, I was in Seattle. It was not like in New York. In New York the atmosphere is so competitive so it was not that nice. But in Seattle it was really cool to be around so many cartoonists and have new friends. It was very friendly. I guess probably it was just to share with the other guys.

But complicated, maybe, for a woman in comics to give up space to a man.

Hm.

Do you miss any of the places you've lived?

No. [*Laughs.*] I went back years later, to Seattle. I really didn't like it.

Seattle's a different place now.

Yeah, and last time I was in Berlin was thirteen years ago.

Sure. Berlin changed fast, too.

Yes, I left in '98 and went back in '03.

Is there a language that you miss speaking from your time living elsewhere? German?

Oh, I didn't really learn German while I was there. The first six months were so horrible. Bad luck and stories. So I thought, OK, I don't want to stay here, I don't want to go back to Montreal, I

want to stay in Europe but where in Europe? So I ended up two and a half years in Berlin but not making the effort to learn the language. When I came back to Montreal I felt so stupid that I took German courses.

That's why I did the *Der Stein* project. To practice my German. It really was a need for the beauty of a new language.

So much of your comics work was about wanting to leave Montreal, and now you are a Montreal-based artist. That's a part of your identity. How do you feel about that?

I am fine with it. But by the time I left in '91 and then when I came back eight years later it was a different planet. It was so different in that sense. It was much better.

Quebec tends to be a little bit more social[ist] than the rest of Canada. I'd go for [seceding] if that party that was going to propose that was true left, but other than that. … No, it's never going to happen.

It's just the language, mostly. The culture and the language. It's a tiny bit more socialist, but it's mostly to protect the language. But it's insane, that a lot of Anglo-Quebecois, they speak French. Here in North America? Everybody speaks English everywhere, and still, in Quebec province, people are learning French. That's amazing.

But for the First Nations, [secession] would be another frontier, and that's not good.

You have to realize that for Quebec, it's very touchy. It's a French-speaking community, all the immigrants speak English. Before we started to have immigrants that spoke French, and had direct contact with immigrant communities from elsewhere.

Can you talk me through your strip on Quebecois separatism?

Oh, it's silly. It's not like this anymore, and I don't know that it's ever been like this in the States, but on election day, you can't buy alcohol before 8 o'clock, or something like that.

So [*points to strip*] I was just waking up and saying, "Oh, if I go vote—of course, when I go vote—they are just going to cancel my vote, so should I bother going? Oh of course! But it's time for a drink, it's aperitif time!" So I go to the store to buy beer, but it's not late enough. So I come out of the store and yell, "FREE QUEBEC!!!"

And that's what it takes for you to do an overtly political strip: being denied beer.

[*Laughs, deeper and harder than I've heard her laugh before.*] Yeah.

So what was it about, always wanting to leave this place you obviously have strong feelings for?

The reason why I really, really wanted to leave Montreal in the first place was that everything for me was happening in the States. I would be telling that to people around here, or family or whatever, and they would be looking at me like, "What is she talking about?" So I didn't feel appreciated.

I left because of that but also because, you know, here, life is nice. It's easy, it's cheap. It's not so much anymore but for a long, long time it was easy to get by and not work so much. And because of that, it makes people kind of flaky. There's not this energy, this emergency to do something, all the time. I really felt like this, a lot of the time. I felt this urgency to do stuff.

Do you still feel that urgency?

When I can back from Berlin, I knew exactly what was waiting for me, and I accepted that, and it was fine. But eventually I met

these women [at the print-making studio] and one of them was very active and a great artist and working hard and working all the time, and her life was just that. Still, today. So that was the one person I was clinging on to. I mean, we were best friends for a long time. But eventually, yeah, I got to meet other people like that.

Are you still involved in the studio?

It closed, and then moved away. It reopened somewhere else, kind of far away. But I don't really have printing projects. Now the clientele has changed quite a lot, and younger and younger and younger. People coming out of school.

I don't know if this is like this everywhere but now, as a cartoonist, you can go to school to learn how to draw comics. So you can get grants, you can get exhibitions, and you have to write an artist's statement. So people coming out of art school, they are domesticated. They are very ambitious as well, so they work hard, but there is this emptiness. Not everyone of them. But there is this … domestication. No will. You don't feel the emergency.

You know, I tried to stop making art, but I just couldn't do it. These days where I feel tired, I just can't go on like this, I wish I could do other things. So I say, OK, I quit, and then the next thing you know, I buy another sketchbook! But you don't feel that energy, at least in that crowd.

Sure. Professionalization and domestication—and the ease of internet publishing without the pressure to live an interesting life from which interesting stories might come—I see it too. Is it strange for you, when you aren't actually involved in the day-to-day of the comics world?

Yeah, it's very strange.

It reminds me that, as it's become known that I'm doing this book, I've had people—men—urge me to use it to convince you to make more comics, to come back to comics.

Oh, I know. When I said I was quitting comics, nobody believed me. They said, "Oh, she'll be back in two years." But I never came back. Even close friends, cartoonists from Europe, would be like, "In five years you'll be back. You just can't do that. You just can't. It's impossible." It's like being a priest and wanting to quit.

Is there any fight in you to regain that space? Or are you waiting for everyone to catch on to the fact that what you're doing now might be more interesting than comics?

Oh, I gave up on that.

I mean, everyone is going to want to tell you that it's changed, that it's all different now, there are more women, it's all easier. But it's 2017 and I'm still sometimes the only woman in the room at the comics event.

Right now, I have to say, drawing comics to me sounds like something that could be really fun to do. I haven't figured it out, but I have been toying with that idea. Don't tell that to anybody, of course.

But I find the comics audience disappointing, because if you do something a bit too weird, nobody's going to follow you. It has changed quite a lot, and it's better than it used to be, but for that reason, I'm not sure I want to go back to drawing comics. I go back and forth. I shouldn't think that if I draw comics that I can make a living from that, because I know that a lot of people will be disappointed in me.

ACKNOWLEDGEMENTS

Thanks of course are due to Julie Doucet, who I suspect found this process intolerable, yet who responded patiently to my every query, a great many of which concerned the proper spelling of French cat names. Without her this book would obviously not exist, and a great many of my other works and adventures would likely have suffered or failed to come to fruition as well. Chris Oliveros, Peggy Burns, Tracy Hurren, Tom Devlin, and other kind folks at Drawn & Quarterly deserve similarly deep appreciation, for publishing great books, but particularly for taking a chance on the series without which *this* book would have been impossible. Their support—through interviews, and by granting me access to archives—was similarly fundamental.

Special thanks are owed Melissa Mendes, the best in all matters, and my occasional far-flung collaborators Katharina Brandl, Roju, Laura Kenins, and Verna Kuutti, as well as the many hundreds of people over the years who worked with the ever-shifting Ladydrawers Comics Collective of Chicago, Illinois. At max we numbered in the hundreds, but deserving of particular note are Nicole Boyett, Rivven Prink, Morgan Claire Sirene, and Sheika Lugtu. Too, Esther Pearl Watson, Lauren Weinstein, Leela Corman, Phoebe Gloeckner, and Laura Park keep me engaged in the world of comics and, at occasional

points in the creation of this book, also kept me from losing my mind. Corinne Halbert, of Quimby's Bookstore, went above and beyond the booksellers' credo by lending me her personal collection of Dame Darcy's *Meat Cake*. Thanks also to Quimby's in general, where I likely purchased several early *Dirty Plotte* floppies, probably even from long-time manager Liz Mason before we were besties. Sam Henderson pulled valuable material from his own archives for my use, for which I am grateful.

Super high fives to Xander Marro, who I like to think is crafting a physical world similar to the one Doucet imagined, or whose Imagined Self might imagine, and whose insights, therefore, were invaluable to this process. Tom Hart and John Porcellino made the research process a joy. Patrick JB Flynn, mentor and friend, set me on the path toward this project remarkably early. Joe Garden deserves recognition for putting up with me for four of my most Julie-the-character-like years, including the many, many times I can recall wandering around a scuzzy apartment casting things that genuinely needed washing aside in order to proclaim, always, that it was time to wash my plotte.

These acknowledgements wouldn't be complete without a shoutout to haters. You have ranked, over the years, from the most esteemed positions in comics to the most vile—not to mention those in other fields, including politics, labor, and media—but you never fail to amuse me. Honestly! I've read your internet comments aloud at dinner parties and your one-star book reviews to students and of course we also did that whole puppet show. Sincere thanks for your seemingly unending efforts, without which, I can honestly say, I wouldn't do what I do.

Final thanks to my publisher Tom Kaczynski for convincing me to write this book. I wanted to write a different one! But I was wrong.